Watercolour Landscapes
Step-by-Step

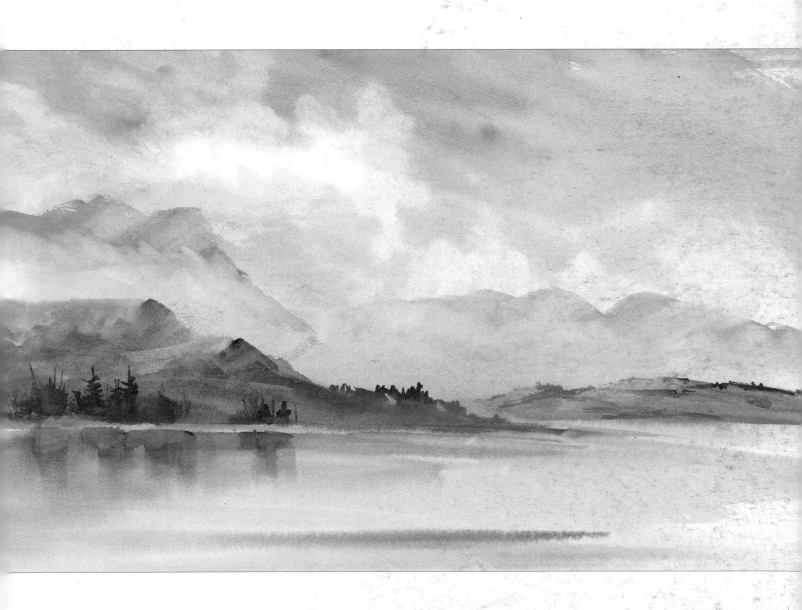

First published 2014

Search Press Limited
Wellwood, North Farm Road,
Tunbridge Wells, Kent TN2 3DR

Based on the following books published by Search Press:

Step-by-Step Leisure Arts series:
Buildings in Watercolour by Ray Campbell Smith, 2004
Perspective by Ray Campbell Smith, 2001
Sea and Sky in Watercolour by Arnold Lowrey, 2001
Water in Watercolour by Joe Francis Dowden, 2001

Watercolour Tips and Techniques series:
From Sketch to Painting by Wendy Jelbert, 2003
Painting Mood & Atmosphere by Barry Herniman, 2004
Perspective, Depth & Distance by Geoff Kersey, 2004
Starting to Paint by Arnold Lowrey, 2003

Suppliers
If you have any difficulty obtaining any of the materials
and equipment mentioned in this book, please visit the
Search Press website: www.searchpress.com

Printed in Malaysia

Cover
Frosty Morning by Barry Herniman
*This painting also appears as a step-by-step demonstration
from page 146.*

Page 1
Early Morning Mist by Arnold Lowrey
This painting also appears on page 104.

Pages 2–3
Reflections in the Sand by Arnold Lowrey
*This painting also appears as a step-by-step demonstration
from page 106.*

Page 5
Greek Doorway by Wendy Jelbert
This painting also appears on page 33.

Publisher's note
All the step-by-step photographs in this book feature the
authors, Ray Campbell Smith, Joe Francis Dowden,
Barry Herniman, Wendy Jelbert, Geoff Kersey and
Arnold Lowrey, demonstrating watercolour painting techniques.
No models have been used.

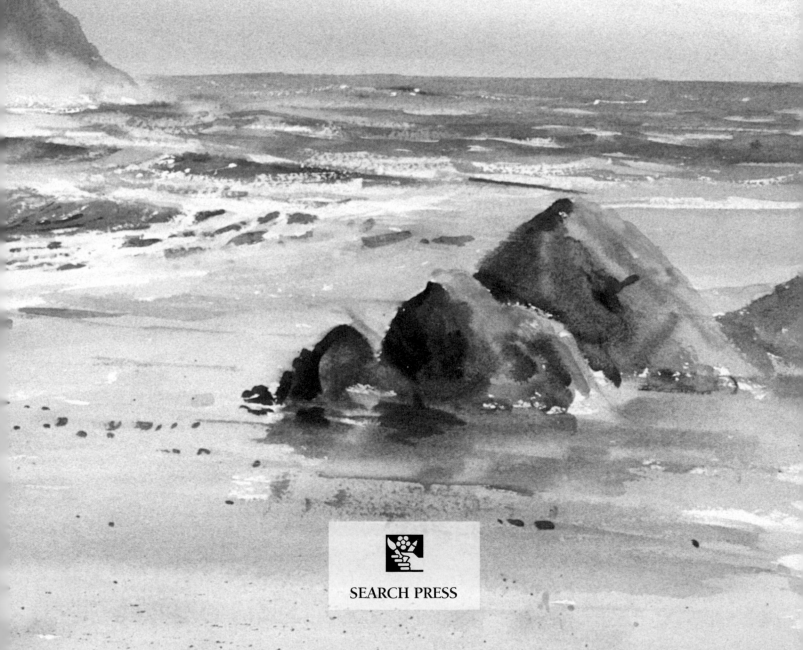

Watercolour Landscapes
Step-by-Step

RAY CAMPBELL SMITH,
JOE FRANCIS DOWDEN,
BARRY HERNIMAN, WENDY JELBERT,
GEOFF KERSEY AND ARNOLD LOWREY

SEARCH PRESS

Contents

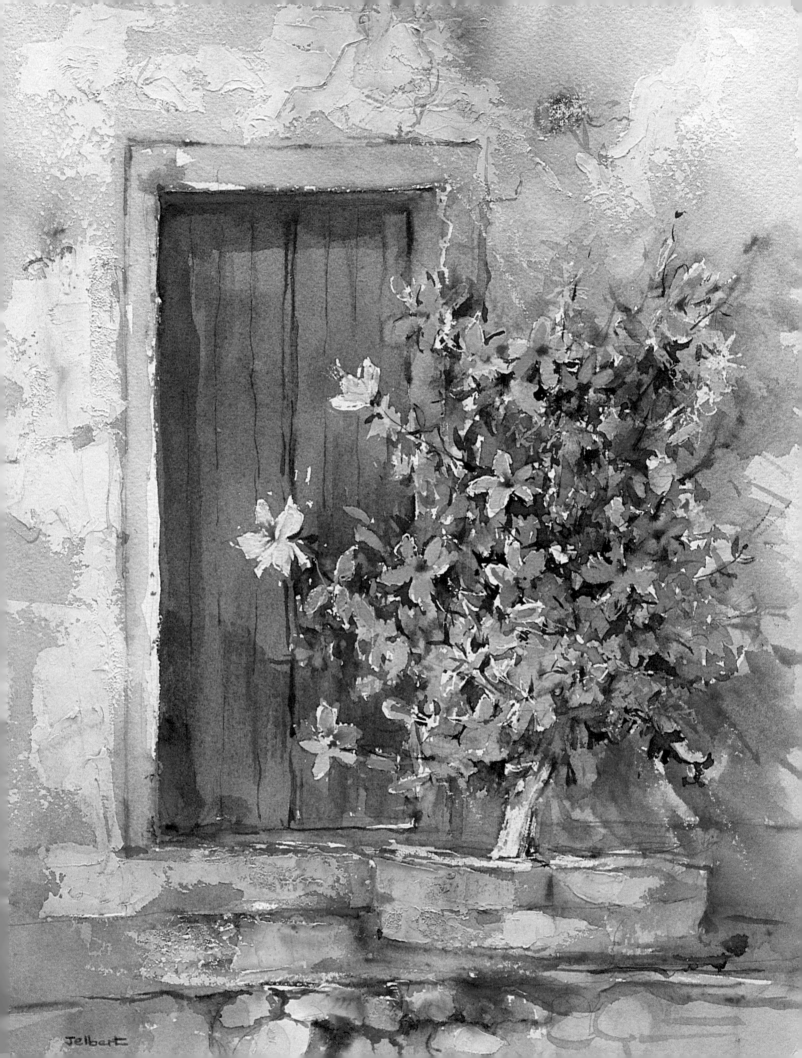

Jelbert

Materials

Paints

Watercolours are available in tubes or solid pans. Many artists prefer tube paints because they are already in a semi-liquid state, making it easier and quicker to mix washes. Squeeze tube paints out into the small wells of a palette.

Artists' quality paints can be expensive, but many artists recommend them for their superior richness, clarity and brilliance. They also have a higher ratio of pigment to gum, so they may go further. The less expensive, students' quality colours are quite versatile however, and might be suitable if you are a beginner or on a budget.

Although there is a vast array of colours available, you can work with quite a limited palette. Some artists prefer to work with just a few colours, others with a very wide range. Most experienced artists develop their own basic palette, including two of each primary colour (warm and cool reds, blues and yellows), earth colours, and additional colours that they have found useful over the years.

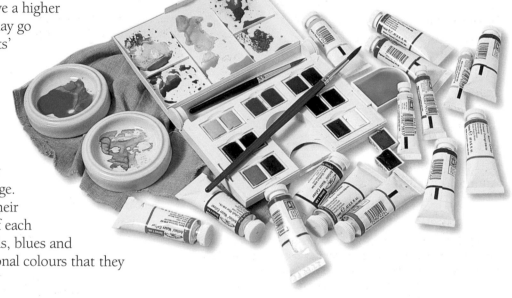

Palettes

There is a very wide range of palettes on the market: large ones for the studio; small ones for working outdoors; flat palettes for water control; palettes with wells for glazing. The best palettes have a lid – if you keep a damp sponge inside them when not in use, the paints will not dry up.

A palette ideal for studio work, with a removable lid, sixteen spaces for colours, a large, flat mixing area and two wells for washes.

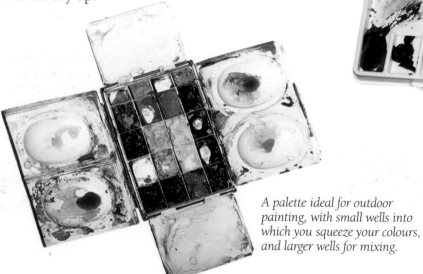

A palette ideal for outdoor painting, with small wells into which you squeeze your colours, and larger wells for mixing.

Brushes

Synthetic brushes have a springier texture than sable ones, and can last longer, but they do not carry as much colour and they are much cheaper.

Sable brushes not only hold more water than synthetic ones, but they also give out paint at a controlled rate. However, they are not as durable as synthetic brushes and can lose their all-important points with wear. Sable/synthetic brushes are a good compromise. Squirrel brushes are the softest of all, and these are excellent for glazing over other work. Bristle brushes are very useful for lifting out paint, and are perfect for laying washes with lots of water and strong pigment.

The size of brushes you use will depend on the scale of your paintings. Large brushes that hold plenty of colour are good for painting large washes, such as skies, but you will need smaller brushes for more controlled work and smaller still for fine detail.

Try to avoid mixing paint with good sable brushes, as it will wear them out. Wash brushes gently in cold water.

The choice of brushes for watercolour painting is a very individual thing. This page shows several different collections belonging to different artists. Refer to the brushes recommended at the beginning of the step by step projects in this book if you want to replicate the paintings.

Geoff Kersey generally favours synthetic brushes because they keep their points and uses round numbers 4, 8, 10 12 and 16 and a rigger, and a flat 2.5cm (1in). He also uses a large filbert wash brush that is a squirrel and synthetic mix.

Wendy Jelbert's selection of brushes includes a small round brush for general work, a rigger for fine detail, a small flat for blocking in objects with sharp edges and a large one for washes. On the far left is a brush she designed, which is wedge-shaped with a fine rigger tip.

Arnold Lowrey uses this 2.5cm (1in) sable/nylon flat brush, also known as a one-stroke, among his other favourites. If you look closely at his paintings, you can perhaps identify the influence of this brush.

7

Paper

There are three watercolour surfaces: HP (hot pressed) or smooth; Not (cold pressed) or medium; and Rough. Most landscape artists prefer either Rough or Not paper because they have a texture which helps with effects such as dry brush work. Smooth paper is more suitable for detailed work.

The thickness of the paper is denoted by its weight in either gsm (grams per square metre) or pounds (lb), which refers to the weight of a whole ream of paper.

Paper expands when it is wet, and if it is wetted unevenly, as can happen with watercolour washes, the thinner papers can cockle out of shape. The solution is to use heavier papers, 300gsm (140lb) and above and attach them firmly to a painting board. If you are using lighter papers, you can stretch them first to avoid cockling. Immerse the paper in water for a minute, lay it flat on a painting board and leave it for another couple of minutes to expand. Pull it flat and secure it to the board with either gummed tape or staples. The paper contracts as it dries and pulls taut and flat. Some artists always stretch paper, even when using the heavier weights.

Rag or cotton-based paper is tougher and more resilient than pulp-based paper, but more expensive.

Experiment to find out which type of paper suits you and stick to your favourite, as you will know how it works and what effects you can achieve with it.

Easels

Watercolours should be painted with the painting board at an angle so that excess water flows downwards. If you work on a flat surface, puddles can form. If you are painting indoors, you can work seated at a table with the back of your painting board propped up at an angle of around 30°. For outside work, however, an easel is useful. There is a wide range available, from small table easels to large free-standing ones. There are also box easels that have a box to hold all your equipment, but these can be heavy to transport. A good easel for a beginner would be an aluminium or steel telescopic easel as they are strong, fairly light, easy to assemble and not too expensive.

Sketchbooks

There are many different sketchbooks to be found and it can be a bewildering choice for anyone just starting to sketch. They vary in binding, size, shape and the type and colour of paper they contain. Some have paper with a smooth surface and they are ideal for pencil techniques and pen and ink; others contain heavier watercolour paper and these can be used for quick watercolour sketches or even small paintings. Most sketchbooks hold only one type of paper, although the colours may vary. Some are spiral-bound, which facilitates drawing and sketching because the papers lie flat and do not spring up when you are working. It is worth finding out what you feel comfortable with and important to use the right media with the right paper.

Hardback books of around 25 x 17.5cm (10 x 7in) are useful as they have their own stiff board to lean on, but smaller books of 12.5 x 17.5cm (5 x 7in) are also handy as they will fit into a pocket or a bag easily. You might want to use watercolour paper sketchbooks if you want to add colour to your sketches; otherwise you can use thick cartridge paper. These can be used for both drawing and painting. Gummed pads of watercolour paper are available in different weights and a wide range of sizes.

Wendy Jelbert's collection of sketchbooks.

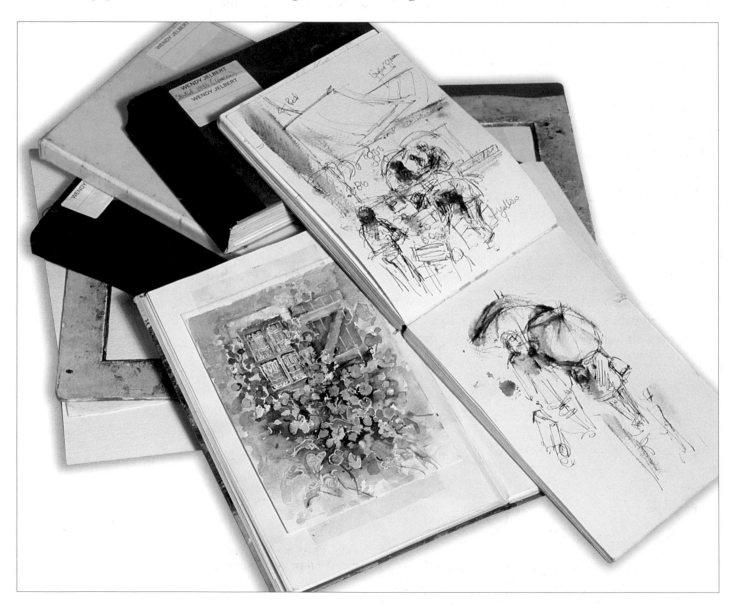

Other equipment

A **putty eraser** does less harm to the delicate surface of watercolour paper than the plastic or rubber variety. Erase pencil lines when your work is completely dry.

Masking tape and **masking fluid** are handy additions that are used to protect small areas from large washes. Use masking fluid with care as it tends to lift underlying colour and it can rip soft papers when it is removed. It wrecks brushes, so use old or cheap brushes or colour shapers to apply it. For random spattering use an **old tooth-brush** – create a fine spray of tiny dots by dragging the thumb across the bristles, or make larger droplets by banging the brush down against your hand. Clean all tools in hot water. Comb the bristles of toothbrushes with a needle to remove dried fluid.

Candle wax can also be used to create texture: rub it straight on to either the bare paper or on top of a dried wash prior to overpainting.

A **craft knife** is used to sharpen pencils, and also to scratch out highlights. **Razor blades** can also be used for scratching out.

For sketching, you can use a **2B pencil** or **graphite stick** but some artists use a **fibre-tipped pen**, **ballpoint pen**, **technical pen** or even a **fountain pen**.

A hairdryer is useful for studio work, saving hours of waiting for the paper to dry naturally. Do not dry your paper too rapidly, and dry work evenly to avoid backruns and hard edges.

Scissors For cutting masks, stencils, and paper.

Scrap paper Use pieces of this to create masks for spattering colour. The natural-looking torn edge works well for the edge of a river bank. You can also cut masks in the shape of a tree branch, for example, then use this to scrub out colour.

Kitchen paper For dabbing off excess colour. Use it wet or dry to create clouds in wet skies, and for other effects. Twist it up into coils for mare's-tail clouds. A **cotton rag** can also be used to clean up.

Some artists use a **spray diffuser bottle** to keep paints moist and also to move paint around on the paper to create effects.

Many watercolour artists use **white gouache** for final details, or to create an opaque colour mixed with watercolour. Most keep it to a minimum though, and never put it in the palette with watercolours, as this will make them chalky.

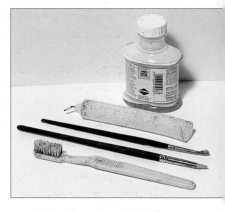

A toothbrush, colour shaper or old brush can be used to apply masking fluid. Candle wax also makes a good resist.

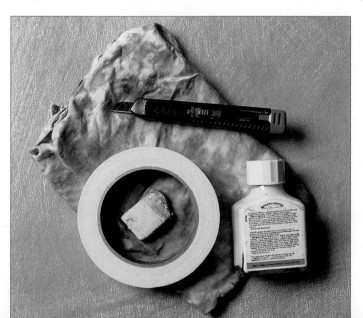

A **natural sponge** is useful for creating the texture of trees, foliage and sea spray.

A **plastic card** such as an old credit card can be used to drag paint about or creating texture.

Putty eraser, masking fluid, masking tape, craft knife and cotton rag.

11

TECHNIQUES

Basic techniques

Handling brushes

The way you present a loaded brush to the surface of the paper affects the way pigment is applied.

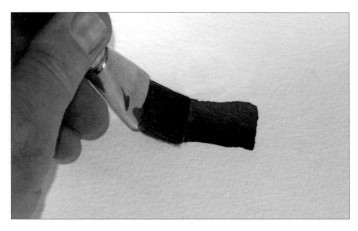

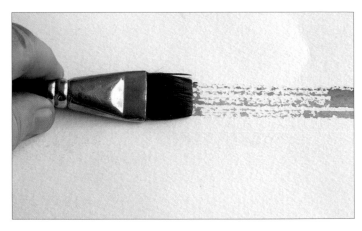

If you hold a loaded brush at right angles to the paper and move it across the surface, the tips of the hairs reach down into the troughs in the surface texture, and pigment is applied to the whole surface of the paper. Use this technique for laying washes and for blocking in.

If you hold the brush so that the hairs are parallel to the paper, then drag the brush across the surface, pigment only sits on the top of the textured surface, creating a sparkle effect. This brush technique is ideal for indicating the edges of foliage and moving water.

Applying washes

For large areas of colour, such as skies, use a large brush such as a 2.5cm (1in) flat bristle or sable brush.

Sponging

A sponge is ideal for creating highlights on rocks and for denoting the softness of foaming water.

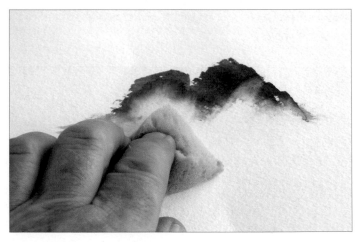

Some artists lay a wash by making parallel horizontal strokes of a loaded brush, carefully catching the bead of water as they work down the paper. Others create skies in a painterly way, brushing colour quickly and freely in all directions – the result is a fresh, clear sky.

Paint in the rock, using quite dry mixes of colour, then, while it is still wet, push a clean, damp sponge into the edge you want to soften. Clean the sponge after each stroke or you will push pigment back into the area you have just lightened.

Scraping into wet

My 12mm (½in) flat scraper brush is wonderful for pulling out trees, branches and grasses from dark areas, and for cutting out the sunlit sides of rocks. Ensure there is enough pigment in the background tone to allow you to scrape lighter marks. The paint should be damp, not wet; if there is too much water on the paper, you will end up cutting a trough and the pigment will drop into it, producing a dark line.

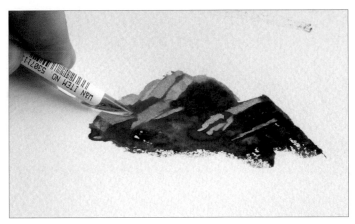

Use the scraper as you use a knife to scrape butter off toast and you will have no problem. Hold the brush down low, angle the flat of the scraper blade, then push it firmly across the paint. Pushing it sideways produces a thicker line as more of the edge comes in contact with the paper.

Using a rigger brush

Rigger brushes come in various sizes, but I prefer to use the no. 3 size. As its name suggests, this brush was originally designed for painting the rigging of ships. The long hairs hold a relatively large reservoir of water, which can be released quite slowly to create extremely long lines. The rigger brush can be used for branches, twigs and grasses, and for adding fine textural detail.

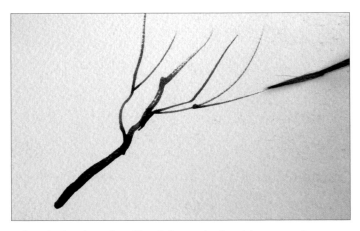

When the brush is placed hard (up to the ferrule) against the paper, it produces a thick line; as it is drawn backwards and upwards, the line narrows progressively – which is ideal for creating bare winter branches.

Using kitchen paper

Kitchen paper is useful for pulling out hard, crisp shapes from skies. It can also be used to lift out the peaks in waves.

Scrunch up a sheet of kitchen paper, then press this on the wet paper to lift out colour and create hard-edged clouds.

Using razor blades

Razor blades can be used to produce the tiny bright sparkles created by the spray from a breaking wave. This technique works best against the dark tones.

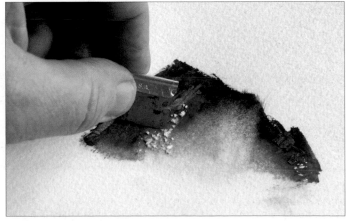

Use the tip of the blade to nick out tiny pieces of colour when the paper is completely dry.

Controlling water

The control of water is, perhaps, the greatest stumbling block when learning to paint in watercolour. You must decide where your water needs to be. For most techniques where you want to control the pigment, the water should be either on the paper, in the palette or on the brush. These pages introduce some techniques which will help you control your water and yourself!

Glazing

If you mix colours in the palette and apply it to dry paper, the pigments merge and they will all dry together. When this wash is completely dry, another wash can be glazed on top. More than three washes will start to destroy the luminosity of watercolour, as the light needs to travel through the washes and bounce back off the paper.

It is most important that you clean your brush, and remove all excess water, before reloading it with fresh paint. Otherwise, it will be like putting a wet sponge into a puddle; it will not pick anything up.

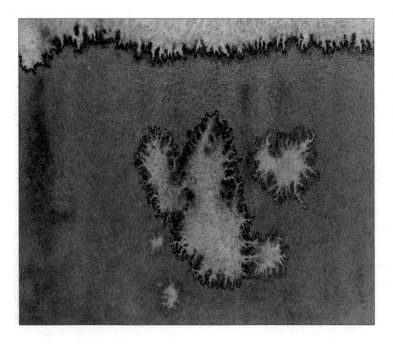

Backruns

Backruns (sometimes referred to as cauliflowers) are created when water is added to partly-dry paint; the water leaches into the drier areas of paint, causing strange cauliflower-like shapes. Sometimes, this effect can be put to good use to depict, for example, ground mist at the base of a forest.

Lifting out wet paint

You can lift shapes out of wet paint with a 'thirsty' brush – a term which means that the brush has less water in it than is on the paper, so that, when the brush touches the paper, it soaks up water and pigment. All the shapes lifted out will have a slightly soft edge. Clean the brush and wring out excess water each time to lift out colour.

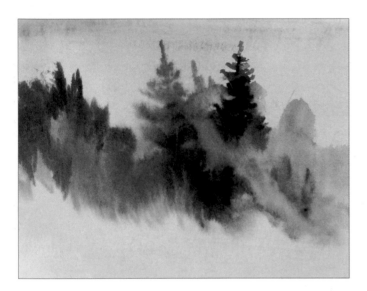

Dry into wet

This technique also uses a thirsty brush and involves applying neat colour into a wet area; it is particularly effective for waves, misty trees, etc.

Apply clean water or wet paint to the area, wring out a clean brush, pick up neat pigment, then paint it into the wet area. Because the brush is drier (or thirstier) than the wet paper, it draws water from the paper and drops on new pigment without it spreading. This happens because the new area is drier than that around it. The wet area attacks the edge of the drier area and softens it. Lighter values of tone can be applied in this way by dragging out some of the pigment on a dry palette before application.

Mingling

For this technique, the paper is first wetted with clean water, then colours are pumped into the wet area – the pigments mix together and dry as one glaze to give maximum luminosity.

Having wetted your paper, mix your colour with water to the required tonal strength on a flat palette. Wring out the brush, then pick up the paint in one stroke and paint it straight into the wet. There should be just enough water in your brush to allow you to add pigment into the wet without lifting paint back out. You can keep painting this way for five minutes providing you keep the paper wet and mingle clean colours of the same tonal value.

Further techniques

Masking fluid

This is a really great medium which enables you to do a wet-into-wet wash over the whole painting and still reserve your whites. But beware! If masking fluid is applied with a heavy hand – slopped on as if with a plasterer's trowel or squeezed out like toothpaste from a masking fluid pen – you could end up with something rather horrid. You can apply masking fluid with an old brush, a twig, a piece of string or anything else that makes a delicate painterly mark and the result is better for it.

Masking fluid applied with an old brush.

Tip Remove masking fluid as soon as possible

Be careful not to leave masking fluid on the painting too long. Get your initial washes down, then, as soon as they are dry, get the masking fluid off.

Tip Masking fluid and hairdryers

Take care when using a hairdryer to dry paintings with masking fluid on. The heat can make the masking fluid rubbery, causing it to smear when you try to remove it.

Masking fluid spattered on to the paper, then moved around with the handle of a brush.

Highlights scraped out of dry paint with a craft knife or razor blade.

Scratching out on dry paint

Use quick sideways movements of a craft knife or razor blade to carefully scratch highlights out of dry paint. A great technique for those final sparkles across water. However, it does damage the surface of the paper and you will not be able to paint over it once done.

Scraping out from wet paint

This is a great way to produce light tree trunks against dark backgrounds. The underlying paint must be just damp for this to work. Lightly scrape the side of a palette knife, fingernail or plastic card (nothing with too sharp an edge) into the paint to produce your light marks. If the paint is still too wet, the mark that is left will be considerably darker – which is fine if you planned it that way!

Tree trunks scraped out of wet paint with the handle of a brush.

Lifting out

You must let the paint dry for this technique to work, and you should use a brush that is slightly more abrasive than a watercolour brush (a hog or bristle brush is ideal). Wet the brush with clean water, gently rub the area to be lifted, then dab the wet marks with a clean piece of paper towel to lift the colour.

Highlights lifted out with a damp brush.

Dry paint spatter lift

Another way of lifting out paint is to use the spatter technique. Flick a brush, loaded with clean water over a dry passage of colour, leave for a while, then dab the wet marks with a clean paper towel. Alternatively, use a squirt bottle to apply a light spray of clean water over an area and lift out with a paper towel. These methods of lifting out create a really good random texture which is great for rocks and cliffs.

These marks were made by lifting out colour after flicking a brush loaded with clean water on the dry paint.

Use a spray diffuser bottle to spray water on the dry paint before lifting out the colour.

Dry brush

This technique works best on Rough paper that has plenty of tooth; it is perfect for speckled highlights on water. Load a brush with colour (not too wet, or it will flood into in the 'valleys' of the paper and you will lose the sparkle), then drag the side of the brush quickly across the paper catching the 'ridges' of the paper surface.

Speckled highlights created by dragging a dry brush (loaded with blue paint) across the surface of Rough paper.

Salt applied to wet paint creates a random patterned effect.

Salt

Using salt is a lovely way to create texture, especially within foliage areas. Allow the wash to dry slightly, then drop in dry salt crystals where you want the texture to be. The pattern that emerges is completely unpredictable, as it is dependent on the dampness of the paper and the size of the salt crystals.

Gouache (opaque white)

Gouache is a good way of producing small, crisp, wispy highlights. Here, gouache has been used to brush in some water rivulets over the rocks, then more paint was flicked on to form the spray. Do not overdo the use of gouache; remember that it is opaque and you can very easily create a very dull passage of colour.

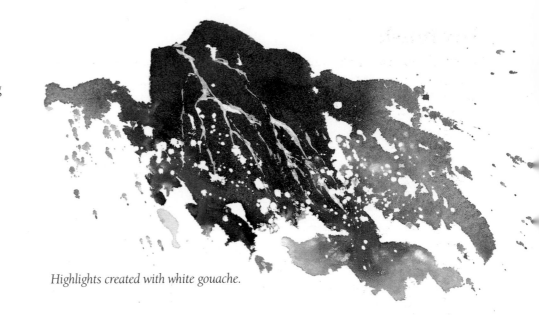

Highlights created with white gouache.

Tip Using gouache

Unlike watercolours, which tend to dry lighter than the applied wet colour, gouache dries darker – and the more you dilute it, the darker it becomes. If you want a really white highlight, you will have to use almost neat white gouache.

Two colours spattered together on dry paper (left) and wet paper (right).

Spattering

This technique can be done in any number of ways and combinations. In this example, a brush was loaded with yellow paint, then the point was flicked diagonally across the paper. While that was wet, blue was introduced. Half the paper was dry and the other half had water on it – notice how the paint diffused nicely on the wet side.

COLOUR

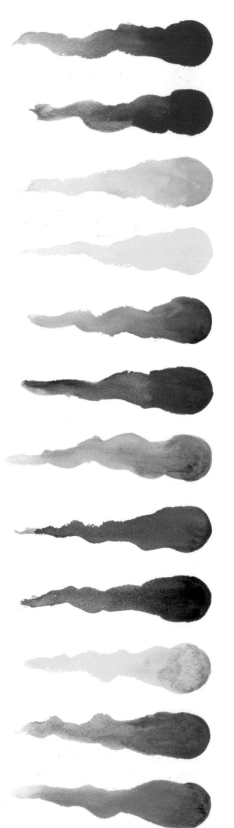

Mixing colours

Colour mixing can be a daunting task, and one of the questions students frequently ask is: 'How do I get clean colour? All I get is mud.' On these and the following pages, Arnold Lowrey explains his method of mixing colour. His palette of colours is shown left, and you will note that he classifies them as being clean, dirty or other colours.

Clean colours

We all know that pairs of the three primary colours, red, yellow and blue, can be mixed to make the secondary colours, orange, green and purple. However, there are no perfect reds, yellows and blues; each has a touch of at least one of the others in it. Reds, for example, either have a tinge of yellow to make them warm, or a tinge of blue, to make them cool. To make clean secondary colours, it is vital that you have a warm and cool shade of each primary colour in your palette; the colour wheel opposite shows my colours and the relationship between them.

My greens, for example, are mixes of Winsor blue (which has a touch of yellow in it) and lemon yellow (which has a touch of blue). Neither of these colours has any red in them so the result is a beautiful clean green. Similarly, clean purples are mixes of the cool permanent rose and warm ultramarine blue (neither colour has any yellow in it), and oranges are mixes of warm cadmium scarlet and warm cadmium yellow.

Dirty colours

The introduction of a third primary colour will grey the mix into what I refer to as a dirty colour. I classify the earth colours, raw sienna, burnt sienna and burnt umber, and all mixed browns as dirty colours because they contain three primary colours. However, dirty colours are not muddy, they are neutral greyed colours which still remain quite transparent. Sometimes, you will want to dirty a clean colour to make it less intense. Try mixing a purple from cadmium scarlet and Winsor Blue (both of which have tinges of yellow) and note how less intense the colour is compared to the clean mix mentioned above.

My palette of colours (from the top):

Clean:	Permanent rose	Dirty:	Raw sienna	Other:	Aureolin
	Cadmium scarlet		Burnt sienna		Cobalt blue
	Cadmium yellow		Burnt umber		Viridian
	Lemon yellow				
	Winsor blue				
	Ultramarine blue				

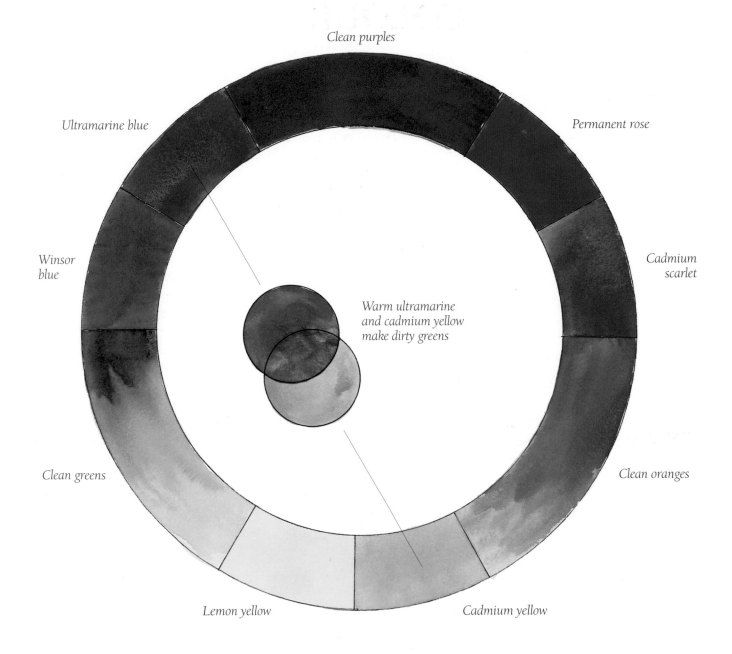

Clean purples

Ultramarine blue

Permanent rose

Winsor blue

Cadmium scarlet

Warm ultramarine and cadmium yellow make dirty greens

Clean greens

Clean oranges

Lemon yellow

Cadmium yellow

Additional colours

The other colours in my palette, aureolin, cobalt blue and viridian, are there simply because they are particular favourites of mine. Aureolin is a slightly golden yellow which has a high transparent quality. Cobalt blue is nearly a perfect blue and highly transparent. Viridian (not one of Nature's greens) is quite transparent which can be mixed with permanent rose (also transparent), to produce highly transparent greys.

Muddy colours are produced by applying too many layers of paint. These layers stop the light from reflecting off the watercolour paper giving the resultant colour an opaque quality.

Mixing greens

My students often ask me how to mix greens. I, in turn, ask them three questions to describe the colour they want to reproduce. Is it a warm or cool green? Is it a light or dark shade? Is it a clean or dirty colour? Answer these three questions and you can begin mixing the colour in your mind, before you even pick up a brush. Always start mixing with the palest colour, then add tiny amounts of the darker one(s).

If, for example, you describe the green as being cool, dark and dirty, all three primary colours are required. Start by squeezing some cool lemon yellow into your palette. Next, nudge in a cool Winsor blue until the green is dark enough. Then, finally, add a touch of a red (either cadmium scarlet or permanent rose) to dirty it down slightly.

Other shades of green can be cool and bright or warm and slightly dirty. Mixing them is only a matter of practice, as is anything worthwhile.

The colour mixes on this page clearly illustrate how you can achieve a wide variety of tones by mixing just two pigments.

Useful greens

Viridian and raw sienna.

Winsor blue and raw sienna.

Viridian and burnt sienna.

Burnt umber and Winsor blue.

Greys and blacks

Viridian and permanent rose.

Ultramarine blue and cadmium scarlet.

Winsor blue and burnt sienna.

Burnt umber and ultramarine blue.

Tonal values

Many artists try to create a range of tones in their paintings, placing the lightest lights against the darkest darks, and this method of painting is often referred to as tonalism. I admire many painters, Rowland Hilder in Great Britain and Andrew Wyeth in the USA, for example, who use this principle as the dominant force in their paintings. However, there are other concepts which can be used to create different moods in your painting. These could be: warm colour against cool colour, clean colours against dirty ones; textured shapes against smooth shapes; and rough edges against soft edges.

Light against dark will always be the dominant concept, since the light/dark sensors in our eyes are far more powerful that our colour ones. So, if you want to stress the colour in your painting, then a good concept would be to use clean against dirty colours. This means that you must subdue most of the light/dark contrasts and eliminate any white. White in a painting says to any colour, 'I am lighter than you'.

These two colour sketches illustrate the difference between a painting where light against dark is the dominant principle, and one where clean colours have been used against dirty ones.

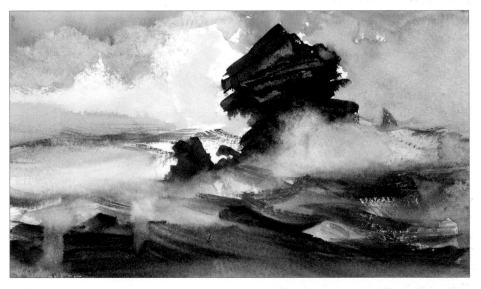

In this dramatic composition, the light against dark technique is dominant. It has interesting shapes with edge qualities ranging from hard to rough to smooth. The lightest light meets the darkest dark in the area of the painting I want you to end up looking at – the focal point.

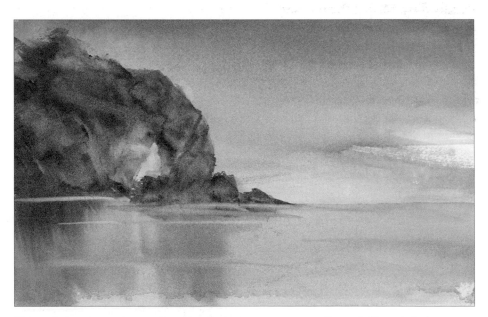

This painting, in contrast to the scene above, imparts a tranquil mood. Essentially, it is a clean against dirty painting. The strong light/dark elements have been subdued to allow colour to become the dominant feature. Note, however, that the dirty colours are not muddy – they actually appear to glow!

TONE

The tone of any colour varies from light to dark, and is governed by the ratio of pigment to exposed white paper. Transparent watercolours and inks, for example, can be diluted to form a range of tones from the weakest wash through to pure pigment. With pencils and pens, a similar range of tones can be achieved by varying the density of marks (scribbles, dots, dashes, crosshatching, etc.) made on the paper. Work up gradated columns of tone (see below), then number them from 1 (the lightest tone) to 6 (the darkest). Different media have different characteristics, and only practice will allow you to represent a particular tone in your chosen medium.

The tonal exercise (right) could help you build up confidence with using tones, before you start working on more complex compositions. The more you practise, the more you will discover the subtlety of tone. You will soon realise that there are more than just six tones, and that you will want to refer to a tone as, say, 2½ – somewhere between 2 and 3.

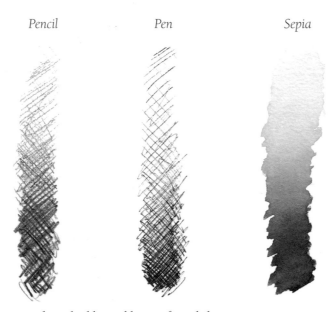

Pencil Pen Sepia

Use different media to build up a library of tonal charts.

Start with a soft 4B pencil, then, using hardly any pressure, cover a small area of paper. Now, with slightly more pressure, cover another small area beneath the first. Continue building up the column with denser tones until you have an almost solid black.

Use a steel-nibbed pen to work up another column with crosshatching, varying the intensity of marks from almost nothing to almost solid.

Now, using a dark watercolour (sepia was used in this example) work up a third column. Start with a watery wash and build up to neat pigment.

Always start by marking the lightest and darkest areas of a composition. Then, having committed yourself to the extremes, you will find it much easier to decide on where to place the other tones. Finish the sketch with relevant colour notes and you should have all the vital information to allow you to construct a finished painting at a later date.

Tonal exercise

Set up a simple still life composition with different coloured papers and, maybe, a pen. Bend the papers into shapes that catch the light at different angles.

Make a tonal chart in the medium you want to use. Draw the outlines of the composition in your sketchbook, then, referring to your tonal chart, number all the surfaces and add colour notes.

Cover the still life, then working from your notes, shade in the sketch. When this is complete, compare it with the original.

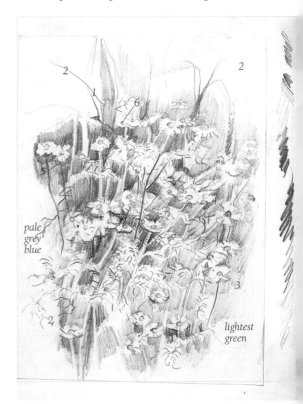

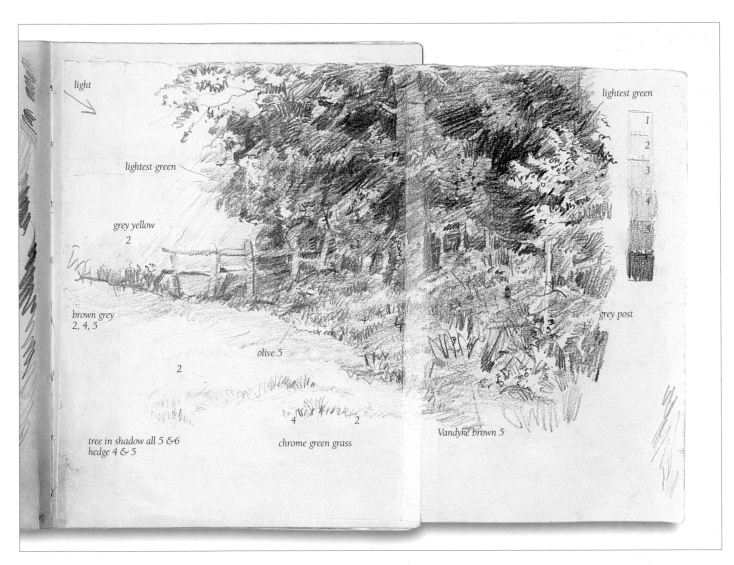

light

lightest green

lightest green

grey yellow
2

brown grey
2, 4, 5

2

olive 5

4 2

tree in shadow all 5 &6
hedge 4 & 5

chrome green grass

Vandyke brown 5

grey post

1
2
3
4
5

Summer Hedgerow

This carefully constructed sketch corresponds to the tonal chart in shading
and bears the numbers and colour notes needed for future reference.

If you do not have the time to work up a detailed
tonal sketch, you can at least rough out the shapes
and add tonal numbers and colour notes. The
jigsaw-effect sketch above, simple as it is, will help
you decipher the shapes and structure of a subject.

Apart from indicating the light and dark areas of a
composition, you can also use tones to denote perspective.
Note the differences in tones and spacing from the
foreground to the distance in this sketch.

COMPOSITION

Composition is the art of apportioning space in a satisfying and truthful way – it is the architecture of art.

A simple approach is to place a frame or aperture round your chosen image, rather than trying to arrange individual elements within a frame. Then, by moving the frame about, you can control the composition.

Find a focal point and move the frame to make this point slightly off-centre. The focal point can be distant, out of focus or even indefinable, so that the eye wanders and explores the whole composition, never arriving at the 'end' of the painting. River scenes have a ready-made passage to lead the eye to the focal point.

Decide on where to place the horizon. A high horizon gives a painting more foreground, creating depth and enhancing distance, whereas a low horizon gives a sense of space and height, and a tall sky can be used for painting wide expanses of open country. The horizon might define a long narrow rectangle of sky area above it, and a much broader one below – two simple counterbalancing shapes. A composition can be that simple.

Opposite
This comfortable composition places the viewer on the river bank. The wide expanse of water gives ample space for wonderful reflections. The main group of trees is well to the right of centre and the focal point is just beyond them. The footpath leads us into the picture, then the other elements of the painting take over making the eye wander all over it. The small white-roofed building, also set off-centre, provides contrast for the gentle wall of foliage in the distance. Its image also contributes to the reflections on the surface of the river.

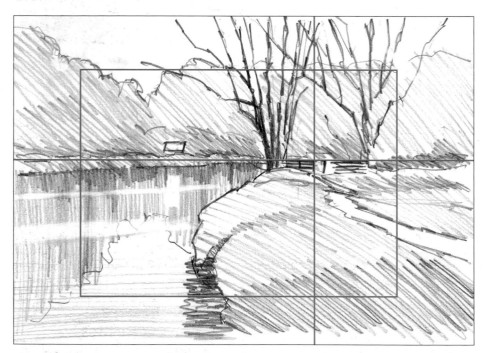

This is one of my sketches of the scene depicted in the two paintings opposite. The superimposed frame was used for the top painting and the horizon and the main focal point (where the vertical line crosses the horizon) are also marked.

The horizon is well off-centre, creating two rectangles – a narrow one for the background and a larger one for the foreground. The foreground area is made up of several triangular shapes all converging at the focal point. The two groups of trees form inverted triangles that link the two rectangles.

Experiment with different shapes and sizes of frame. Let the composition dictate the proportions of your painting, not the size of paper you are using.

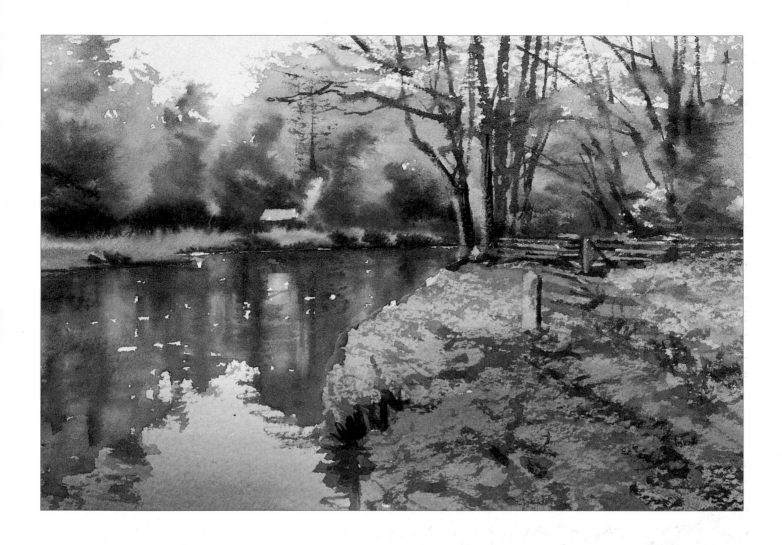

This painting is the same scene as that above, but from a different viewpoint. We are much closer to the trees which are now just left of centre. The river and path both lead us to an indistinct focal point above the fence and gate. The building, now with a red roof to provide a point of interest, counters all the greens. The high horizon creates a deep foreground area, the perspective of which is enhanced by the leaf details at the bottom of the painting.

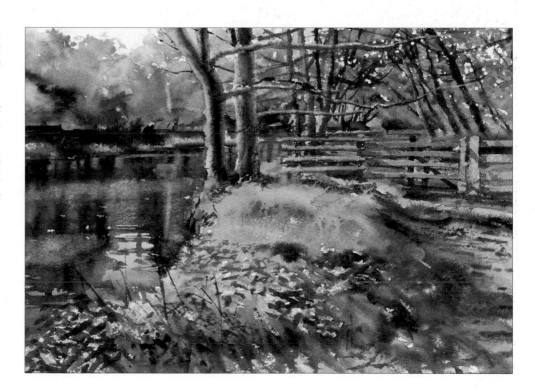

PLANNING A PAINTING

When you have decided on a composition for your painting, you then have to consider how to paint it. Always remember that your painting, unlike a photograph, is your interpretation of the scene – other viewers of your finished painting will not have seen what you 'saw', so you can change anything. The following exercises show different interpretations of the same scene, shown in this photograph.

You can affect the mood of a painting by varying one or more of the following: the tonal structure (the relationship between lights, mid-tones and darks); the temperature range of the colours (warm or cool); the direction of the light source and shadows; the time of day (the tone of the shadows); and edge textures.

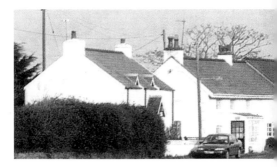

This photograph inspired the following exercises in tone, shadows, edge structures and colour temperature.

Tonal structure

Before starting to paint a subject, it is always worthwhile making a tonal sketch of the scene and looking at the relationship between the light, dark and mid-tone areas. Lots of similar tones next to each other will produce flat, uninteresting pictures. If your first tonal sketch of what you see appears that way, try working it again setting light and dark areas against mid-tone ones.

These three tonal sketches of the same scene each have different relationships between the light, mid-tone and dark areas. See how they affect the mood of the picture.

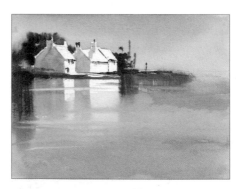

Mid-tones dominate this version of the scene, but they help emphasise the light areas of the cottages, (the focal point), which are also brought into relief by the dark areas on either side. The combined area of the light and dark tones makes an interesting shape.

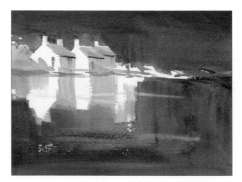

In this sketch, dark tones predominate, but the eye is still drawn to the light and mid-tones used for the cottages. Note the different shapes created by the reflections.

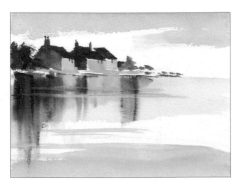

Here, the focal point consists of mid- and dark tones which are brought to prominence by the light tones in the sky behind the cottages and those across the foreground stretch of water.

Colour temperature

The range of colours used for a painting also has a profound effect on the perception of the viewer as to its mood. Note the difference between these two colour sketches – one is full of warm and inviting colours, the other cool and aloof ones. Both images, which are based on the first tonal sketches shown opposite, still look rather flat. This problem could be overcome by introducing touches of cool colours to the yellow sketch and touches of warm colours to the blue one (see the sketches below).

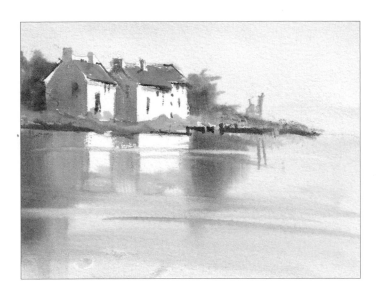
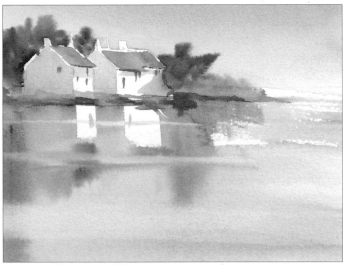

Direction of the light source

You can place the sun wherever you want it to be, but remember to make all the shadows consistent with the chosen position, especially if you are working from a photograph. Also remember that if you are painting outside, the sun and shadows are moving all the time.

In the sketch, below left, the light is coming from the right-hand side, lighting up the front walls and roofs of the cottages. In the sketch below right, the light is from the left-hand side, lighting up the gable ends of the cottages. Note the use of cast shadows on the nearest cottage to create interesting shapes.

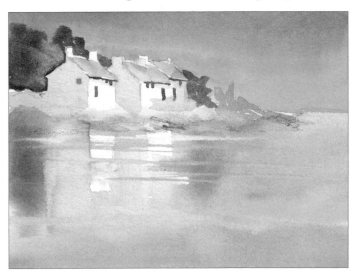
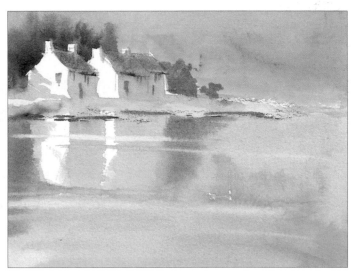

SKETCHING

Sketching is an important part of becoming a landscape artist. The following advice is from Wendy Jelbert.

Whatever type of artist you are – a professional, a serious amateur, a weekend artist, or a beginner – a few crucial lines, some written notes and, maybe, a couple of photographs, will help capture forever a fleeting moment of time that sparks your interest. You never know when these moments are going to occur, so you must be prepared. Personally, I never leave home without a small sketchbook and a pen or pencil in my pocket; I might forget my keys, but never my sketchbook! Remember that you only have a brief time in which to record a scene, so it is important to get all the right information down quickly and accurately.

When I see something that captures my imagination, I ask myself why it does so. Then, I say out loud why I like it! Whatever the answer, I try to capture the movement, the shapes, the contrasts or textures immediately.

I have been painting for many years now, and my collection of sketchbooks are as dear to me as my family. They are filled with memories of people, places and objects that I have come across over the years. Some of the sketches are just doodles to capture a particular pose or an interesting shape, others are more detailed, worked up in whatever medium I have to hand, and include handwritten notes about colours, tones and textures. I never discard anything, and many of my favourite paintings have been inspired by old sketches.

Tip Sketch in comfort
On a sketching expedition, dress in something comfortable and always carry a lightweight waterproof and a cardigan – even in summer or in a hot climate! When you are concentrating on sketching, you can easily forget how cold it can become. If possible, carry a small stool so that you can sit in comfort; mine is combined in a rucksack. A black plastic bin liner can be extremely useful in inclement weather conditions. Pop your legs inside the bag and they will be protected from cold winds. It does not look very fashionable, but you will be warm.

These small farmyard studies were worked up in sepia water-soluble pen. I loved the clutter and machinery and the curves of the pecking hens!

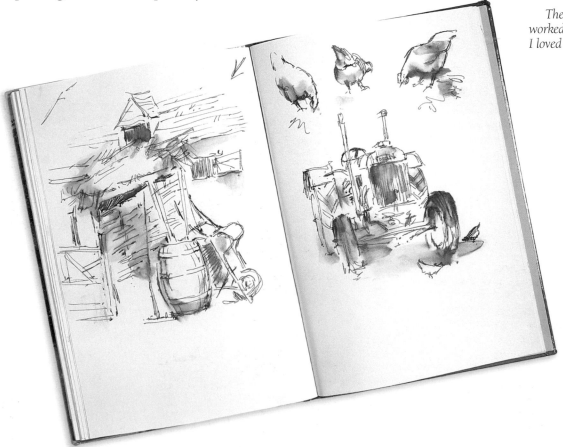

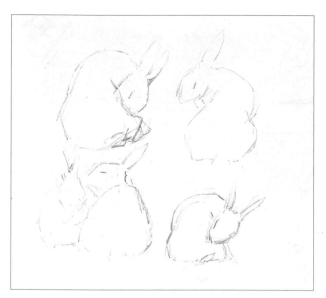

These rabbits, worked up in pencil, were a delight to sketch as they formed gorgeous and varied shapes.

Use simple free-flowing lines (you do not have to be very accurate at first) and concentrate on the very 'essence' or 'action' of the subject. Work up various widths of line; heavy ones to denote forceful and active feelings and thinner ones for distance and structure. Support these with accents of shading to give depth and contrast.

Runner beans sketched with waterproof pens. It was quite a challenge to sketch the fascinating negative shapes of these beans, some of which were in sharp contrast to adjacent shapes. Often this type of sketch can be done as fast, spontaneous scribbles. Keep the pen or pencil continually on the paper, hardly looking at what you are drawing, but concentrating deeply on the subject. This method can add a freshness and freedom to your sketching which can give some unexpected results.

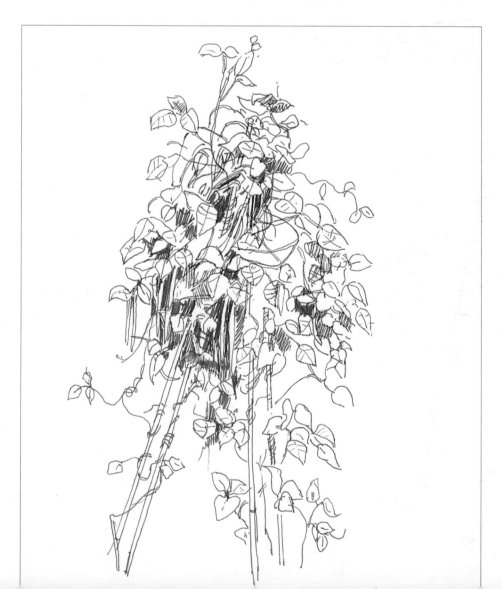

Using sketching materials

Never be afraid of using different media, either on their own or mixed together. The images on this page show the same scene sketched in different ways, while opposite, I have included a finished painting of the same scene. The sketches were the result of an exercise I set some students while on a painting holiday in Greece. Every time we left our courtyard, we were confronted with this adorable doorway and hibiscus plant, so it was quite handy to use this as our subject.

Tip Colours for flowers

Flower colours can be very complex so analyse them carefully. Try out colours on a piece of paper and make notes about different mixes. These are just as vital as the shapes and tones on the sketches. Get things right before committing yourself to a finished painting.

The hibiscus colours are alizarin crimson, vermillion and permanent rose. For sunlit petals use weak washes of these colours. For the mid-tone areas, darken the wash with more pigment. At the flower centres, mix at least two colours together. For the shaded areas add touches of cobalt blue to the reds.

Greens are often regarded as a problem. Ready-mixed greens – Hooker's green, emerald or viridian – can look artificial, but they can be mixed with other colours to provide a wide range of natural greens. Add yellow ochre or cadmium yellow to the ready-mixed green for pale greens; burnt sienna or cobalt blue for mid greens; and sepia, violet or deep blue for a range of dark greens.

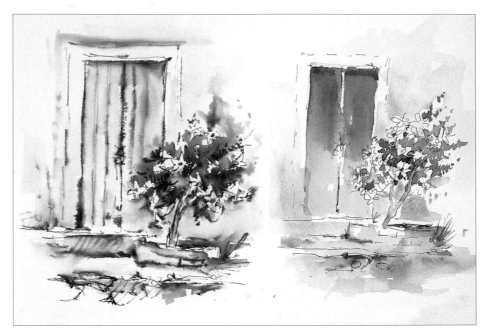

In this image, the doorway was drawn in with pencil, then overlaid with a network of non-waterproof sepia ink, adding more detailed work in the darker areas and much less in the lighter ones. I then used a wetted brush to coax water over the doorway, allowing it to seep and bleed into a diffused tonal wash. I added a tiny spot of blue for the wall colour and mid green for the foliage.

In this version of the scene, I drew the basic outlines using a steel-nibbed pen and black waterproof ink. I worked quickly to produce fine broken lines and light scribbles for the foliage. I then used watercolours to block in the shapes.

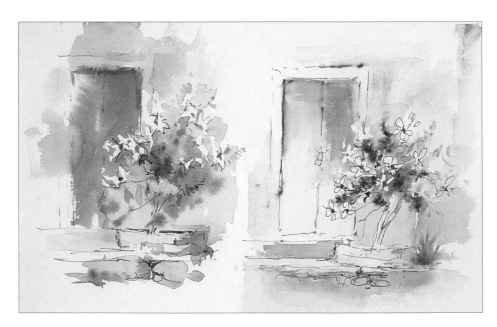

Here, I worked up a free-flowing watercolour study, then, when this was thoroughly dry, I penned in detail with sepia ink.

In this final study, I made an initial drawing with a mixture of waterproof and non-waterproof sepia inks. When I then added watercolours on top, some of the non-waterproof ink ran into the colours while the waterproof ink remained stable.

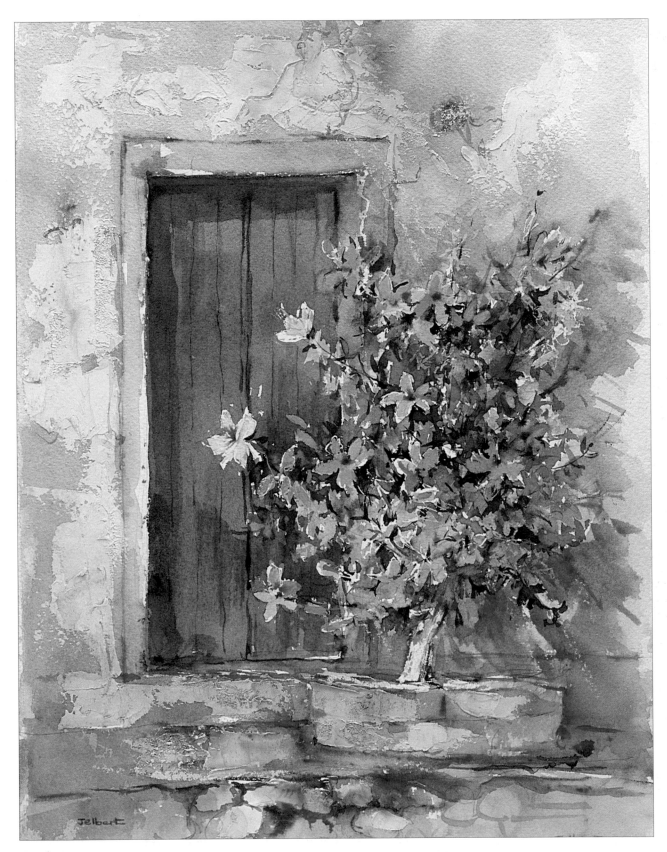

Greek Doorway

*This composition was painted from the studies opposite using a mixture of inks with
watercolours. This combination of techniques creates a fluid and gentle feel in the
shaded areas and gives a more structured look to the stones and foliage.*

33

Useful sketches

If your sketches are to become a reliable reference source for future paintings, you must include notes about colours that you see. These notes are very personal. There are no standard rules or codes to follow, so invent your own form of shorthand. But, remember that you must be able to read your notes as well as write them! Only practice will perfect your skills.

Do not be tempted to rely on photographs for this aspect of sketching. With the busy lives we lead, it is an easily-formed habit, but, although photographs have their uses, the colours reproduced often bear no relationship to those of the subject.

If you are sketching with coloured water-soluble pencils or watercolours, try to make the colours as accurate as possible. On the other hand, if you like sketching with graphite pencils or ink, annotate the finished sketch with written notes about the colours. Sometimes dots or small slithers of each colour can be added to the sketch instead of words.

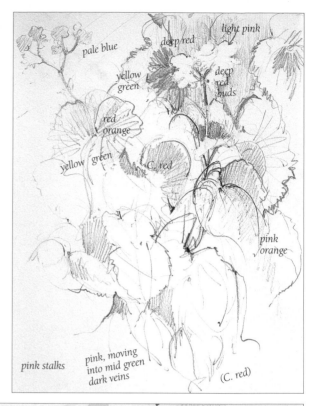

Pencil sketch with handwritten colour notes.

This sketch of a pot plant was worked with water-soluble pencils.

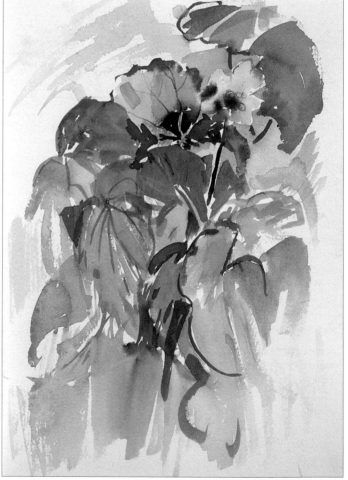

Here I sketched the same subject as above with watercolours.

34

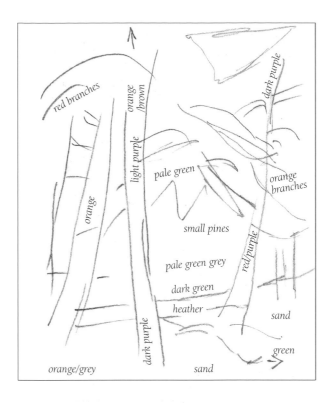

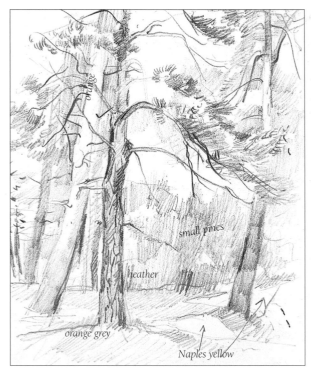

This painting of a woodland scene was worked up from the sketchbook references above.

The photograph of a large group of trees is a general reference of the scene; I chose to simplify the composition and to concentrate on just a few of the trees. A lot of colour information was needed, so I made two pencil sketches. One, top left, is a very simple sketch of basic shapes on which I added most of my notes. The other sketch is more detailed and shows different textures and tones.

Some artists like to make a regimented list of notes on a separate page, but I prefer to have them on my drawings.

Tip Sketching detail

More often than not, one-third of all detail can be left out.

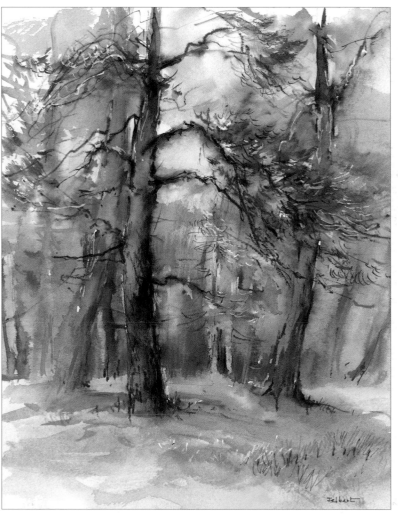

Capturing details

Collecting just the right material for a future painting can be quite a task, especially if you are under pressure and time is a limiting factor. Quite often, when you start sketching, the more you see, the more you add, and your sketch can become very detailed and crowded. Sometimes, this is not bad practice, as you may well be able to develop several compositions from just one sketch. If your sketch is too scanty and brief, there is a danger you will forget what is in that blank space, and you may not be able to recreate it properly even with a bit of imagination! If you have the time, it is worth the effort of producing a full sketch, rich with information and ready to work from – perhaps backing it up with a photograph or two.

Seeing things properly is all important, so be extra curious in your observations. Whenever you have a spare moment, take a look about you. Spot the extraordinary array of surfaces in the scene. How do we sketch these? Look again, more closely this time, and absorb the rhythms and patterns you see. Do they have hard ridges, dots or scales, or is the texture wispy or feathery? Note how one surface compares or contrasts with another, then try to imitate them using lines, dots and dashes and by varying the thickness of your drawing line. Slowly, you will develop your own 'artistic language'. Practice will make you more observant, and will help improve your sketches and paintings.

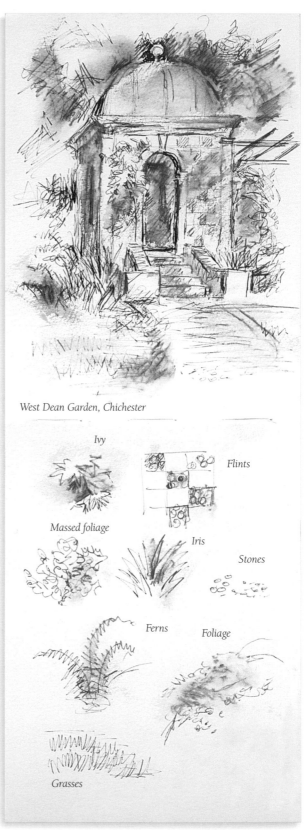

West Dean Garden, Chichester

Ivy

Flints

Massed foliage

Iris

Stones

Ferns

Foliage

Grasses

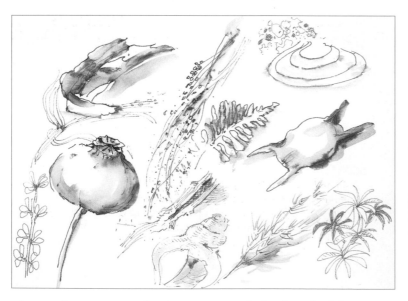

These studies in waterproof and non-waterproof inks, show the different textural qualities of shells, leaves and dried plants.

Here in this study in the gardens at West Dean College near Chichester, my class and I had an enjoyable day sketching and one of the features we liked was this small flint building. We explored the variety of plants, steps, building materials and various surfaces around this busy corner.

The two watercolour sketches on this page, a bell tower and a detail of pomegranates, were painted while on a painting holiday in Greece.

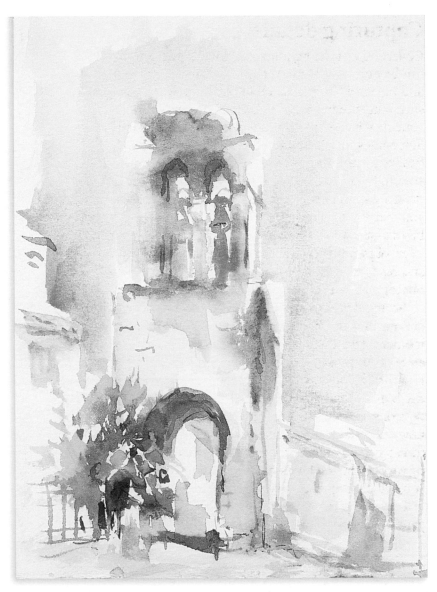

I used the wet-into-wet method to paint the bell tower so that it gently blended into the blue wash of the sky. This technique softened all the edges at the top of the tower emphasising the archway and door which have harder edges.

Cascading over one corner, a beautiful display of pomegranates provided a sharp contrast to the pale area beyond. The bright colours of the fruit and foliage help draw the eye into the middle distance.

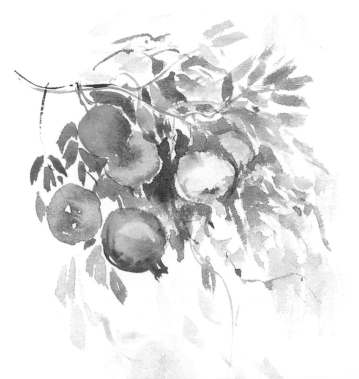

I loved the collection of these delightful pomegranate fruits so much that I decided to paint them for the sheer joy of doing so. I also bore in mind, however, that they could be a useful reference for future work.

PERSPECTIVE

However brilliant the brushwork and the use of colour, a painting will never succeed if the underlying draughtsmanship is flawed. Faulty perspective is an insurmountable bar to excellence. Many aspiring artists have problems with perspective, sometimes because of the geometric constructions involved. However, the geometry is very simple, and everything falls into place once you understand the basic principle.

The laws of perspective show us how to represent a three-dimensional world on a two-dimensional plane. Before the Middle Ages, artists relied on observation alone and the perspective in many early paintings is eccentric to say the least. It was not until the Renaissance that the problem was considered more scientifically, when an architect named Brunelleschi discovered and codified the constructions with which artists today are familiar.

Those with scant knowledge of perspective often have little trouble depicting the natural world and get by on observation alone. Problems arise when they tackle man-made objects such as buildings – for with geometric shapes, any faults become glaringly obvious.

Old Broadstairs
380 x 290mm (15 x 11½in)
It is important to work out where your eye level line is before you start painting a subject such as this (see opposite).

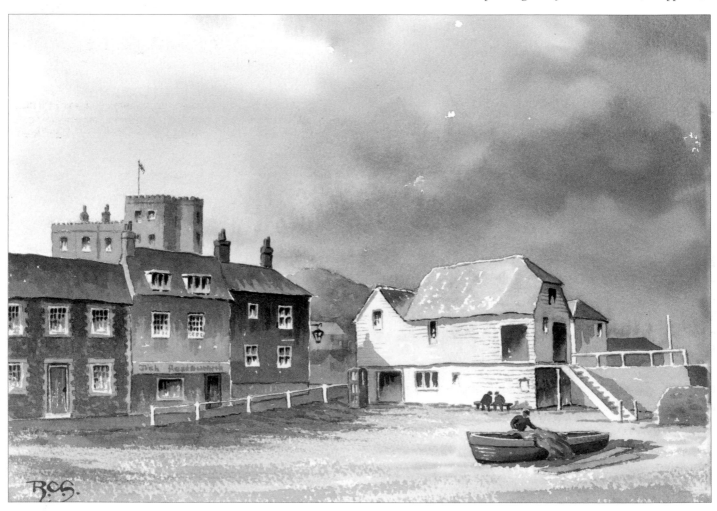

Basic perspective

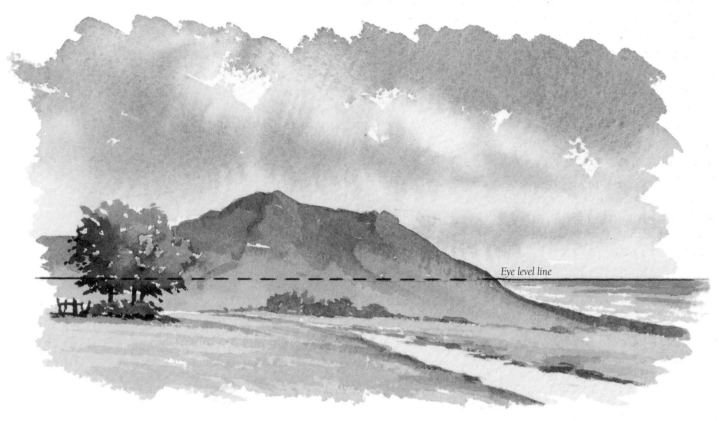

Eye level line

Here, the stretch of sea indicates the position of our eye level line. Without it we have to gauge where a horizontal line from our eyes to the hills would meet the hills (shown by the dotted line).

The first thing we have to understand is the exact meaning of the word horizon. In the context of perspective, the *true* horizon is simply a horizontal line at our eye level (eye level line). At sea or on a dead level plain, the horizon we see is the true horizon. However, hills, trees and buildings often obscure the true horizon, so we have to gauge where it should be. This is not as difficult as it may sound. The sketch above should make matters clear. The position of our eye level line is indicated by the stretch of sea. To find the true horizon, this line, which is indicated by the dotted line, is extended across the hills to the trees beyond. For simplicity the term 'eye level line' instead of 'true horizon' is used throughout this chapter.

You may place your eye level line high or low on your paper, according to the demands of the subject. However, you must remember that objects above that line are above your eye level, and, conversely, that objects below it are below your eye level.

Simple constructions

The concept of perspective is based upon the fact that objects appear to get smaller the further away they are – a fact we can readily verify ourselves.

Figure 1 shows a row of vertical posts, all in line and all of equal height. As you can see, the posts become ever smaller until they disappear altogether, at what is called the vanishing point (VP). If our line of poles is on a dead level surface, this vanishing point will be on our eye level line.

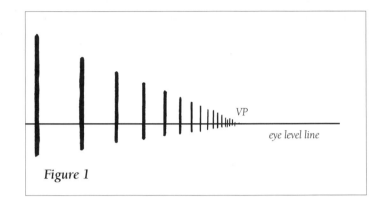

Figure 1

Figure 2 shows what happens if we now draw a line through the tops of the posts and another through the points where they enter the ground. These lines will be straight and will meet at the vanishing point (VP).

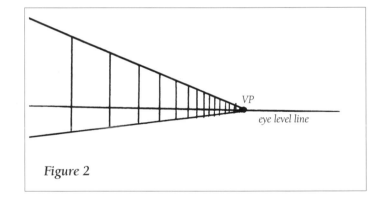

Figure 2

In Figure 3, if the posts are evenly spaced, the gaps between them may be found by drawing the line through their mid-points to the VP, joining the top of the first post to the mid-point of the next and extending it to meet the ground line. This will give you the interval to the third post.

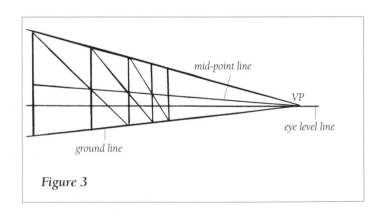

Figure 3

So far we have considered just one vanishing point. Figure 4 shows what happens if we now look at a solid rectangular object, such as a hut. Each of the sides we can see has its own vanishing point, and we now have the simple construction with which we can check the perspective of any solid rectangular figure. Having drawn our hut, we extend the lines forming the tops and bottoms of the visible sides until they meet, and if our drawing is accurate, they will meet at two vanishing points on our eye level line. Of course many buildings are far more complex in shape than this, but they can all be simplified into separate rectangular forms which can then be dealt with individually. It is clear from Figure 4 that lines above the eye level line slope down from the nearest corner of the hut and that lines below the eye level line slope up.

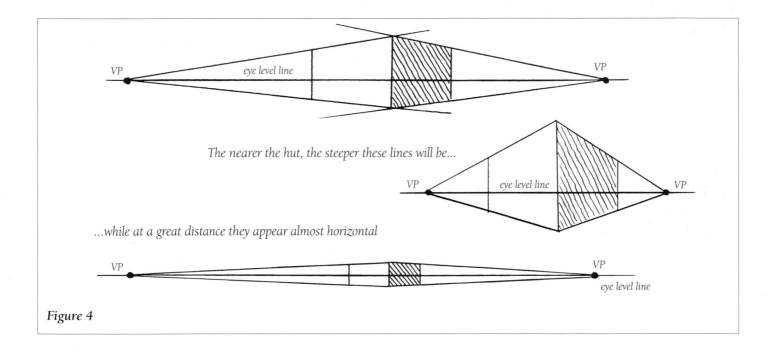

Figure 4

Finally, Figure 5 shows the construction of solid rectangles wholly above and wholly below the eye level line.

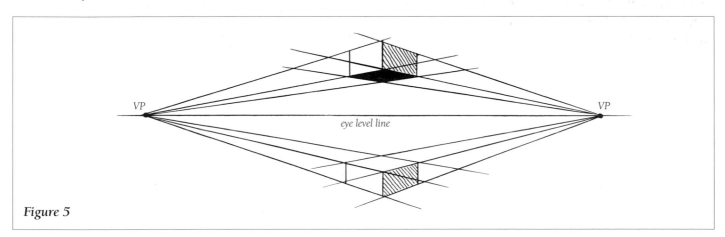

Figure 5

Further constructions

So far we have considered the perspective of simple box-shaped objects and we now have to face the fact that real life is rarely so straightforward. Even our basic hut will have a roof and we must know how to draw it accurately.

Figure 1 shows the two visible walls of the hut drawn in heavy lines. If we now draw a perpendicular through the intersection of the diagonals of the end wall, we know that the nearer end of the roof ridge will be on that line. You will also notice that this perpendicular is not quite in the centre of its wall, but slightly nearer the right-hand corner, thus allowing for the fact that the nearer half of the wall naturally appears larger than the more distant half. We now mark the height of the gable on the perpendicular and join that point to the top corners of the end wall to establish the sloping lines of the roof. We now draw a straight line from the same point to the left hand vanishing point to give us the top ridge of the roof.

The far slope of the roof is roughly parallel to the nearer slope we have already drawn. However, because the top ridge of the roof is slightly more distant than the lower margin of the roof, these slopes will not be exactly parallel, as the construction in Figure 2 makes clear.

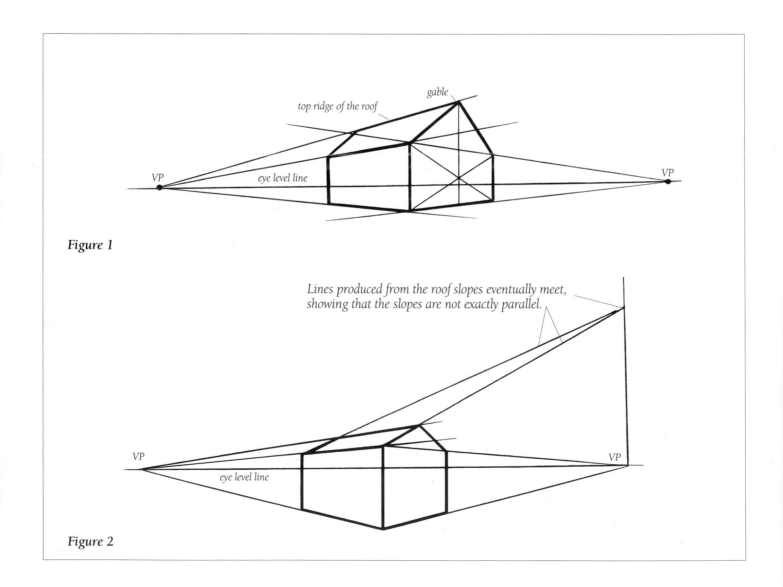

Figure 1

Figure 2

42

Figure 3 shows a more complex shape than our simple hut. The drawing shows a couple of additions and you will see how each has been treated as a simple solid rectangle to establish its perspective. Even the chimney comes in for the same treatment, as do the doors and windows. As long as all the extra bits are at right angles to or parallel with the main block, all will be well and this perspective construction will work.

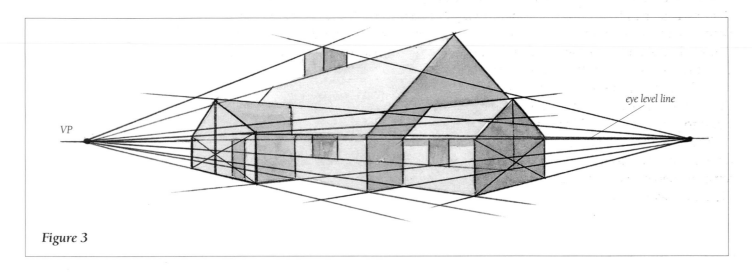

Figure 3

In Figure 4 we learn how to draw objects which are at different angles to each other, like this row of terraced houses built following a curve in the road. The thing to remember here is that each house will have a different vanishing point. You can see that the oblique angled houses have near vanishing points, but the more the houses swing round to face us, the more remote their vanishing points become. When a house is facing us head on, the lines forming the top and bottom of the front wall will be exactly parallel and so will never meet.

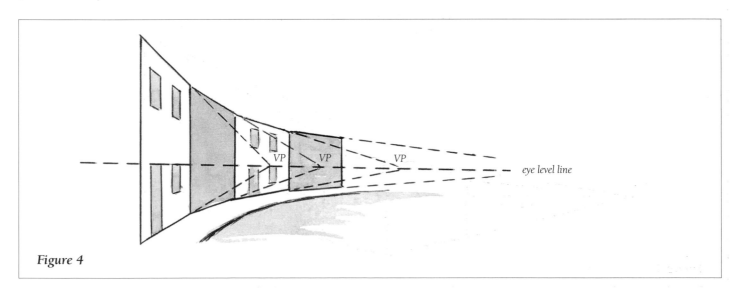

Figure 4

Shadows

The experienced artist usually paints shadows from observation alone, and when they fall across rough or uneven ground, any slight inaccuracy is barely noticeable. However, knowledge of the perspective construction of shadows is a useful safeguard against gross error. With the less experienced, problems are naturally more likely to arise and we have all seen paintings in which the shadows appear to be coming from a variety of directions. This fault usually arises from poor observation rather than ignorance of perspective and often occurs when a painting has taken so long to complete that the position of the sun has shifted appreciably!

Another common fault is that of painting shadows in the field as though they were falling across a completely flat surface rather than over rough ground – again a failure of observation.

Figure 1 shows that, if observed accurately, shadows perform the useful function of helping to describe the surface over which they fall.

Figure 1

The perspective construction of shadows is complicated by the need to consider the direction of the light source – in landscape work, the sun – and the point on the eye level line which appears to be vertically below that light source.

Figure 2 shows the perspective of the shadow cast by a solid rectangular building, and if you study this carefully, you will see how it all works.

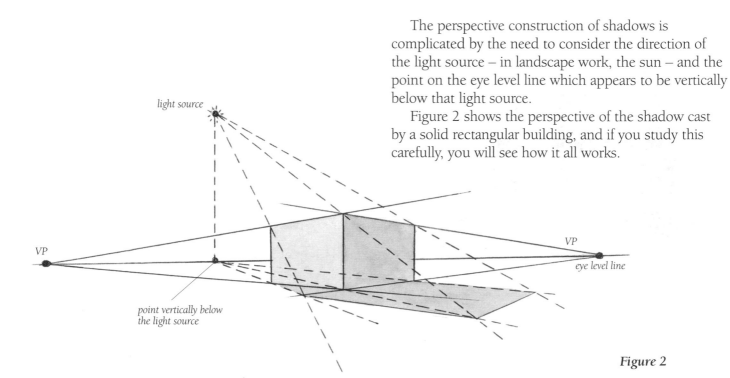

light source

VP

VP

eye level line

point vertically below
the light source

Figure 2

44

Because of its great distance, the shadows cast by the sun are parallel, but the effect of perspective often makes them appear to radiate. This occurs when one is looking, for example, into a copse with the sun behind it, or observing people in a sunlit street, again, with the light behind them.

Figure 3 deals with this situation and explains both the direction and length of the cast shadows.

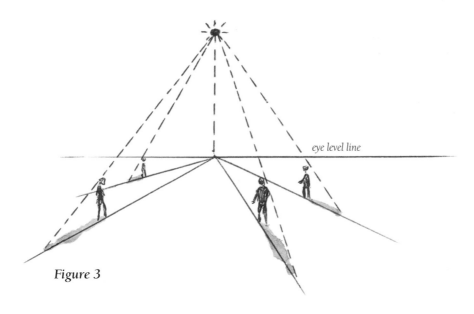

eye level line

Figure 3

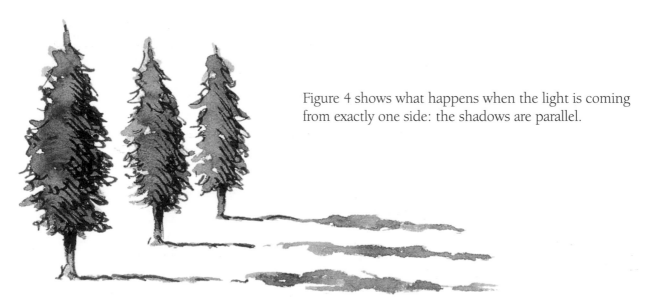

Figure 4 shows what happens when the light is coming from exactly one side: the shadows are parallel.

Figure 4

Exercise 1

The time has come to put into practice the perspective theory we have covered so far and to put our mastery of it to the test. Let us begin by making three quick colour sketches of simple buildings, one on the eye level line, one above it and one below it (right).

 The perspective looks about right but let us now check it. The sketches are repeated in paler tones so that the perspective construction lines will show up more clearly.

 Now it is your turn! Do not worry if your freehand sketches have faults – you can now check for error and accuracy.

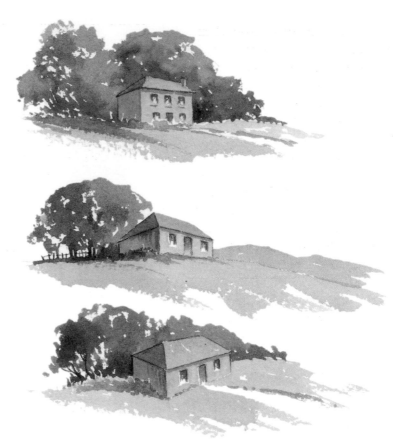

Quick colour sketches

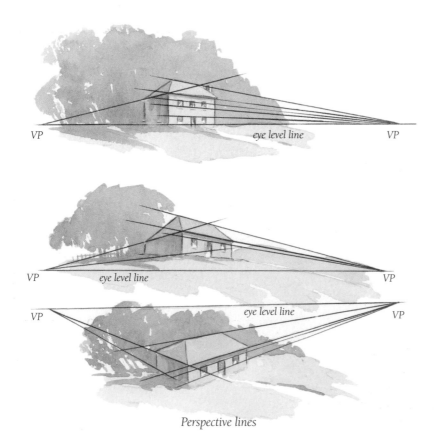

Perspective lines

As usual, we start by putting in the eye level line and we must take good care to get this right. We now plot our first pair of perspective lines; here the lower margins of the roof. Where these lines cut the eye level line gives us our two vanishing points. We now add further perspective lines, for the roof ridge and the tops and bottoms of the windows. If our original drawings were accurate, these lines will confirm it; if not, discrepancies will show up! Here we were reasonably accurate, but it is useful to have our accuracy confirmed.

Problems sometimes arise when buildings are situated on steeply sloping roads, so in our next task we will tackle an attractive lane leading down to the sea. Although the scene may appear to be a daunting one, we will not go far wrong if we apply the basic perspective constructions. Here, then, is our sketch of such a scene; for the sake of simplicity we assume that the buildings, however quaint, are all in the same straight line or, in other words, all parallel.

Now we draw in our red perspective lines. We begin with the eye level line which, conveniently, is the sea horizon. Because the buildings are all parallel, they have a common vanishing point from which the perspective lines radiate. You will see how the construction of the buildings adapts to the steeply sloping road.

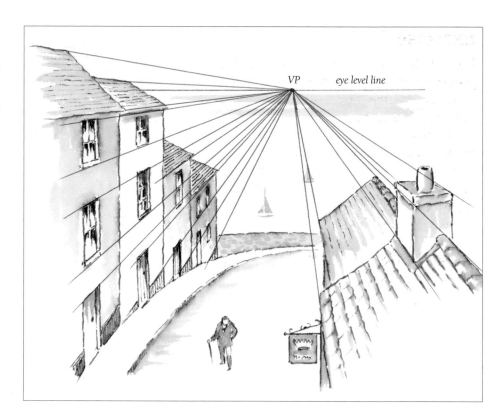

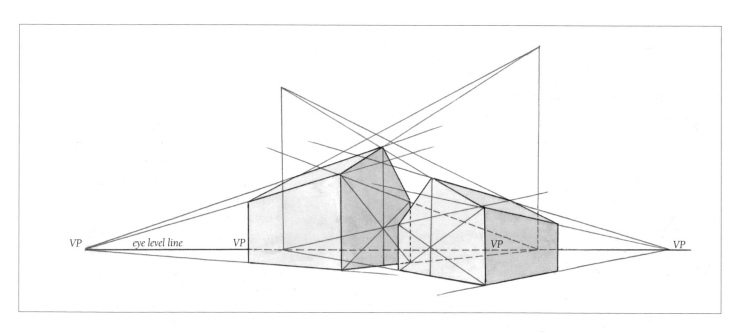

Buildings at different angles will have different vanishing points, though still, of course, on the eye level line. In the above sketch I have included just two buildings, again for the sake of simplicity, but it is easy to see how more, at varying angles, could be added. The addition of the red perspective lines clearly shows the two separate sets of vanishing points.

Aerial perspective

Having considered how to use linear perspective to create a feeling of distance, we can now look at how to reinforce these principles by means of aerial perspective.

Put simply, aerial perspective creates a feeling of distance by observing the effect the atmosphere has on the landscape, making the distance mistier, greyer and altogether less distinct than the foreground. This is a progressive effect i.e. the further away, the paler and less clear the scene becomes.

Nature, however, does not always make this easy for us. On a clear, bright morning without a cloud in the sky, the distant colours can be almost as vivid and sharp as the foreground. If we want a painting with such a feeling of depth and distance that the viewer almost feels they could walk into it, we need to interpret what is in front of us rather than just copy it exactly as it appears. After all we could produce an accurate record with a camera.

We can create aerial perspective by applying the following:

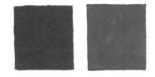

- Cool colours (blues and greys) recede, warm colours (reds, browns and yellows) come forward. Look at the two squares of colour on the right. They are the same size on a flat piece of paper, but somehow the red one has more impact and looks nearer to you.

- Lighter tones look further away than darker ones. Look at the example shown below.

- When we view a scene, we can make out more detail in the foreground, but this detail gets progressively less as we travel into the picture. This seems like stating the obvious, but often what we know to be a fact, we don't think of applying to our paintings.

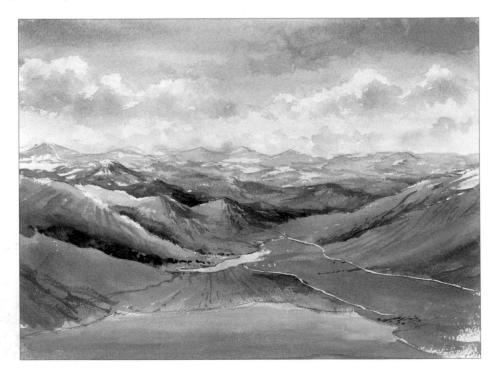

This range of mountains was based on a photograph taken from an aeroplane window. You can see such a long way that it is perfect for illustrating aerial perspective. Look at the most distant hills: these are merely suggested with a pale blue wash using the same colour as the sky. Warmer colours and stronger tones are very gradually introduced as we come further forwards in the painting.

Consider the two paintings below. There's no doubt that the one on the left looks like what it is supposed to be; green hills and pastures with a crisscrossing of dry stone walls and trees under a blue sky.

Now look at the painting on the right: the same scene, but what a difference when we apply some methods to create aerial perspective. First of all note how the sky is darker in tone at the top and lighter towards the skyline. Despite the fact that the distant hills on the photo were green, they have been painted in a pale blue-grey, the furthest hill indicated with the palest wash. A bit of light and atmosphere has been injected into the scene with the bright area in the centre, the tones gradually getting stronger and colours getting darker towards the foreground. Note how the distant trees are painted in softer, mistier shapes, becoming more clearly defined nearer the foreground. To emphasise this effect a hint of brown (a warmer colour) has been added to the nearer trees. Finally a few touches of detail: grasses, foliage etc., have been added to the foreground – remember that the nearer you are to something, the more detail you see.

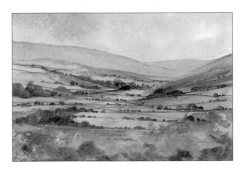 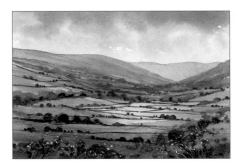

Now look at the painting below. Think about this simple scene and consider how both linear and aerial perspective have been used to create a feeling of depth and distance.

In this simple scene, linear perspective has been used to take the lane right into the distance. All the lines created by the tops of the hedges, the bottoms of the hedges and edges of the track converge on the eye level in the distance. Also the trees gradually become smaller, less detailed and cooler in colour as they recede into the scene, thus employing aerial perspective as well.

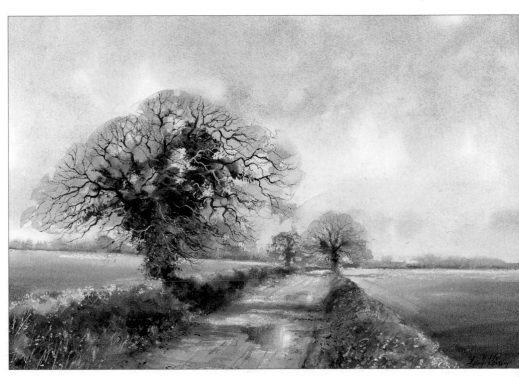

Snow Scene

by Geoff Kersey

I knew this scene was a painting as soon as I came across it, on a woodland walk in the Peak District. There was a light coating of snow under crisp, bright, clear skies. Nature does not often give us a perfect composition, but I think this is one occasion where all the main aspects of the scene are perfectly placed. Our eye is led from the large silver birches on the left, along the winding path to the smaller birches and out into the distance, where we get a glimpse of the hills beyond the woods.

You will need

Rough paper, 380 x 300mm (15 x 11¾in)

Masking fluid

Naples yellow

Cobalt blue

Cobalt violet

Burnt sienna

Raw sienna

French ultramarine

White gouache

Old paintbrush

2.5cm (1in) flat wash brush

Large filbert wash brush
Round brushes: no. 12, no. 4, no. 16, no. 8, rigger

Craft knife

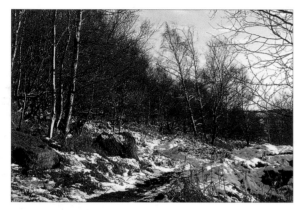

When I came across this scene, I knew instantly that it was a ready-made painting and couldn't wait to get back to the studio to get cracking. A digital camera is ideal for such moments!

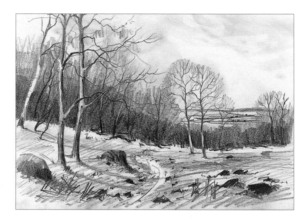

A quick pencil sketch like this helps to identify the basic elements and simplify the scene.

1. Sketch the scene and using an old brush, paint masking fluid on to the silver birches, the rocks in the foreground, the birches in the middle ground and the line where the snow meets the woodland.

2. Use a 2.5cm (1in) flat brush to wash clear water over the painting from the top to the horizon.

3. Using a large filbert wash brush, drop Naples yellow into the wet area in the lower part of the sky to create a glow.

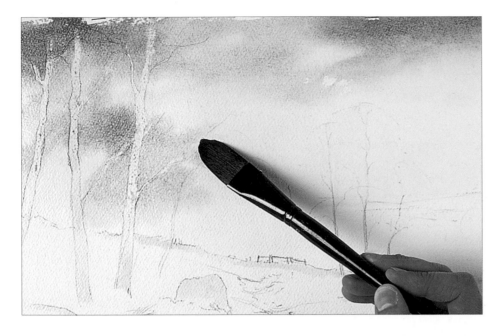

4. While the paper is still wet, drop cobalt blue and cobalt violet in at the top of the painting, down to about half way. The sky should be darker at the top, which gives the impression of perspective. Leave areas of white paper to suggest clouds. Add burnt sienna to the previous mix for a cloudy grey and drop this in.

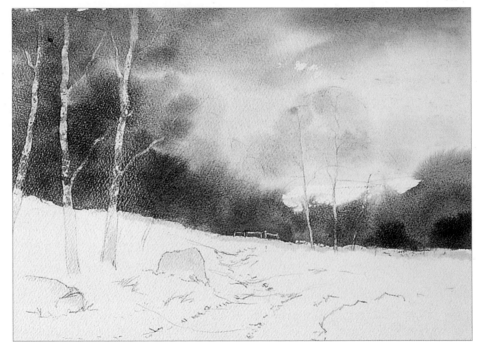

5. Drop in a thick mix of cobalt blue, cobalt violet and burnt sienna for the tree area. Use the side of the brush to suggest soft edges at the tops of the trees. Add raw sienna and burnt sienna for a red glow.

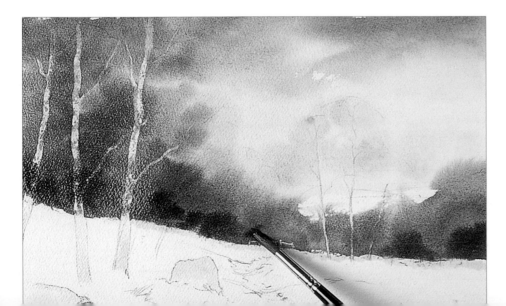

6. Working wet in wet, add cobalt blue and burnt sienna for the darker area at the bottom of the trees. Allow the painting to dry.

51

Tip

For dry brush work, hold the brush on its side with four fingers on one side and the thumb on the other so the side of the hairs just catches the raised area of the Rough paper.

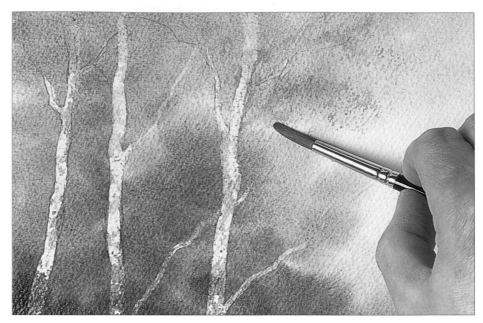

7. Use the side of a no. 12 round brush and the dry brush work technique to suggest the finer foliage at the ends of branches.

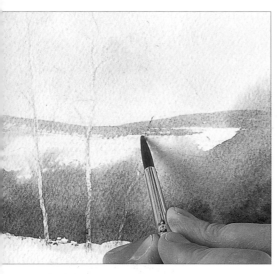

8. Mix cobalt blue, cobalt violet and burnt sienna, the colours that made up the grey and blue of the sky. With the no. 12 round brush, paint in the distant hills, wet on dry. The cool colours will make the hills recede into the background.

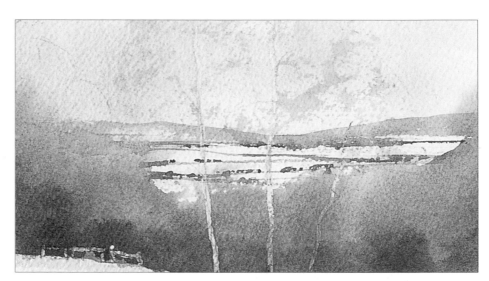

9. Using the same colour mix and the very tip of the no.12 brush, suggest the distant trees and dry stone walls. Use a little bit of dry brush work to emphasise the tops of the trees in the middle distance with raw sienna and burnt sienna.

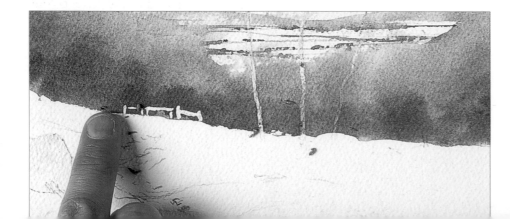

10. Rub off the masking fluid at the base of the treeline using a finger. Clean up with a putty eraser if necessary.

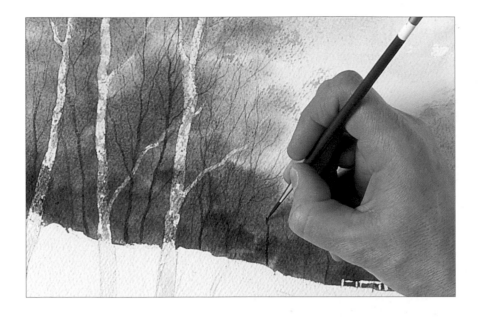

Tip

Rapid strokes of the brush look more convincing when painting trees in the distance. Always paint trunks and branches from the bottom upwards.

11. Mix a brown using cobalt blue mixed with burnt sienna, and with a no. 4 round brush, paint in distant tree trunks. Make some look further away by adding more water to the mix, and some nearer by using thicker paint. Use a rigger brush for finer branches.

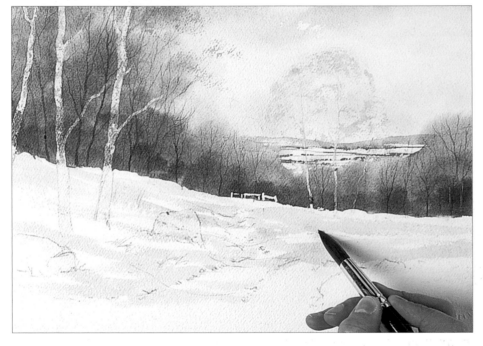

12. Mix the sky colours cobalt blue and cobalt violet for the snow shadows. Wash them on using a no.16 round brush, taking care to leave some of the paper snow-white. Your brush strokes should follow the contour of the land. Dampen the paper for softer areas. Use a weaker wash in the middle distance, and begin to pick out the shape of the path.

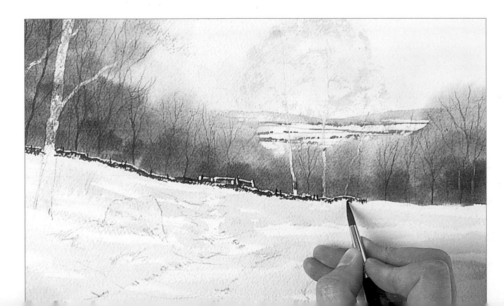

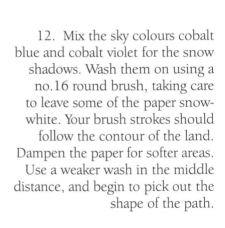

13. In the middle distance, develop the hint of a dry stone wall using a no. 8 round brush and a very dark brown mixed from burnt sienna and French ultramarine. The richer colour of the French ultramarine creates a richer, darker brown. Keep the brush fairly dry and use it to catch the texture of the paper, leaving a sharp white edge to represent snow on the top of the wall. Use the point of the brush for fence posts against the wall.

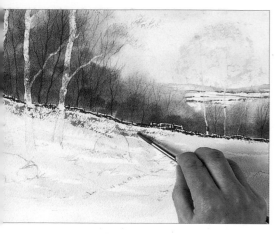

Tip

The scratching out technique depends on good timing. If you scratch out when the paint is too wet, colour runs back in to the grooves; if you leave it too late, the dry paint will not scratch out. The best time is when the shine has just gone from the paint.

14. Make a thick mix of raw sienna and burnt sienna and use the side of a no. 8 round brush to catch the paper texture to indicate bracken in the snow.

15. Drop dark brown in to the red bracken while it is wet. The effect will be soft where the paint is wet and scumbled where it meets the dry paper. Scratch out the shapes of grasses and twigs using a craft knife.

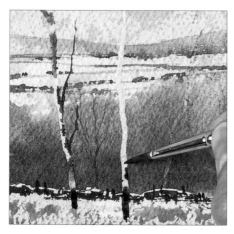

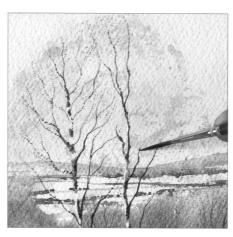

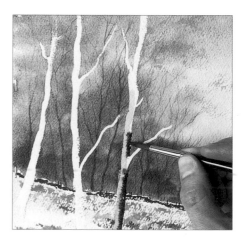

16. Rub off the masking fluid from the middle trees. Wet the trunks with clear water and drop in dark brown using a no. 4 round brush. The paint will spread into the wet area. To bring these trees forwards, the darks on their trunks should be darker than the background and the lights lighter.

17. Take a rigger brush and indicate the finer details of the branchwork.

18. Rub the masking fluid from the foreground trees. Wet the right-hand trunk and drop in a mix of Naples yellow and raw sienna. Working wet in wet to avoid stripes, drop in a mix of cobalt blue and cobalt violet, then add a dark brown mixed from burnt sienna and French ultramarine on the right-hand side, since the light is coming from the left. Paint the finer branches in the same way using a rigger brush.

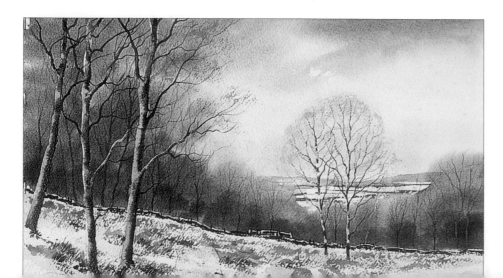

19. Work the remaining two foreground trees in the same way.

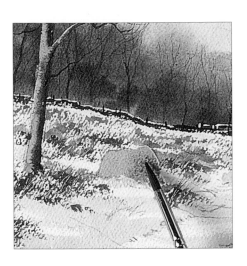

20. Rub the masking fluid off the large rock. Mix raw and burnt sienna plus a green from raw sienna and cobalt blue, and for the darker areas of stone mix burnt sienna and French ultramarine. For shadow use the sky colours, cobalt blue and cobalt violet. Mix all these colours wet in wet on the rock, leaving white for a hint of snow.

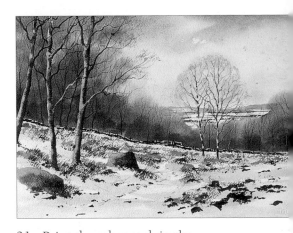

21. Paint the other rock in the same way. Use a no. 8 brush and dark brown to suggest stones sticking up through the snow. Make these larger nearer the foreground to help the perspective.

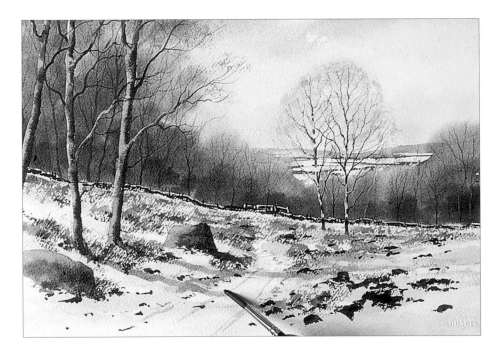

22. Paint the shadows in cobalt blue and cobalt violet. It is important that the paint is transparent so that the colours underneath show through. Put in long shadows for the left-hand trees to emphasise the direction of the light.

23. Paint in shadows to suggest trees beyond the left-hand edge of the picture casting shadows into the scene, and indicate the ruts in the path to create linear perspective. Make your marks stronger near the foreground, which creates aerial perspective. Take a no. 16 round brush and add more of the same colour to bring the foreground forwards. Soften any hard edges with a damp, clean brush.

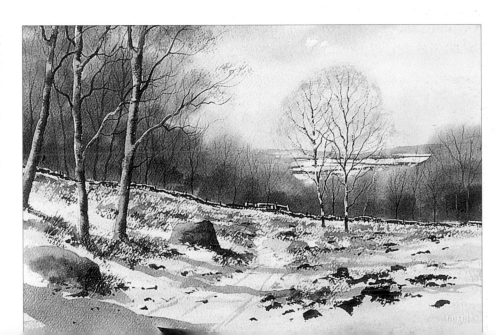

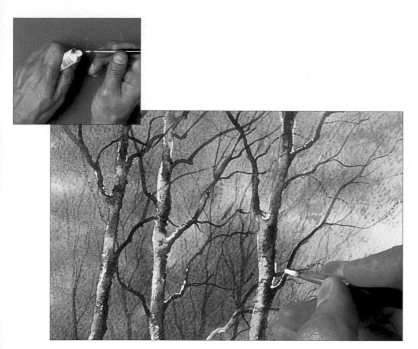

24. Place some white gouache on your board or use it straight from the tube. Do not put it in your palette, or it will make the other colours chalky. When the watercolours are dry, pick out snowy details on the trees using the white gouache and a no. 4 brush. Do not dilute the gouache as it will become less opaque and appear less white.

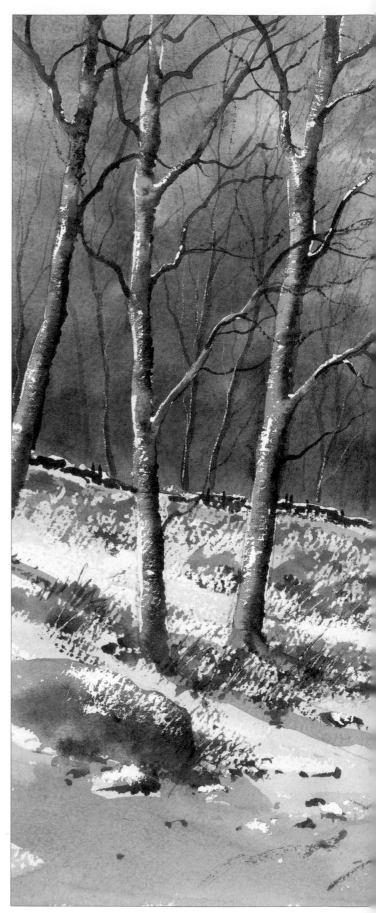

The finished painting.

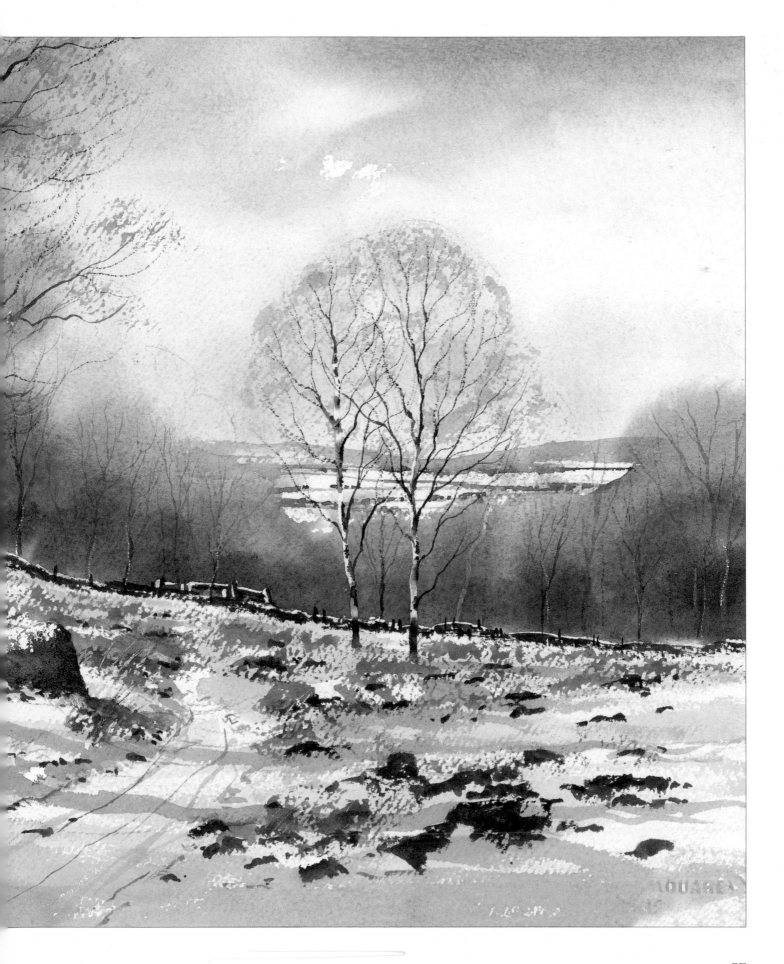

Winter in Padley

35.5 x 27cm (14 x 10½in)

This is one of my favourite areas in the Peak District; I must have painted here dozens of times. The main blue in the sky and in the shadows is cerulean; this is quite a cold colour and really injects a wintry feel into the scene, especially when combined with the milky sunlight effect in the lower part of the sky, suggested with a thin wash of Naples yellow. Note how the shadows have been indicated with the same cold blue, warming it slightly with a touch of rose madder in the foreground to bring it forward.

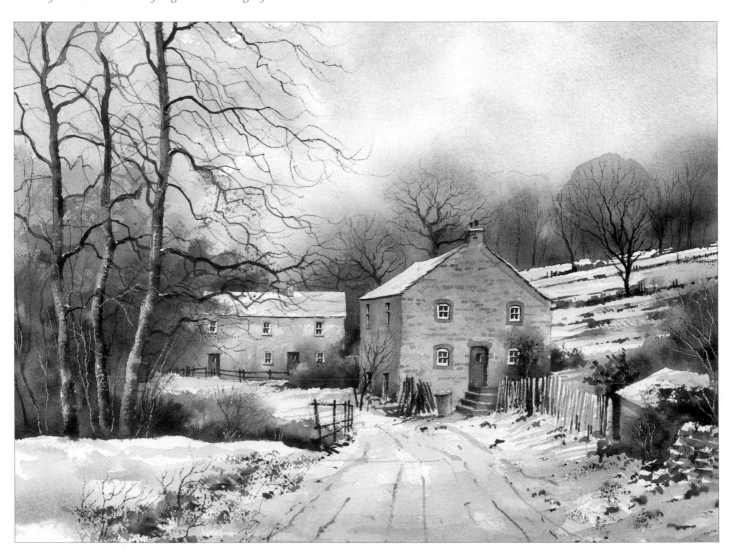

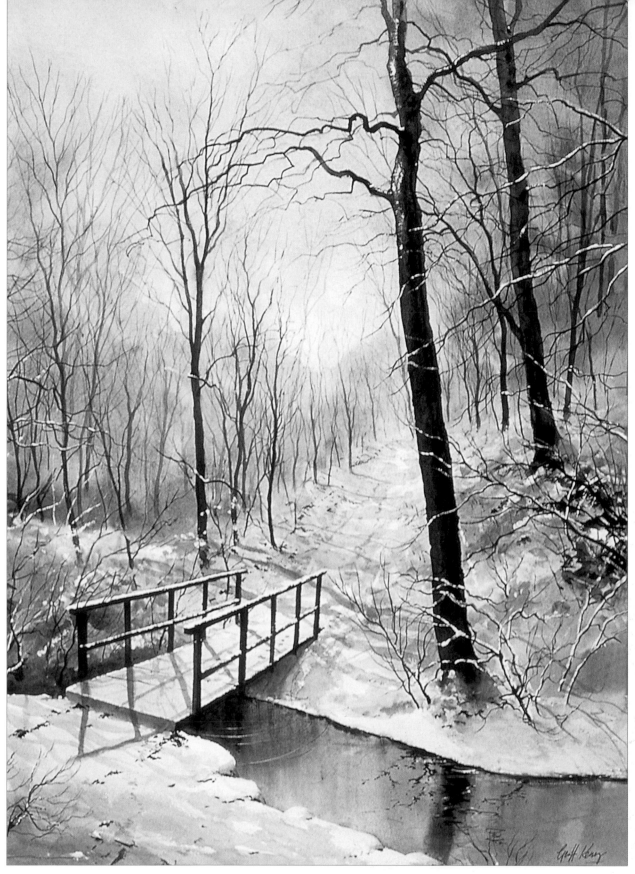

Foot Bridge in the Woods
530 x 750mm (21 x 29¾in)

This is a little hidden location twenty minutes' walk from my home. The light was perfect on this cold winter's afternoon with that beautiful red glow, which I recreated with thin washes of Indian yellow and cadmium red. Note the aerial perspective created by rendering the more distant trees in cooler colours and lighter tones.

TREES

Trees are a growing problem! We all have childhood memories of the things around us, but the problems come when we recall what we thought we saw and try to draw them. Trees are no exception; consequently, they are usually painted with the roots too big and the trunks too fat. When we were children, we were much smaller and our perception of trees was that the roots were big and the trunks huge!

Let's look at the way trees grow. I know that there are lots of different shapes of trees, but, for this particular exercise, there are two groups: deciduous (those that lose their leaves every year); and evergreens.

Deciduous trees

When painting a deciduous tree, look for the overall silhouette formed. If it has good shapes, then you have an interesting tree.

When the trees are covered in leaves, do not try to paint every leaf! Paint clusters of leaves, then put in the bits of branch that show between them. Look at the way the light falls on the tree and remember to paint in the shadows – the formed shadows on the parts of the trunk and foliage facing away from the light, and those cast by the tree on surrounding objects.

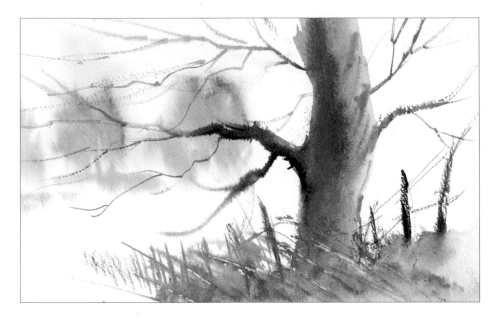

Although there are exceptions, the trunks of most trees in this group do not grow straight. When a young trunk grows up, it sprouts a branch. As this branch increases in size, and gets heavier, the main trunk starts to bend in the opposite direction to balance the weight. The same thing happens as each new branch is formed; the trunk usually ends up looking straight, but will have lots of kinks in it. Trees will sway in the wind, and those in exposed, very windy areas can have a curved trunk, but these forces are counterbalanced by the strength of the root system.

Evergreen trees

I use the term evergreen in a very loose way to denote trees, such as spruce and Douglas fir, with narrow and straight trunks.

Interesting silhouettes of single trees in this group are not easy to find, but look out for them. However, groups of these trees do make good shapes. Overlap them, include different sizes and heights, vary the angle of the trunks and the spacing between them, and you will have good shapes for your painting.

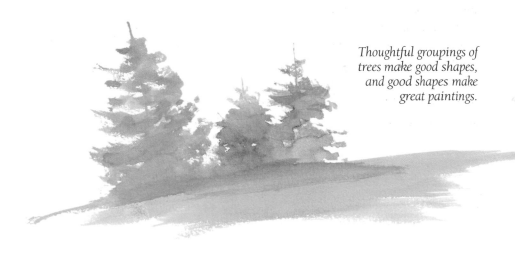

Thoughtful groupings of trees make good shapes, and good shapes make great paintings.

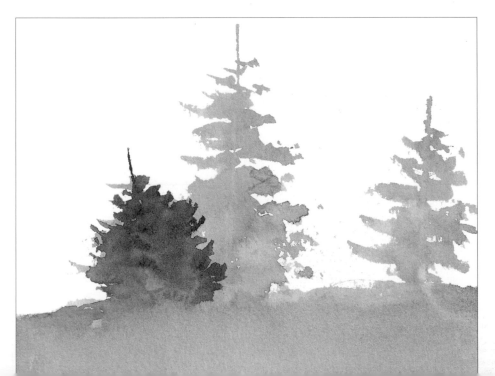

Distant trees should be treated as simple silhouettes. Paint them using the technique of aerial perspective. Make the distant ones soft-edged and pale bluey-green. As you come forward, gradually make the edges sharper, and their colours darker and warmer.

61

WATER

So, you would like to paint water that looks really wet? Watercolour is one of the best mediums for painting water and, in this chapter, you will learn the techniques used by renowned expert, Joe Francis Dowden. There are plenty of tricks, dodges, techniques (call them what you will) that you can use to achieve realistic effects.

Remember that painting in watercolour is not an elitist sport, with a governing body ready to expel anyone not conforming to a set of rules. You can paint how you want, why you want, by whatever means you want, from whatever source material you want and with whatever equipment you have available – you make your own rules.

In this chapter there are step-by-step demonstrations for three types of water that you may come across: a deep, slow-moving river; a fast-moving stream; and a shallow stretch of still water.

Try painting the projects. Use them as guidelines to help you develop skills and to paint in your own unique way. Use the suggested set of colours or try your own and see what results you can achieve.

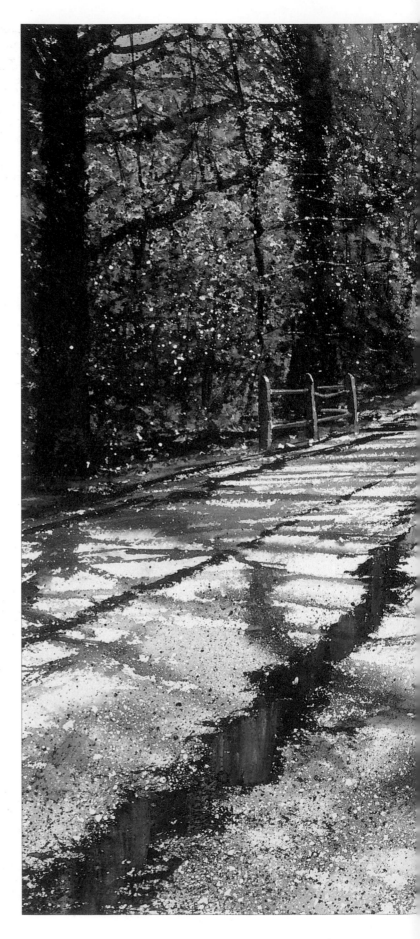

Passing Rainstorm

When a rainstorm marches across the countryside and leaves a brilliant, clear sky in its wake, the sun glints on a watery wonderland. A powerful tonal balance is required for such subjects, and this is achieved by splitting tones into extreme opposites and using very strong pigments.

Masking fluid spattered from a toothbrush has been used all over this painting; on both the bare paper and on top of some colours. For example, the fine, light, grainy texture on the road is created by spattering tiny spots of colours over spattered masking fluid. Larger spattered drops of masking fluid create the highlights on damp leaves glistening in the high overhead sun.

Gum arabic was painted into the puddles and the colour was brushed in vertically. Then, when the paint had dried, a damp bristle brush was scrubbed across them. The puddles would not look wet on their own: it is only the surrounding landscape – the trees, sky and the road – that make it look real!

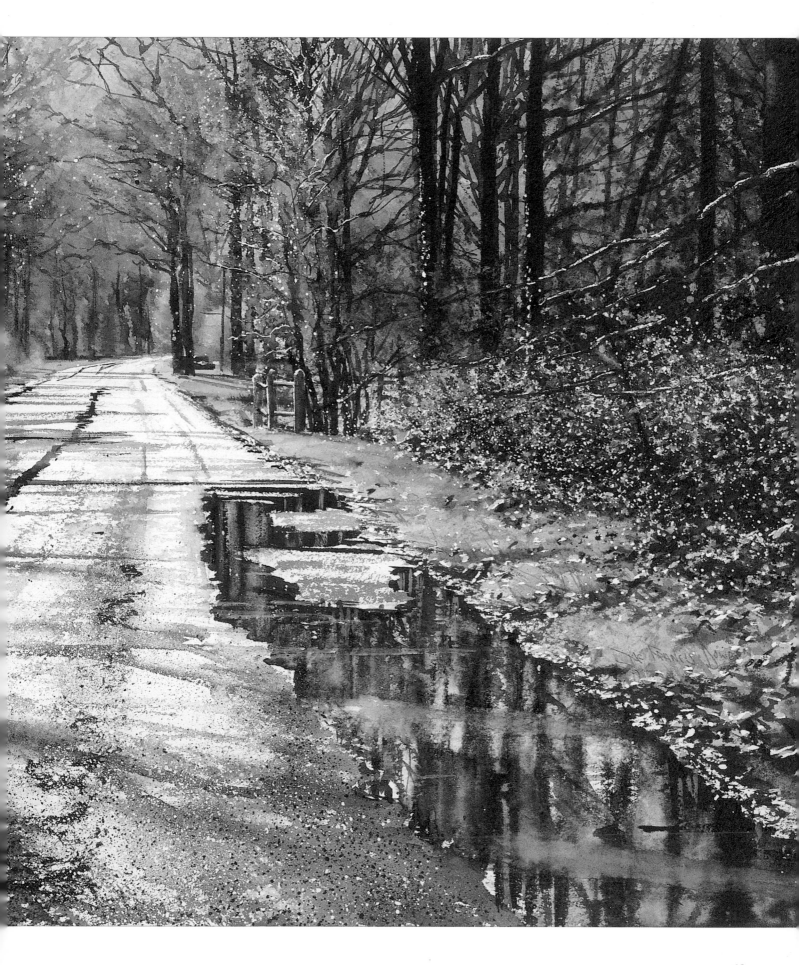

Types of water

Two basic tips for painting water are: keep it wet and blurred; and keep all reflections vertical. By and large these practices will make any water scenes ring true, but there are many different kinds of water, and there are watercolour techniques to make them look real and wet!

We all know that, on its own, water is completely transparent. However, in nature, water takes up (reflects) colours from the sky, foliage and objects around it, and, to make the water look wet, the painting of these is just as important as the painting of the water.

The sketches on these pages and the step-by-step demonstrations illustrate just a few of the multitude of watery scenes about us.

Remember that water bends, refracts and reflects light – twisting, breaking and diffusing shapes – and recreating these characteristics in watercolour is our exciting challenge.

Autumn River

In this peaceful river scene, the soft reflections on the far side of the river were worked wet into wet, with colour brushed in vertically. While these were still wet, horizontal ripples were dragged across them. The reflections of the boat and the foreground ripples were painted wet on dry.

The dark tones of the barge and the far river bank contrast well with the strong red stripes and the warm, lighter tones in the rest of the painting.

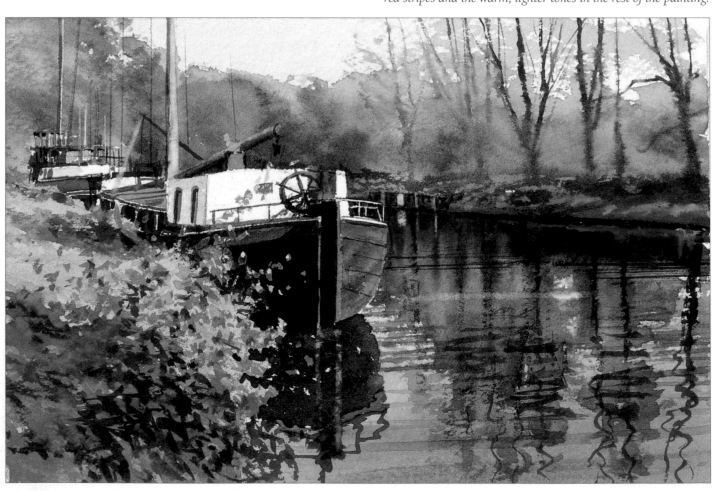

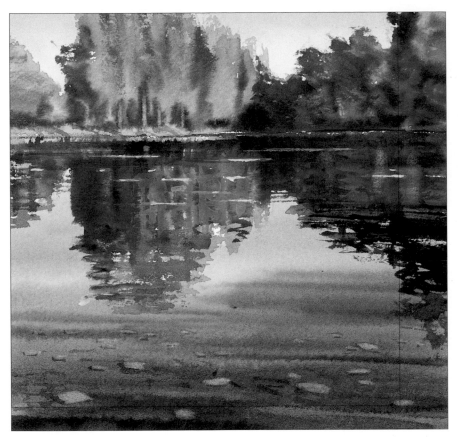

Rural Ford

The reflections in this shallow stream, soft and blurred, but with a slightly hard edge, were worked entirely wet into wet. When the reflections were dry, the pale vertical marks were leached out with a dampened stiff brush, then dabbed with paper towel to stop hard edges forming.

Midsummer Lake

The water of this shallow lake was started by laying in some streaks of masking fluid to indicate clumps of weed floating on the surface. An upside-down sky was then painted, working from the bottom upwards. When this was dry, the tree reflections were painted with very strong colours, wet into wet, then vertical ripples and streaks of a semi-opaque yellow were added. The stones in the foreground were leached out with a dampened stiff brush.

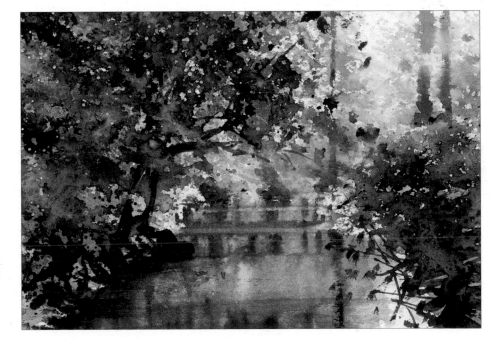

Woodland stream

In shallow woodland streams the reflection of the tree canopy allows the river bottom to become visible. Streaks of sunlight run across the river bed, and patchy sky reflections from the tree tops show as vertical light patches, blurred in the water.

65

Deep water

by Joe Francis Dowden

For my first step-by-step project, I have chosen an autumnal scene of a deep, slow-moving river. If a river is to look convincing, it has to sit comfortably in the surrounding landscape, and the challenge in this composition, where there is hardly any sky, is to merge the old bridge and wooded backdrop, and set the scene for their reflections to be painted in the river. The solution is to mask around the arches and along the parapet, leaving you free to concentrate on the background. Dynamic brush strokes can then be used to paint the trees, and you can work right up to the bridge itself, without fear of painting over it. The wooded hillside in the background helps push the bridge forward to create a three-dimensional scene that looks real.

The river is painted with simple washes with a little fine tuning to give it depth. Gum arabic is incredibly effective for creating a wet look and for making reflections blurred and realistic. Note that the reflections are not entirely symmetrical with the objects they mirror, and the movement on the surface, slight as it is, softens their edges. The colours and tones I use for water are often stronger than those of the objects they reflect, but here I have moderated them. For me there are no rules to be applied every time, just principles and guidelines to build confidence.

I used 425gsm (200lb) Not paper, and the finished painting measures 430 x 295mm (17 x 11½in).

You will need

Burnt sienna, burnt umber, cadmium lemon, cadmium orange, cobalt blue, cobalt turquoise, Naples yellow, Payne's gray, phthalo blue, phthalo green, quinacridone red, ultramarine, Venetian red

Colour shaper

Candle, gum arabic, masking fluid

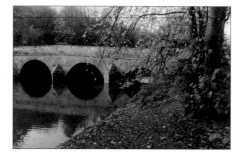

Reference photograph.

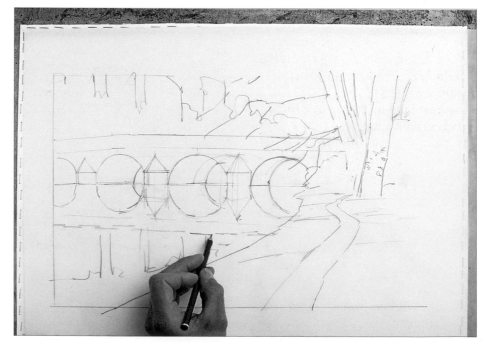

1. Sketch the subject on tracing paper then transfer the basic outlines on to the watercolour paper.

2. Use strips of masking tape to mark the chosen aperture shape. Lightly sketch in a few leaves on the foreground bank of the river – make some large, some medium-sized and some small – then sketch in some more on the overhanging branches. Use an old brush to apply masking fluid randomly over these leaves, then mask a few more leaves floating on the water.

3. Use a colour shaper to apply more masking fluid along the parapet of the bridge and round the right-hand side of the arches. Leave the masking fluid to dry, or speed up the process with a hairdryer.

4. Working at the top right-hand corner of the picture, use roughly torn pieces of scrap paper to mask out the sky, the bridge, the river, the foreground river bank and the tree trunks.

5. Spatter water over the exposed area of the paper.

6. Mix cadmium lemon with a touch of Naples yellow, then spatter this colour randomly over the exposed area of paper.

7. Carefully spread some of the spattered yellow to form larger patches of colour.

Judging hue and tone

If you cut a small aperture in a piece of white paper and place it over your painted image (left), you isolate an area of colour. The contrast between it and the neutral white of the paper will help you evaluate hue and tone more easily.

A photograph can provide a useful reference. If you use one, place the aperture over the corresponding part of it (right), and compare it to your painted image. The idea is not slavishly to copy the photographic image, but to experiment and see how to strengthen your work.

I use this method with photographs, tonal sketches and watercolours painted on site. Remember that none of these reference sources are 'correct', but you can use them to help improve your work.

8. Remove the paper mask. Add a touch of burnt sienna to the yellow, then spatter across the top centre part of the previous marks. Again, use the brush to spread some of this colour, then leave to dry. Apply masking fluid down the lightest side of the tree trunks, then leave this to dry.

9. Replace the paper mask, then spatter more water over the exposed area. Strengthen the yellow with phthalo green and more burnt sienna, then spatter this over the previous colours. Introduce burnt umber to the palette, then repeat the spattering technique using various greens.

10. Use a dry brush to apply water to the tree tops above the bridge. Gently sweep the brush from side to side so that water sits on the texture of the paper. Feather this water into the dry sky area.

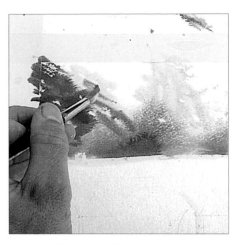

11. Working quickly, wet into wet, start to build up the colours of the foliage. This area needs to be quite dark, so use intense colour mixes of Naples yellow, cadmium lemon, burnt sienna, and cobalt blue.

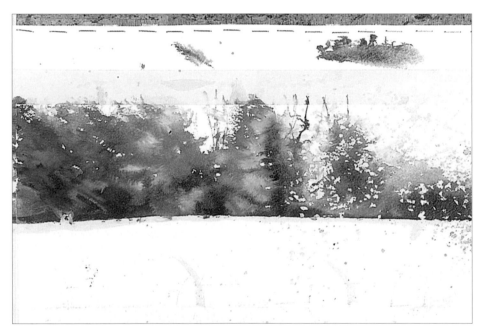

12. Continue painting the foliage across the paper, introducing ultramarine, quinacridone red and cadmium orange to create other tones of green and yellows.

13. Use mixes of cadmium lemon, ultramarine and burnt umber, wet into wet, to paint the areas of foliage that are visible through the arches of the bridge.

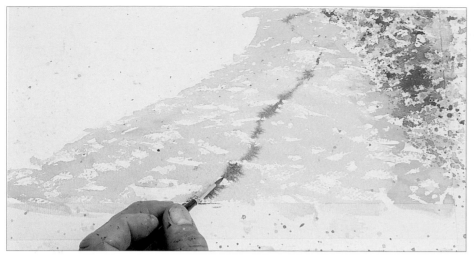

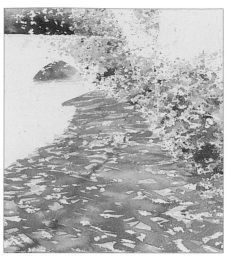

14. Spatter water over the right-hand foliage below the trees, then spatter this area with bright greens – mixes of cadmium yellow and phthalo green with touches of burnt umber and cobalt turquoise. Leave to dry. Mix a brown from Venetian red with touches phthalo green and cadmium lemon. Mix cadmium lemon and Naples yellow, add a touch of the brown mix, then, using crisscross brush strokes, paint the foreground river bank. While this colour is still wet, use one of the green mixes to add a shadow to define the edge of the footpath. Leave to dry.

15. Crisscross water over the fore-ground, then apply the brown mix with similar brush strokes. Make large strokes at the bottom, then gradually make finer strokes as you work up the paper. Add touches of the yellow mix, wet into wet, then leave to dry.

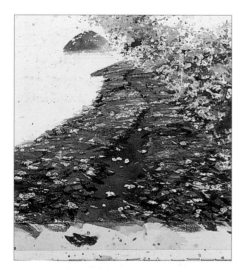

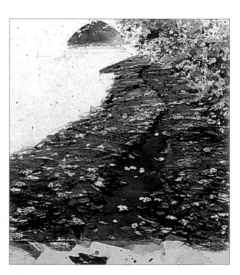

16. Add a touch of ultramarine to the brown mix. Crisscross water over the foreground, then work dark tones selectively over the area, building up the layers of fallen leaves and adding shape to the footpath. Use a dry brush to obscure the crispness of the previous brush strokes and to mimic the untidiness of leaves.

17. Rub candle wax selectively over the foreground area . . .

18. . . . then use Payne's gray to work really dark tones on top of the previous colours, especially over the waxed areas. Re-define the shadow on the footpath.

19. Use Payne's gray to paint the branches and foliage behind the tree trunks.

20. Remove the masking fluid from tree trunks and parapet. Reinstate the small areas of masking fluid for the leaves that break the line of the parapet.

21. Mix a grey from cobalt blue and Naples yellow, then lay a wash of this colour across the bridge. Leave to dry. Create warm and cool tones of grey by adding touches of burnt sienna and ultramarine respectively, then use a semi-dry brush to add tone, texture and shape to the bridge.

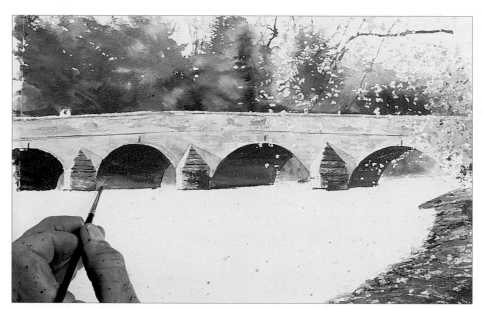

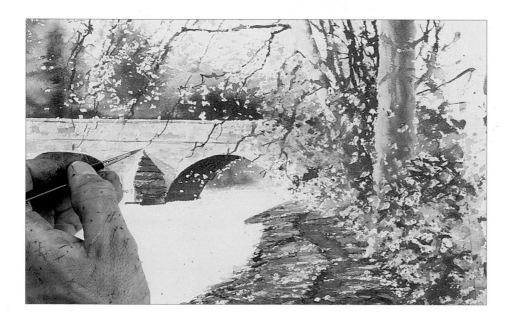

22. Mix a light greyish brown with Naples yellow and a touch of cobalt blue, then paint the tree trunks. Add more cobalt blue on the shadowed side of the trunks and a little yellow green (phthalo green and cadmium lemon) on the light side. Build up a three-dimensional effect by adding touches of Payne's gray, wet into wet, on the dark shadow and the shadows of the branches that cross the trunk. Use Payne's gray to add fine branches that hang down across the bridge.

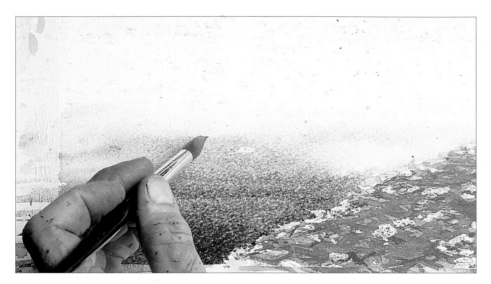

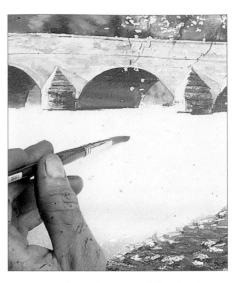

23. Now start to work on the river. First, mix a pale grey sky colour using Payne's gray and phthalo blue. Wet the area up to the edge of the bridge reflection with water, then apply a gradated wash, diluting the colour as you work up the paper. Use this wash to define the edge of the river bank. Leave to dry.

24. Wet the reflection of the bridge, then brush gum arabic into this area to slow the spread of colour in the next stage.

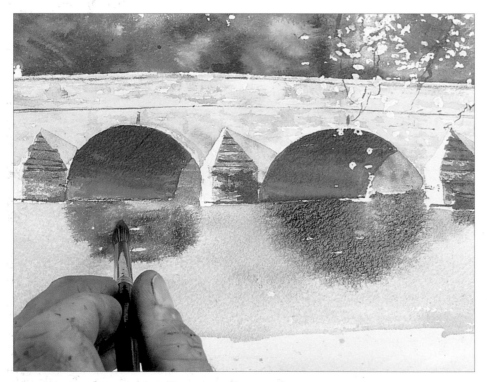

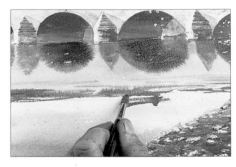

26. Lay horizontal strokes of colour into the wet wash to create rippled reflections from the trees above the bridge. Continue these ripples downwards, wet on dry with lots of water...

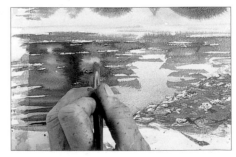

25. Mix burnt sienna, cobalt blue and Naples yellow, then paint in the reflection of the bridge. While the paint is still wet, start to work the reflections of the arches using mixes of Payne's grey and burnt umber. Use more of the same colour to define the masonry line along the reflection of the parapet. Notice how the gum arabic stabilises the soft-focus effect of the arch reflections; the pigments tend to stay where they are and not blend into the surrounding colour.

27. ...then work vertical bands of cadmium lemon and Payne's gray wet-into-wet.

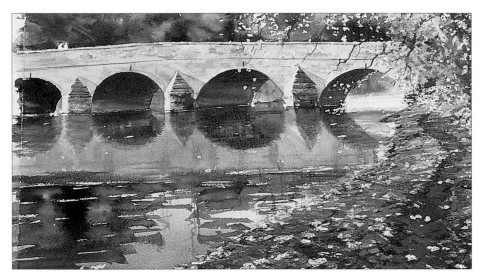

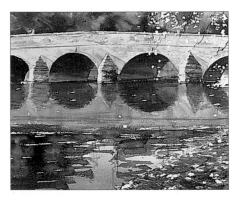

28. Go back to the reflection of the bridge and make short vertical brush strokes with a darker mix (add a touch of phthalo green). Rework the darks under the arches then add touches of cadmium lemon.

29. Remove all masking fluid, then use cadmium red light and ultramarine to add two figures on the bridge. Add fine, dark horizontal strokes across the bottom of the bridge's reflection. Leave to dry.

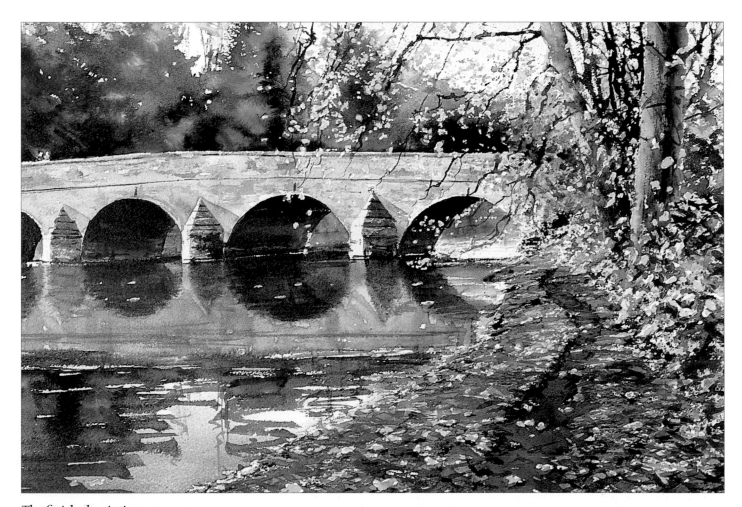

The finished painting

After removing all the masking fluid, I decided to touch in most of the white leaves with neat cadmium yellow and touches of burnt sienna.

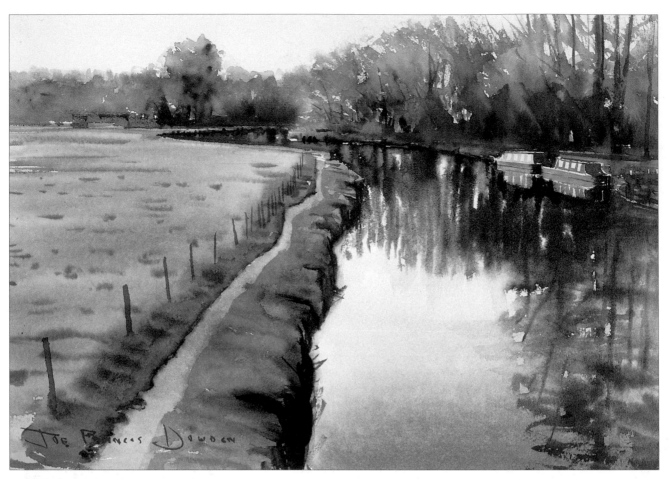

River Navigation

In this rapid sketch, viewed from a bridge across the river, the surface of the water picks up the deep tones from the sky. Rough brush strokes were used to indicate the wooded areas on the river banks. Neat colours, straight from the tube, were painted wet into wet to create the distant trees. The river was worked wet, but I left a few flashes of dry paper as highlights and for the reflections of the boats which were worked when the main stretch of water was dry.

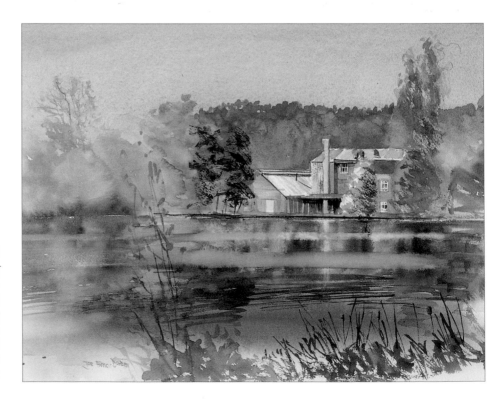

The Old Mill

This sketch was painted in the heat of summer, and the colours seemed to dry as soon as I laid them down. I worked fast and loose with plenty of strong colours. I used a small stiff brush to scrub some streaks across the mill pond to indicate slight ripples on the surface of the water.

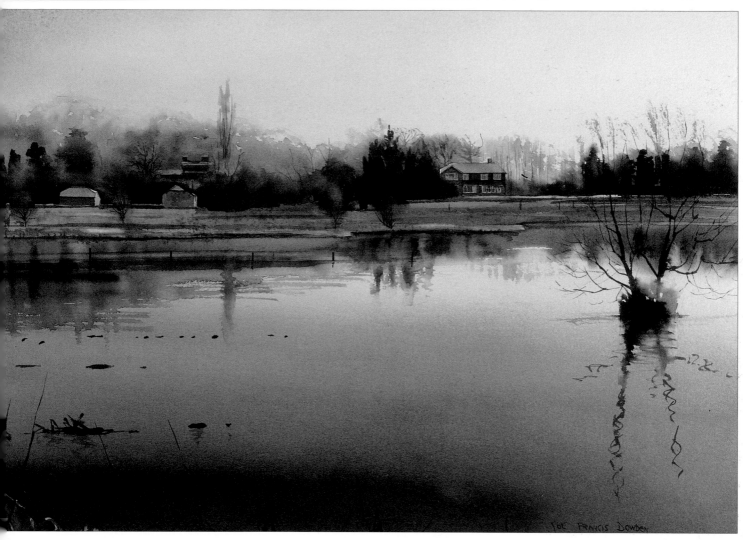

New Day Rising

Early morning light ignites this misty horizon. The view is looking eastwards and the rising sun, lighting up the foggy breath of morning, is beginning to flood through the veil of woodland. The right-hand side of the scene is the nearest to the light source, so the sky is lighter here than at the left.

To achieve the geography of light in this painting, I painted a wash, down and across the paper, working from the top left-hand corner where the sky is darkest. The reflection of the sky, mirrored in the still water, picks up darker tones from the sky that is above and out of the image, as well as the dark tone of the mud on the bed of the lake. I started this stretch of water with a gradated wash of burnt sienna, working from the far bank down the middle of the water. I then mixed a black wash, made from phthalo blue, crimson alizarin and burnt umber, and worked this up from the bottom of the painting. While this was still wet, I returned to the foreground and applied more colour until it was very dark.

Notice that none of the objects is near the centre of the composition, and that none is strong enough to interfere with the tranquil mood. The tall, thin poplar consists of a few streaks of colour painted into a brush stroke of water, and the reflection is almost identical. The reflections of the branches of the half-submerged willow are just two wavy lines. Doubling a reflection in this way captures the movement of a brief instant in time – very effective for thin objects.

Lively water

by Joe Francis Dowden

In this next demonstration I show you how I deal with moving water, and I have chosen this view of a river that tumbles through the countryside, rushing down a succession of fast-flowing reaches.

 The natural fibres of brushes, used in a loose rhythmic way, release the energy for waves on its lively surface. Bright colour is balanced with dark tone. Halation reveals the power of the sun and all the elements are reflected on the river's shining course.

 I used 425gsm (200lb) Not paper, and the finished painting measures 300 x 385mm (11¾ x 15in).

You will need

Alizarin crimson, burnt umber, cadmium lemon, cerulean blue, cobalt turquoise, indigo, Naples yellow, Payne's gray, phthalo blue, phthalo green

Candle, gum arabic, masking fluid

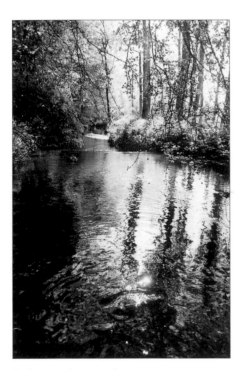

Reference photograph.

 1. Mask the edges of the painting area, then draw the basic outlines of the trees on to the paper. Use an old brush to apply masking fluid to the highlight on the distant stretch of water, then use an old toothbrush to spatter random marks on the foliage and the rippled surface of the water. Make big marks by tapping the loaded toothbrush on your hand, and small ones by scraping your finger across the bristles of the toothbrush.

2. Mask the water area of the painting with scrap paper, then use the spattering technique to wet the tree area. Spatter cadmium lemon to create the indication of foliage. Add Naples yellow to the mix, then brush this into the bright centre area. Use water to dilute the edges of yellow. Paint in the tree trunks with cadmium lemon. Leave to dry.

3. Use the spattering technique of wetting, painting and drying to continue building up the foliage colour by colour. Mix pale greens from cadmium yellow and phthalo green, add burnt umber to the mix on the palette for mid greens, then Payne's gray and cobalt turquoise for darker tones. Add touches of cobalt turquoise and alizarin crimson, wet into wet, into areas of yellow to define dark distant foliage behind tree trunks. Leave to dry.

4. Add more Payne's gray to the green mix, then work up dark areas in the foliage at the left-hand side and along the far bank of the river. Leave to dry.

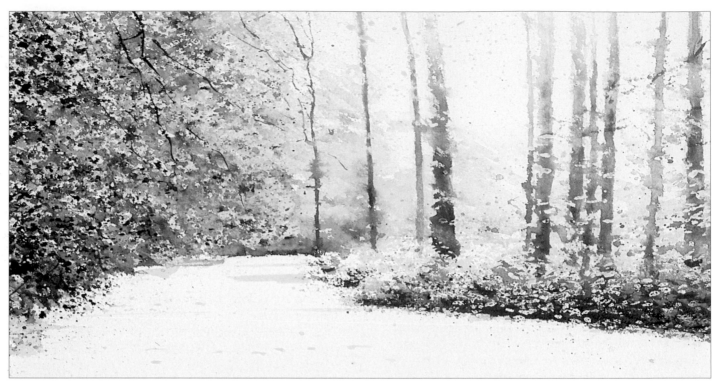

5. Use a candle to apply a wax resist here and there on the tree trunks. Apply patches of the last mix on the tree trunks, then leave to dry. Spatter water over the trees, then spatter darks into this area. Mix Naples yellow and cerulean blue, then paint the tree trunks from the bottom upwards, diluting the mix with water as you work up the trunk. Add touches of burnt umber here and there, and darken the base of the trees with Payne's gray. Add traces of branches and twigs among the splattered leaves, and a few fine branches across the tree trunks.

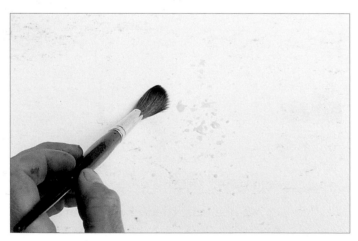

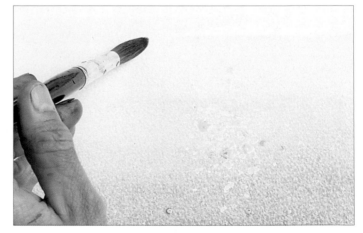

6. Now start to work on the water. At this stage treat the water as an upside-down sky, so dampen the area with water from the bottom upwards. You may note that before starting this stage, I added a few more masking fluid highlights in the foreground ripples. Leave the masking fluid to dry before wetting the paper.

7. Mix a strong wash of phthalo blue, then apply it to the damp paper. Start at the bottom, then gradually weaken the wash with water as you work up the painting.

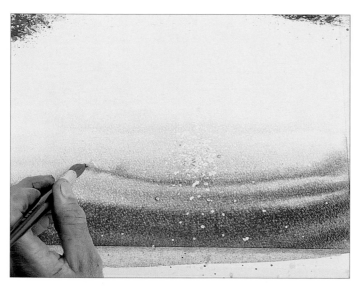

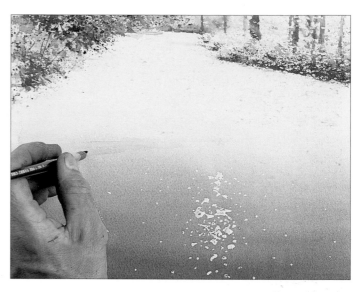

8. While the phthalo blue is still wet, lay in a graded wash of indigo, working from the bottom upwards and taking this colour just short of the weakest part of the previous phthalo blue wash. Strengthen with more colour at the bottom if necessary, then leave to dry. Indigo tends to dry much paler than it appears when wet, so apply another indigo wash if necessary.

9. Start the reflections by wetting a broad band of the water, excluding the far reach of water, then add a few streaks of gum arabic. Refer to the photographs below, at steps 10 and 11, to see the extent of the area to be wetted.

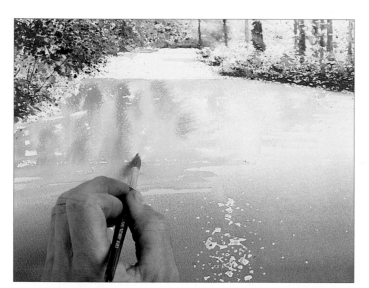

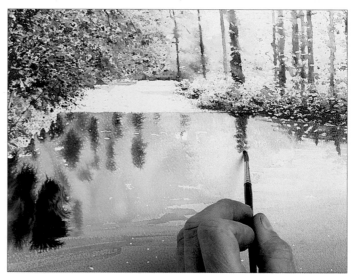

10. Work the reflections from the palest colours through to the darkest, bearing in mind that these are slightly darker than the tones they reflect due to the darkness of the river bed. Start by adding a touch of burnt sienna to cadmium lemon, then apply this colour to indicate the massed reflections of foliage. Drag the wash down to end with a broken line of horizontal ripples. Add touches of phthalo green, wet into wet, to indicate shadows.

11. Working wet into wet, add touches of burnt umber to Naples yellow then paint the reflections under the tree trunks. Add touches of Payne's gray to create more dark tones, and patches of cadmium lemon to give soft-edged reflections.

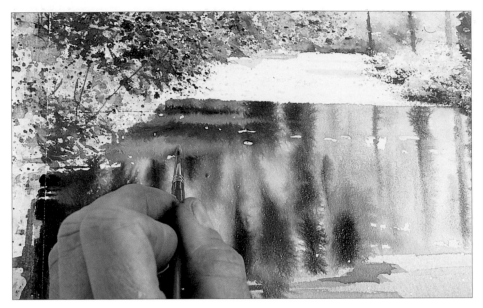

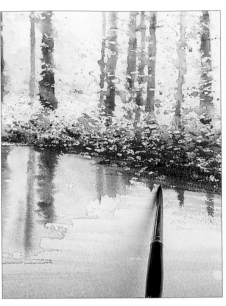

12. Add touches of cerulean blue to reflect soft passages of light passing through the canopy of trees, mixing and blending colours on the paper. Mix a dense wash cadmium lemon and burnt sienna, then add a streak of this colour to indicate a patch of sunlight on the water.

13. Use a dry brush to paint horizontal streaks of dark across the vertical reflections, leaving speckles of white paper to indicate highlights.

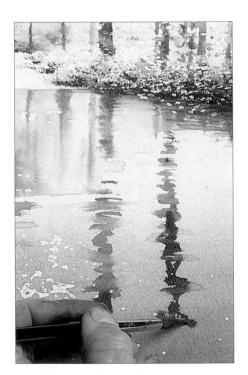

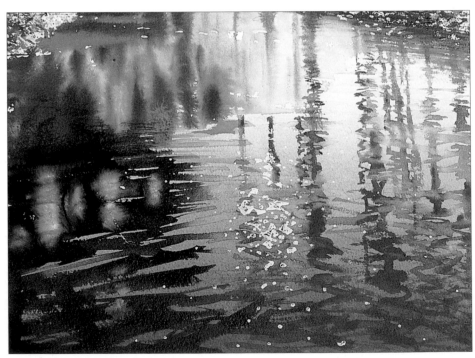

14. Use water to make crisscross reflections of the tree trunks down into the blue area of water. Use a mix of Payne's gray and the dark green on the palette to create rippled reflections.

15. Continue working up the reflections of tree trunks, then, using bold strokes, paint in the darks at the bottom left-hand corner. Add touches of cadmium lemon, wet into wet, to achieve a mix of hard- and soft-edged reflections.

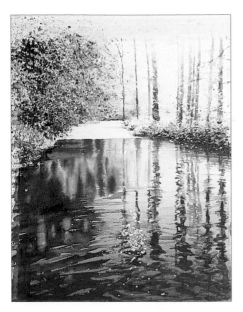

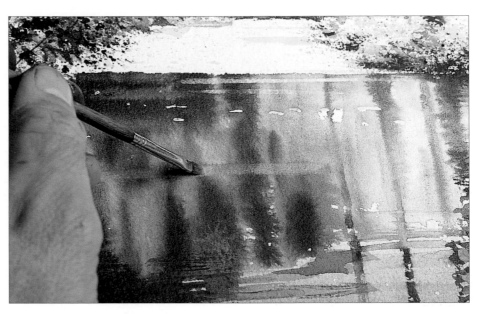

16. Start re-defining and unifying the structure of the reflection. Remember that the brushstrokes in the foreground must be larger than those in the distance.

17. Use a small bristle brush and water to leach out a few horizontal streaks across the surface of the water.

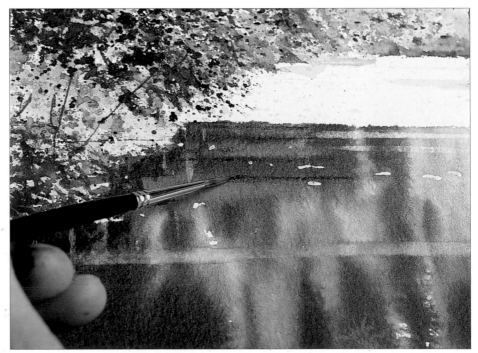

18. Use a dry brush and neat cadmium lemon to create short vertical streaks of colour to represent the strong reflections of sunlit leaves.

19. Add a few fine horizontal streaks of dark colour.

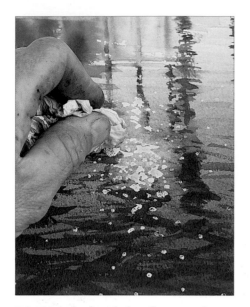 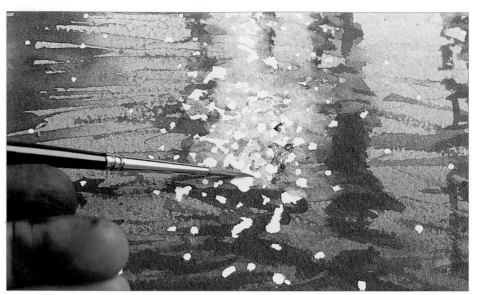

20. Use the bristle brush to scrub water around the mass of masking fluid highlights, then use a paper towel to dab off some of the colour.

21. Remove the masking fluid from the highlights in the water then start to 'model' the highlights. Break the larger marks into smaller ones by painting over them or by wetting the paper around each shape and gently dragging the surrounding colour on to them.

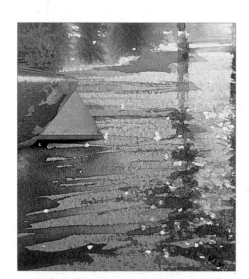 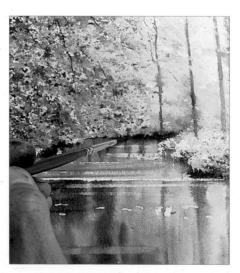 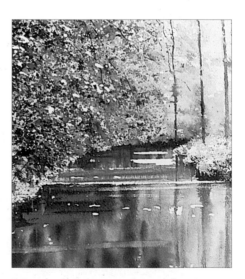

22. Re-define the reflections of tree trunks that pass through the highlights, then continue to model the highlights. Use a craft knife to scratch some of them into short vertical shapes.

23. Now block in the distant stretch of water, laying bands of cerulean blue and cadmium lemon. Add vertical streaks of yellow, then touches of Payne's gray. Define the distant river bank with a hard edge and its reflections with soft edges.

24. Finally, remove the masking fluid from the foliage and from the distant stretch of water.

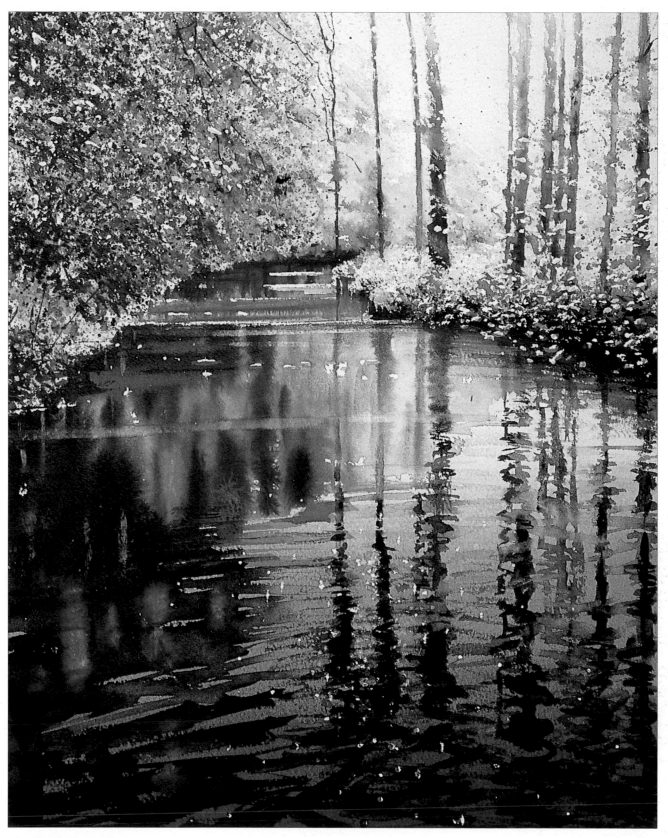

The finished painting
I added a few fine details and softened some of the exposed highlights with touches of colour.

Boating Lake

The lively dance of light on the surface of the water in this painting is captured with the point of a rhythmically-worked brush before new colours – yellows, greens and browns – are sunk into the still-wet wash. Sitting just below the horizon line, the far shore is high enough to put emphasis on the foreground water, and to place the observer in the scene.

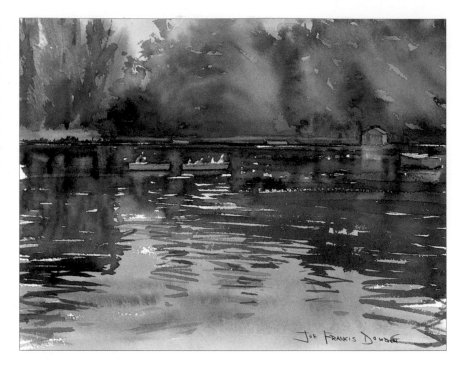

Bourneside

This rural reach, with its gently-rippled surface agitated by a succession of small waterfalls, is just what artist's brushes were made for. The point of a round sable brush effortlessly produces wave and ripple shapes as revealed by the dark reflections. The light patterns in the bed of the river, made by the flow of water, can be rendered either by lifting out colour or by dropping in semi-opaque colours – cadmium lemon, Naples yellow, Chinese white or titanium white – wet into wet.

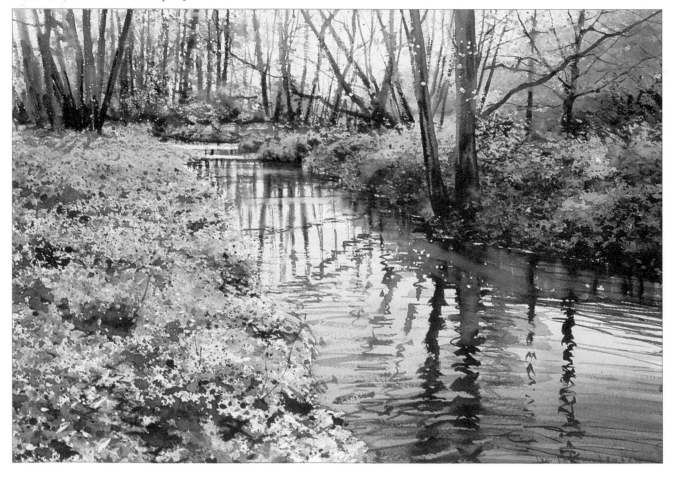

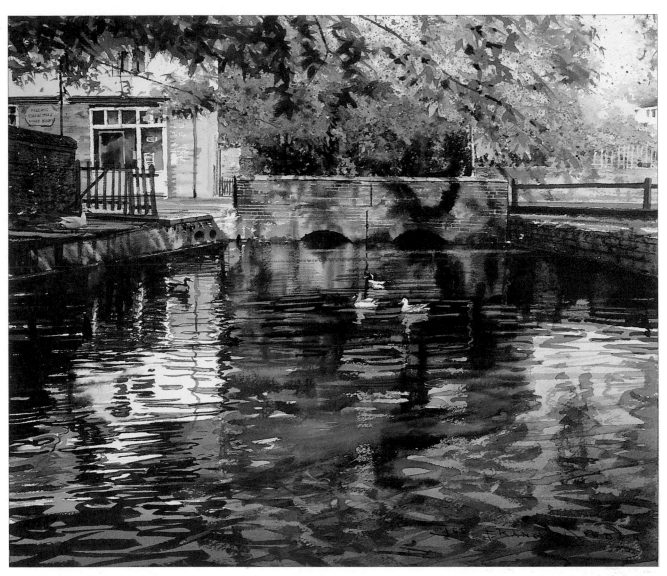

River and Road

An ancient route crosses a river at the site of a medieval village. Where they meet, the river spills out into these sunlit shallows. Rich in colour and tone, the water was worked very strongly, wet into wet. When these first colours were dry, more ripples were added, wet on dry, painting lighter opaque colours on top of the darks, much as with oil painting. The warmth of the bridge contrasts with the deep blue reflection of the sky, which is much darker than the sky itself; this is often the case with shallow water where the dark bottom enhances the darker reflections but not the lighter ones. Tonal contrast is provided by the white on the building, so the painting contains a full range of colour and tone. As well as depicting light and shade, a painting can capture the movement of water in a way that is quite unobtainable photographically. Adding water to a composition gives the artist an opportunity to bring a painting to life.

Shallow water

by Joe Francis Dowden

The river depicted in this demonstration flows down from the high Andalusian mountains in Spain and forged this rocky terrain during the rainy seasons. When the waters subside, the river provides the perfect foil for this arid landscape; a deep blue sky reflecting in stretches of shallow water, rocks above and below the surface, and soft reflections from the far shore. In this painting, which measures 420 x 315mm (12½ x 16½in) and is painted on 300gsm (140lb) Not paper, I show how easy it can be to capture these features in watercolour.

You will need

Alizarin crimson, burnt sienna, burnt umber, cadmium lemon, cadmium orange, cobalt blue, cobalt turquoise, helio turquoise, indigo, Naples yellow, olive green, Payne's gray, phthalo blue, phthalo green, quinacridone red, ultramarine, yellow ochre

Masking fluid, gum arabic

Reference photograph.

1. Tape up the outer edges of the composition, then, using the reference photograph as a guide, make a pencil sketch of the main outlines of the scene.

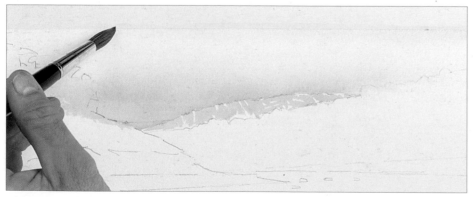

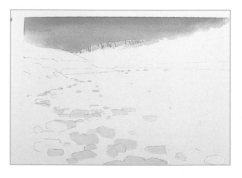

2. Wet the sky area, then lay in a graded wash of quinacridone red, from the bottom of the sky upwards over half the sky. Drag some colour down on to the hills. Leave to dry. Wet all the sky area avoiding the hills, then lay in a wash of phthalo blue with touches of helio turquoise and cobalt blue from the top of the painting downwards.

3. Strengthen the sky with cobalt blue, then add shadows in the far hills. Remove the masking tape from round the sky, then, while the sky dries, use an old brush to apply masking fluid to all the dry parts of the rocks in the water.

4. Mix ultramarine with touches of quinacridone red and yellow ochre, then block in the distant horizon and add texture to the far hills. Mix yellow ochre with a touch of cadmium orange, then block in the near hills; take this colour up on to the blue at the right-hand side to create a green tree line. Use the same colour with a dry brush to indicate foliage for the trees at the left-hand side. Leave to dry.

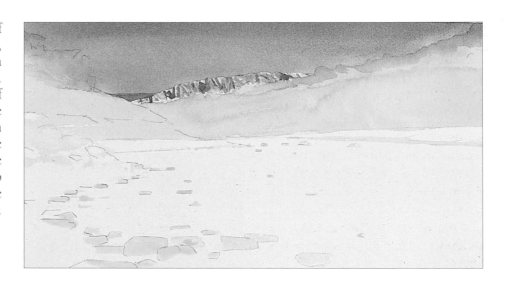

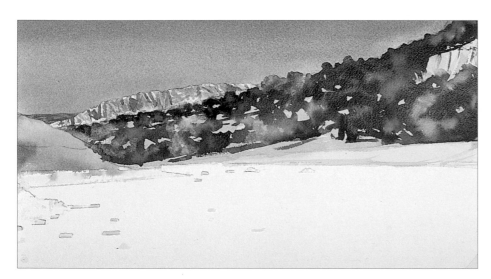

5. Glaze tones of cadmium orange and burnt umber over parts of the near hills. Dry the far bank of the river, wet the hill side, then drop in splashes of olive green, wet-into-wet, to indicate trees. Create highlights of cobalt turquoise, Naples yellow and cadmium lemon, all wet-into-wet. Create shadows with burnt umber and ultramarine. Use a clean paper towel to dab out some of the colour in the distance.

6. Wet the left-hand hill and work olive green into this area to denote foliage. Dry brush some of this colour for the trees on the skyline. Add burnt umber and ultramarine for the darks in the foliage. Add more shadows to the distant mountains and some tiny clumps of foliage on the skyline.

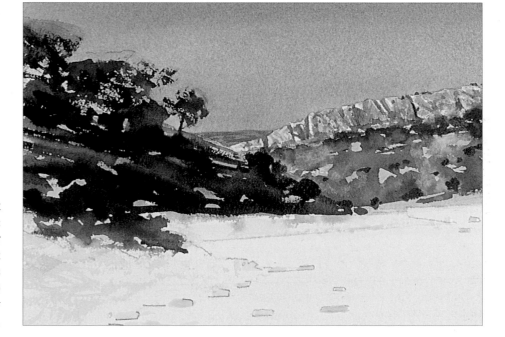

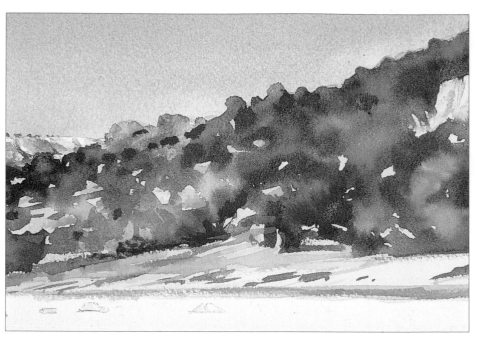

7. Using a mixture of the darks on the palette and a dry brush, crisscross texture across the rocky scree in the foreground and middle distance. Leave to dry, then crisscross small brush strokes of darker tones over the first set of brush strokes to define form and create shadows.

8. Mix yellow ochre with a touch of burnt umber, then work a few strokes of this colour across the bank of the river. Add touches of quinacridone red, then brush some of this to the bank and one or two touches to the rocky crag at top right. Add a few marks of olive green to denote patches of grass.

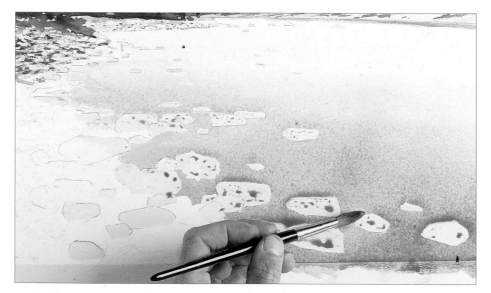

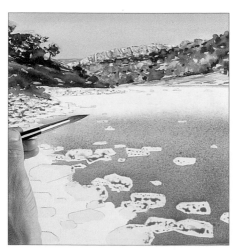

9. Wet all the water area with water, then brush gum arabic over the top 25mm (1in) of the water. Lay a strong wash of burnt sienna across the bottom edge of the water, then, working up from the bottom, gradually dilute the wash with water.

10. Working wet into wet, add more burnt sienna to the bottom edge, then lay in neat alizarin crimson over the burnt sienna, laying a strong band of this red towards the top.

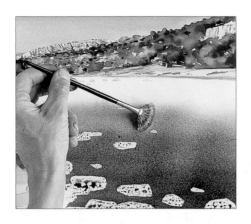

11. Working wet into wet, from the bottom upwards, lay in a wash of indigo, then add a few horizontal strokes of phthalo green. Use a dry fan brush to blend all the colours together.

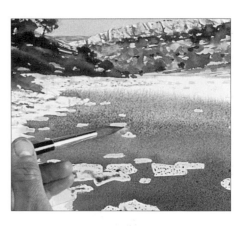

12. Mix a wash of phthalo blue, then lay a band of this colour above the red.

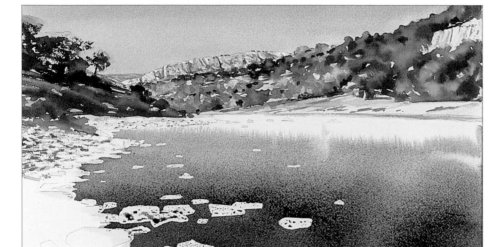

13. Bring the blue down over the previous colours, gradually diluting the wash with more water. While the blue is still wet, use a clean brush to lift out a patch of colour for the reflection of the rocky crags. Leave to dry.

14. Size the depth of the reflection about the real horizon line. The hill at the right-hand side is cut by the top of the painting, so remember to add this missing part in the reflection.

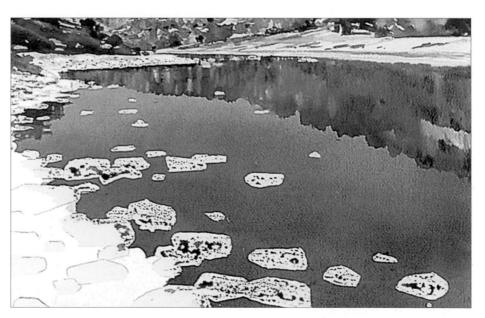

15. Wet the area of water in which the reflection of the hillside appears, then paint the reflections, wet into wet, using olive green, phthalo green, Payne's gray, cadmium orange and Naples yellow.

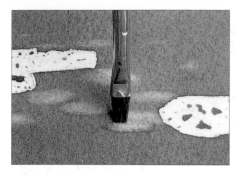

16. Use a small bristle brush to leach out patches of colour from the water to indicate the submerged rocks. Work with the board at a slight angle to allow the water to form a hard line at the bottom of each rock.

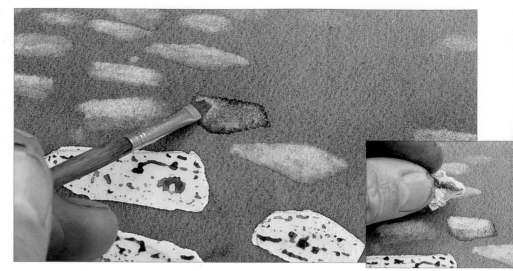

17. For the larger rocks, wet the shape of the rock with water, then use a rolled-up tissue to remove colour from the top edge of the rock.

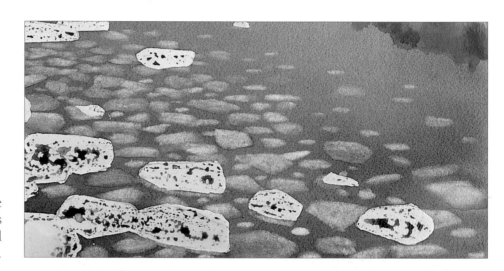

18. Continue leaching out the rest of the submerged rocks. This is very straightforward and well worth the effort.

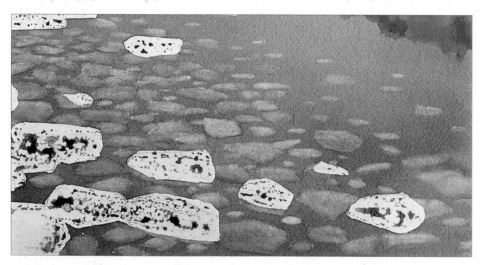

20. Use Payne's gray to add fine shadows at the right-hand and bottom sides of the large rocks. Work some wet into wet, some wet on dry. Work dark shapes between the rocks to define the underlying bed of rocks.

19. Use weak washes of burnt sienna to apply colour to the leached out rocks. Use paper towel to dab off excess colour from some rocks.

21. Remove the masking fluid, then start to colour the exposed rocks. Use mixes of burnt sienna and ultramarine, with touches of alizarin crimson here and there; make weak washes for the tops of the rocks, then strengthen the blue for the shadowed area. Use burnt umber and ultramarine for dark shadows.

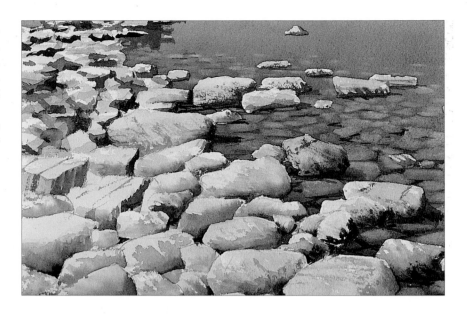

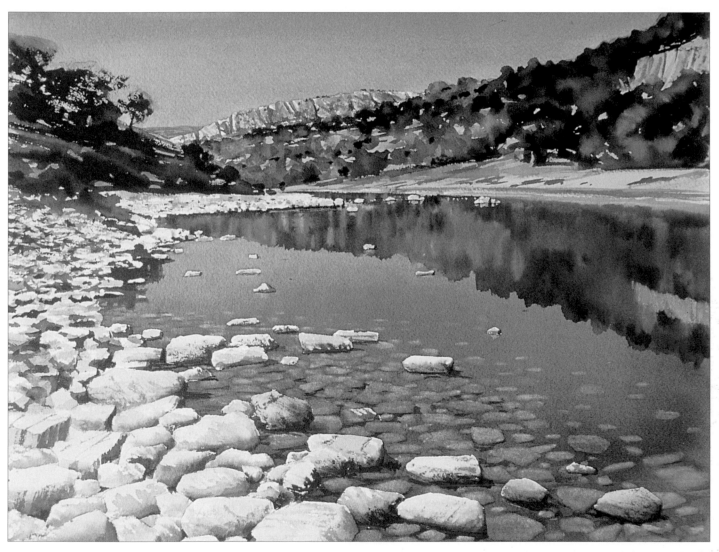

The finished painting

Sparkling Water

I painted this picture in spring, when the weather fluctuated between rain and sunshine every few minutes. The sun was directly ahead, but just above the top edge of the painting, and its intense light created the sparkling flashes of light reflected on the ripples in the water. These highlights were enhanced by the darker tones of the sombre clouds in the lower part of the sky.

This scene required strong tones in the river, and these were built up with successive glazes of Naples yellow, burnt umber and Payne's gray. The sparkles are vertical scratches, made with tip of a blade, to mimic their up and down motion in the water. In addition to these ripples, markings on the river bed are also visible. By careful observation, all these effects can be identified and painted in watercolour.

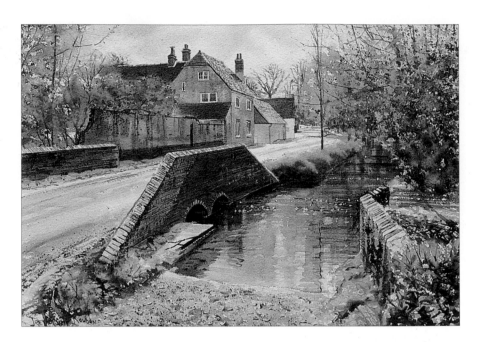

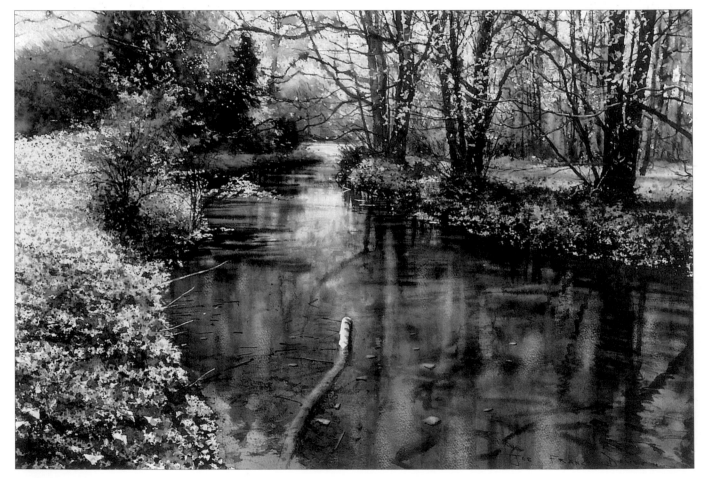

Bend in the River

The half-submerged branch was masked where it emerges from the water, and scrubbed out below the waterline. The decaying twigs and branches on the river bed were painted, wet into wet, on the strong underlying wash. The soft vertical marks are reflected highlights from the bright sky shining through the tree canopy; these were lifted out of the dry wash with a damp brush, then dabbed with a paper towel.

92

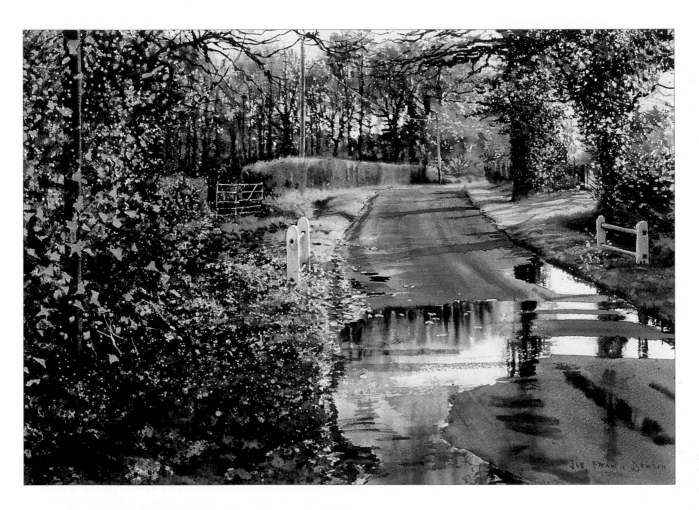

Rural Lane

Water reflecting light is as attractive as any gem in a jeweller's shop window. Water lying on a road is often taken for granted, but reflections in the water can transform a scene and unite two halves of a composition. It is incredible how much one location can yield, and these two paintings illustrate this point. The view (left) is from the right-hand grassy bank in the painting above. Note how the telegraph pole, puddles and culvert bridge feature in each painting.

The lane is painted with ultramarine, burnt sienna and alizarin crimson; touches of cerulean blue were added to create granulation and give the tarmac texture. Gum arabic was used in the puddles, and the culvert railings were masked. Vertical reflections always help to make water look wet.

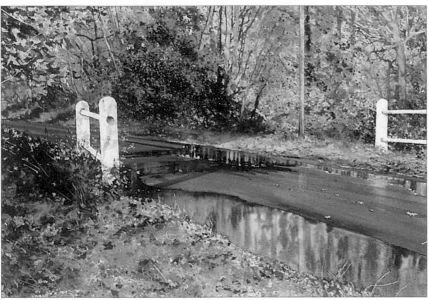

93

SEA AND SKY

The following advice on painting these vital subjects in watercolour is from Arnold Lowrey.

Get to know the subject of sea and sky before you start painting them in watercolour. Take time to watch the breakers form in the sea; study the foam patterns, note how the waves crash against rocks and how the water pours off them, observe how the sun reflects off the waves. Study the various types of cloud formation – cumulus, cirrus, etc., and the different colours in the sky. Then, you will be able to apply this new-found knowledge with imagination and skill. This chapter should slay a few dragons for you, and make you try new things – if you are bold enough, you will produce original paintings that will surprise you.

Stormy Seas
Size: 675 x 520mm (26½ x 20½in)
The rough seas pounding the shoreline provides all the action in this composition, so the sky was kept quite simple. The diagonal structures in the sea give a feeling of movement, and this is heightened by the use of soft and rough edges on the waves. The diagonals repeated on the land area add to the overall dramatic effect.

94

Painting skies

It is impossible to illustrate all the different skies you may encounter – they change by the second – but here are a few of the more common types, and some points for you to consider when painting them.

A clear 'blue' sky is not the same blue all over, and it can range from a deep, purply blue high up, down to a pale, eggshell blue near the horizon. Similarly, clouds are not always white; they can vary from being very light against a dark sky to quite dark against a light sky.

Remember the rules of perspective; clouds directly overhead are much larger than those in the distance. They also pack closer together as they recede. The tops of low clouds against a bright sky have crisp, hard edges, whereas their undersides usually have soft edges.

Really high clouds can be quite wispy, or they can cover the whole sky and take up some wonderful pastel tones.

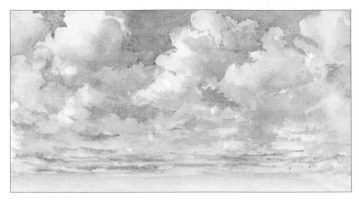

These clouds overlap each other and create interesting silhouettes. Note that the largest clouds are near the top (front) of the composition and that they become smaller as they get further away. Note also how the background sky colour becomes cooler as it recedes into the distance.

This evening sky was started with a background of aureolin. While the paper was still wet the mingling technique (see page 15) was used to pump permanent rose and cobalt blue into the lower, more distant part of the sky. Darker mixes, made with ultramarine blue and cadmium scarlet, were then applied into the higher, closer cloud formations.

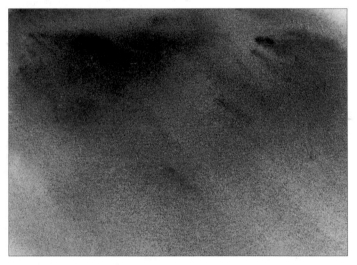

This detail shows rain clouds which have a diagonal direction created by the prevailing winds. To achieve this effect, the sky was first painted with a suitable background colour and allowed to dry. A strong dark was painted into the top left-hand corner, then the paper was immediately tilted to an angle of about 60°, corner to corner. A small spray gun, held far enough away from the paper for the water to atomise, was then used to wet the paper until the applied colour slid diagonally across the paper of its own accord.

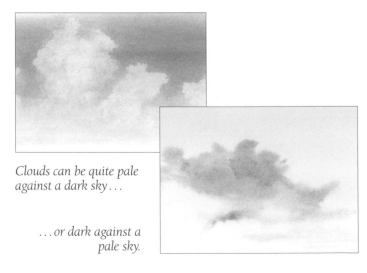

Clouds can be quite pale against a dark sky...

...or dark against a pale sky.

Painting seas

It is important to get to know the sea and the seashore before you start painting, and, to this end, take every opportunity to walk along the coastline irrespective of the weather conditions. Take a sketchbook with you and try to capture all the different moods you see.

Note, for instance, how the swells on the surface develop into breakers, then crash against the rocks creating lots of spray. Watch how the water cascades off the rocks and, then, how this turbulence produces foamy patterns.

Light direction changes throughout the day, so take note of how various lighting conditions affect colour and tonal values. Atmospheric conditions also have a profound effect; the horizon can be dark and clear, or so pale it almost merges with the sky.

The sea reflects the colours in the sky; so it is no use painting a warm, ultramarine blue sky and a cool, Winsor blue sea. This is a common problem, and many seascapes are ruined by having completely different colours for the sea and sky.

Remember that the sea is moving all the time – tides ebb and flow – and the shapes in the sea are changing continually. The texture of the edges of shapes is important; rough or soft edges show movement, whereas hard edges give the impression of stillness. Note how reflections become more prominent when there is little movement in the water, and how the angle of the light creates different highlights and shadows.

Armed with your observations and trial sketches, establish what mood you want to paint. Decide on a focal point – a lighthouse, a boat or just a large wave – then place it so that it draws the eye into the composition. Then try out a few tonal sketches to clarify your mind. You will soon gain the confidence to begin painting seascapes.

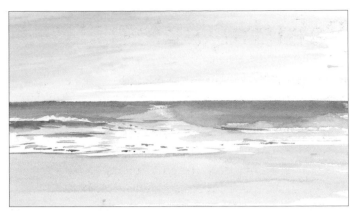

This beach scene shows how the colours of the simple sky are reflected in both the gently moving sea and the wet sand. The waves are too far away to need much detail.

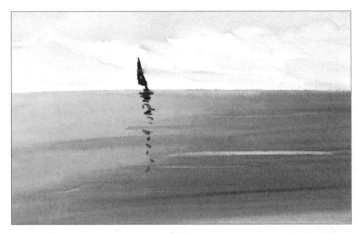

The dominantly horizontal design of the shapes in this composition, together with the hard edges of the horizon and the reflections of the boat indicate a very calm sea.

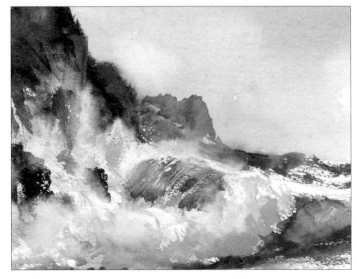

This is obviously a rough sea. The use of interesting shapes with rough and soft edges is vital to create the right mood.

Gower Coast

by Arnold Lowrey

For this first project, I have chosen a simple seascape where the sky is the largest and, therefore, the most important part of the painting. The low horizon, approximately one-quarter of the way up the paper, still provides adequate space to create an interesting foreground to lead the eye into the painting, and the small yacht provides a focal point. The silhouette of the rocks which link the sea and sky have unpredictable shapes to create the maximum interest.

Although I painted this demonstration on a 660 x 460mm (26 x 18in) sheet of 535gsm (250lb) Not paper, I worked within an aperture of 510 x 330mm (20 x 13in) to create a wider vista.

You will need

Brushes: 25mm (1in) flat bristle, 25mm (1in) flat sable, 12mm (½in) flat nylon with a scraper end

Colours: aureolin, burnt sienna, burnt umber, cadmium scarlet, cadmium yellow, cobalt blue, permanent rose, ultramarine blue

Other equipment: paper towel, razor blade

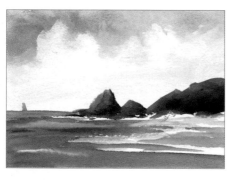

Tonal sketch

Having made this sketch, I decided to lower the horizon and develop the sky, breaking it up into a variety of interesting shapes.

1. Transfer the basic outlines of the composition on to the paper.

2. This sky must be painted quickly, so prepare washes of aureolin, cadmium scarlet, cobalt blue and ultramarine blue in advance. Then, start the sky by using a 25mm (1in) flat bristle brush to wet all the paper.

3. Lay in a few random strokes of aureolin across the middle of the wetted sky area.

4. Use the cobalt blue wash to block in the top part of the sky behind the clouds.

5. At the right-hand side of the sky, brush random strokes of a weak wash of cobalt blue, then drop in some permanent rose and cadmium scarlet. Allow all the colours to blend together.

6. Lay in more cobalt blue to redefine the top edges of the clouds…

7. …and to darken the lower sky behind the headland.

8. Use a paper towel to lift out colour and soften the top edges of the clouds.

9. Quickly push colour across the paper with a paper towel to form streaks of wispy cloud.

10. Use the flat bristle brush and a 'negative painting' technique to add more cobalt blue to define the edges of large clouds...

11. ...then use a damp clean brush to vary the edges of the clouds to give them a 'lost and found' effect.

12. Use more cobalt blue to add some wispy clouds at the bottom left-hand side of the sky.

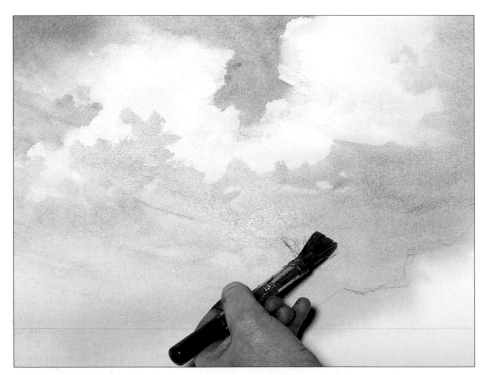

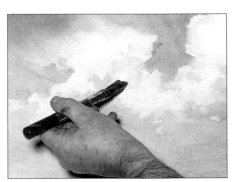

14. Again, use a clean brush to soften some of the hard edges that start to form.

13. Mix ultramarine blue with touches of cadmium scarlet, then start adding darker clouds. Move the brush quickly and lightly across the paper for some shapes, then touch the paper gently with the brush almost flat to create some rough edges.

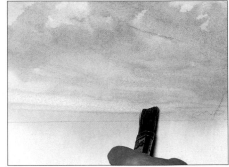

15. Lay in a few wispy clouds in the distant sky just above the horizon line.

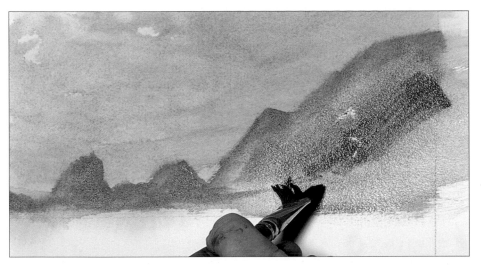

16. Mix ultramarine blue with touches of burnt sienna, then use the 25mm (1in) flat sable brush to block in the headland. Add touches of cobalt blue for the more distant rocks. Add cadmium yellow to the mix, then drop this into the near headland. Use the colours on the palette to accentuate edges, and to build up shape and tone.

17. While the colours are still wet, use the scraper end of the 12mm (½in) flat nylon brush to scratch highlights in the rocks.

18. Use mixes of cobalt blue and ultramarine blue, and the flat sable brush to lay in the sea; Make long sweeping horizontal strokes, leaving some areas of sparkle on the surface. Add touches of cadmium scarlet to the distant water.

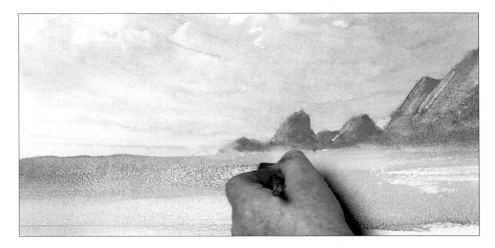

19. Use the tip of the brush to make the horizon line straight and horizontal.

20. Use a clean damp brush to lift out some wave shapes.

21. Use a clean damp brush to push colour up into the headland to create spray.

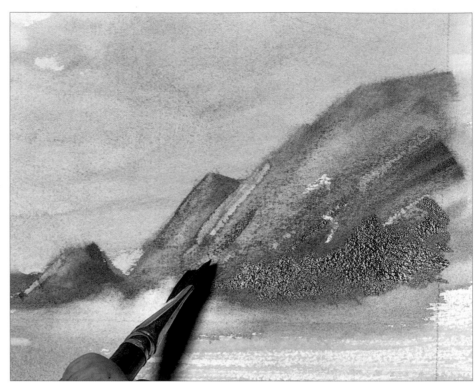

22. Use mixes of ultramarine blue and burnt umber to create rocky shapes on the headland.

23. Use the scraper end of the 12mm (½in) flat nylon brush to create highlights and shape.

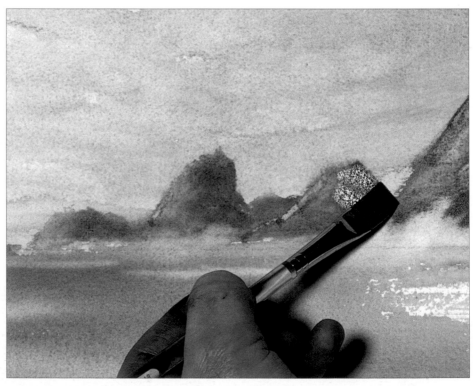

24. Darken the middle distance rocks to create depth and shadows, and if necessary, rework some rocks to eliminate any repetitive shapes.

25. Add a small sailing boat on the horizon as a scaler, then use a rigger to add shape and detail to the wave at the left-hand side.

26. Use the corner of a razor blade to nick out fine speckles of spray on the left-hand wave.

27. Then, finally, draw the razor blade horizontally across the distant sea to create some lively areas of sparkle.

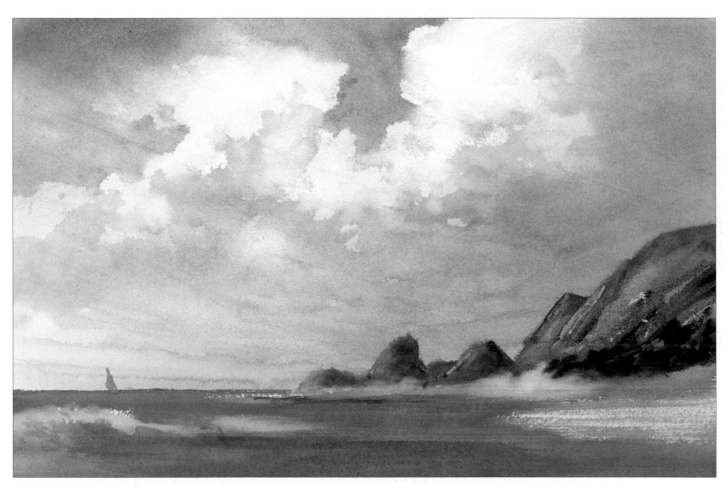

The finished painting
Size: 510 x 330mm (20 x 13in)

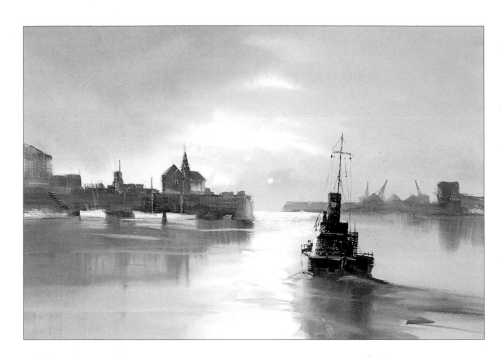

Cardiff Docks
Size: 660 x 460mm (26 x 18in)

In this composition, the sky and sea were created by mingling random strokes of aureolin, permanent rose and cobalt blue. The buildings and reflections were applied with a thirsty brush using ultramarine blue and cadmium scarlet

The tugboat, also painted with ultramarine blue and cadmium scarlet, was added when the background was completely dry to ensure crisp hard edges.

Early Morning Mist
Size: 460 x 330mm (18 x 13in)

The atmospheric effect of this painting was produced by dragging a paper towel diagonally across the mountains to break up their edges, and by sponging their bases to create the mist. The reflections were produced by using a thirsty brush to drag paint from the rocks into the water area, whereas the highlights in the water were created by using a thirsty brush to lift out colour.

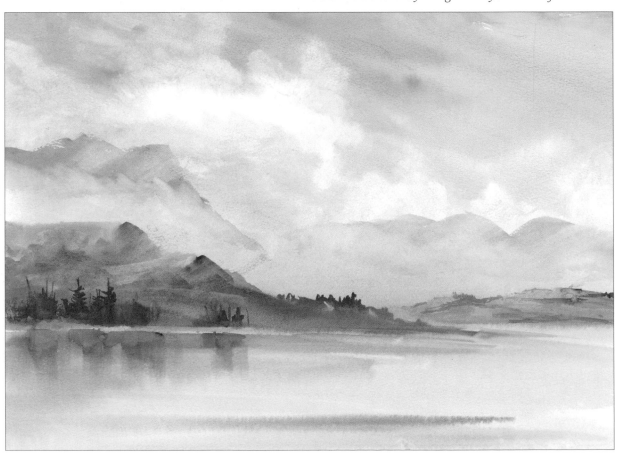

Cliffs

Size: 305 x 510mm (12 x 20in)

The soft edges in this painting were achieved by applying most of the colours while the paper was wet. The spray from the breaking waves was sponged out of the rocks and sky, then the actual waves were applied with a thirsty brush, again to eliminate hard edges.

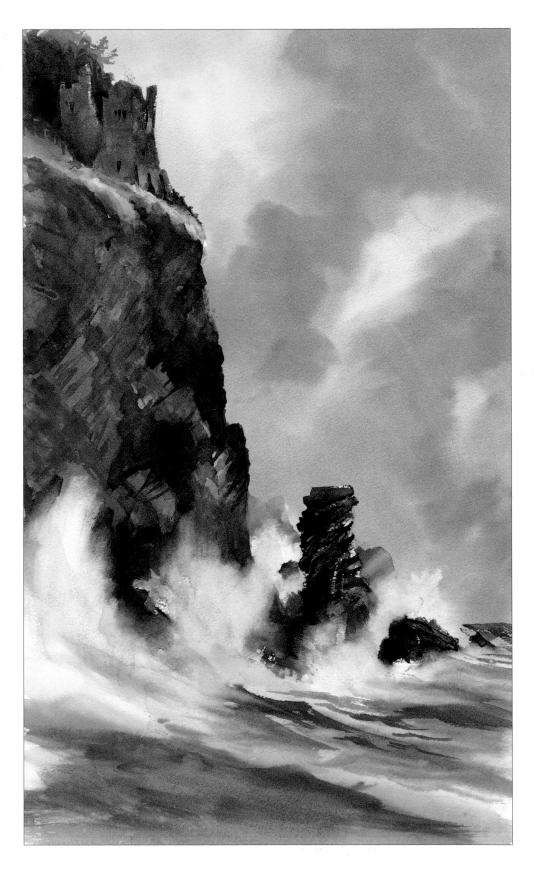

Reflections in the Sand

by Arnold Lowrey

In this scene, the receding tide leaves large shallow pools of water on the beach which produce wonderful soft reflections. Distance is emphasised by aerial perspective; the colours used to depict the cliffs gradually change from warm to cool as they get further away. The diagonal shape of the large foreground rocks provide a point of interest and creates a 'path' to lead the eye into the distance. The diagonals in the sky, opposite to those in the cliffs, create a balanced composition. I painted this demonstration on a 660 x 460mm (26 x 18in) sheet of 300gsm (140lb) Not paper, in a 510 x 400mm (20 x 16in) aperture.

You will need

Brushes: 25mm (1in) flat sable, 12mm (½in) flat nylon with scraper end, No. 3 rigger

Colours: aureolin, burnt sienna, cadmium scarlet, cobalt blue, lemon yellow, permanent rose, raw sienna, ultramarine blue

Other equipment: sponge, paper towel, razor blade

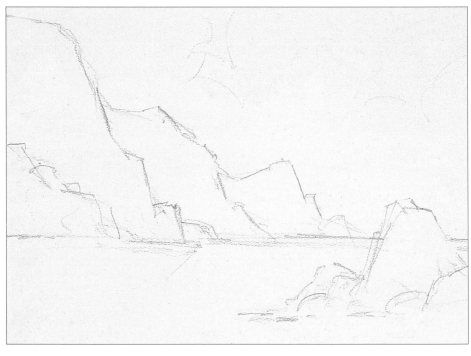

Having made this tonal sketch, I then decided to make the left-hand cliff slightly lower and make its top visible (see step 1). However, while painting the scene, I changed my mind again (see step 9), and reinstated the full height of the cliff face.

1. Sketch the basic outlines of the composition on to the paper.

2. Prepare weak washes of aureolin, permanent rose and cobalt blue. Start the sky by using the 25mm (1in) flat sable brush to wet the whole sky area, taking the water just across the outlines of the headland and the rocks.

3. Working quickly, lay random streaks of aureolin across the middle of the sky...

4. ...then brush the permanent rose randomly over the yellow...

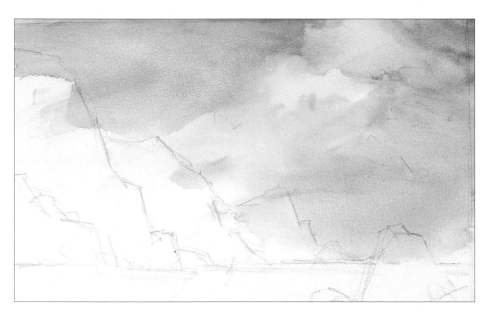

5. ...and, while the first colours are still wet, lay in the cobalt blue to shape out the clear areas of the sky...

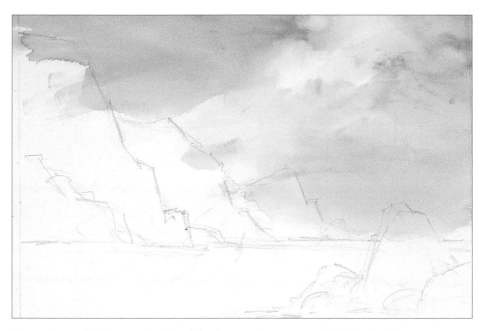

6. ... then, finally, use a clean brush to soften some of the hard edges that start to form. Leave to dry.

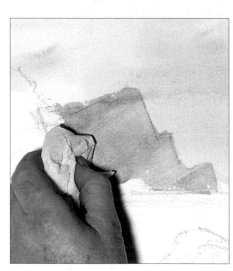

7. Mix cobalt blue with a touch of permanent rose, then block in the distant headland. Make diagonal strokes with clean paper towel to wipe out some of the hard edges.

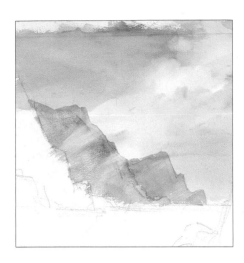

8. Add touches of lemon yellow to the grey mix, then block in the next nearest cliff with different tones of this colour. Again, use paper towel to soften some edges.

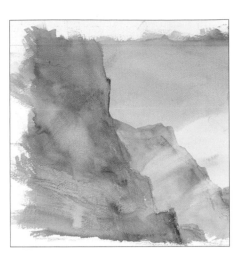

9. Add raw sienna and burnt sienna to the mix, then block in the nearest cliff. Vary the colour with touches of permanent rose. Notice that I have increased the height of the foreground cliff.

10. Mix cobalt blue with a touch of cadmium scarlet, then start adding shadows into the distant headlands. Strengthen the mix to add shape and texture.

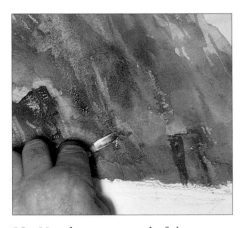

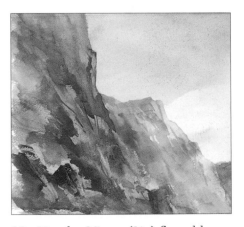

11. Apply random strokes of clean water to the near headland, then use mixes of burnt sienna and ultramarine blue to add darks and create texture.

12. Use the scraper end of the 12mm (½in) flat nylon brush to scrape rocky shapes into the wet areas of colour.

13. Use the 25mm (1in) flat sable to strengthen the burnt sienna and ultramarine blue mix, then continue to develop shape and texture. Use a clean brush to soften some edges. Leave to dry.

14. Add more burnt sienna to the mix to form a really dark colour, then paint this on the middle distance headland to bring the edge of the foreground cliff into relief. Soften the right-hand side of this colour with clean water. Bring the edge of the middle distant headland into relief in a similar manner, by using cobalt blue on the far headland.

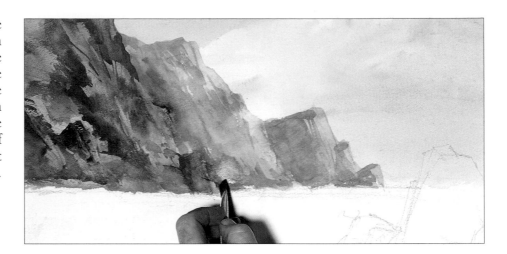

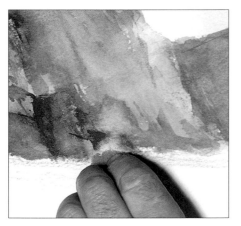

15. At sea level, push a clean damp sponge into the darks to indicate a small area of spray.

16. Mix cobalt blue with a touch of lemon yellow, then use short vertical strokes of the 25mm (1in) flat sable brush to create small waves on the distant sea.

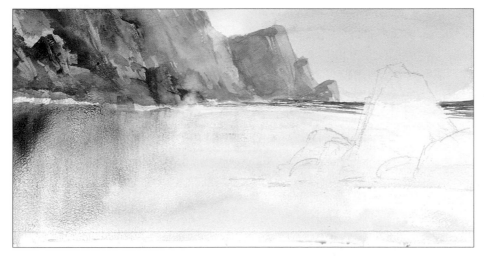

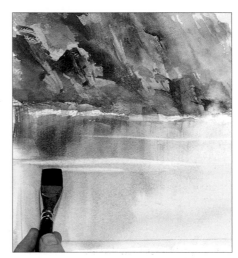

17. Wet the area of sand with clean water, then lay in a wash of raw sienna. Add touches of burnt sienna into the foreground, then, working quickly with a thirsty brush, lay in vertical strokes of the colours used for the foreground cliff.

18. While the paint is still wet, use a clean thirsty brush to lift out horizontal strokes across the beach to emphasise the reflection.

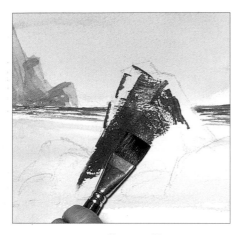

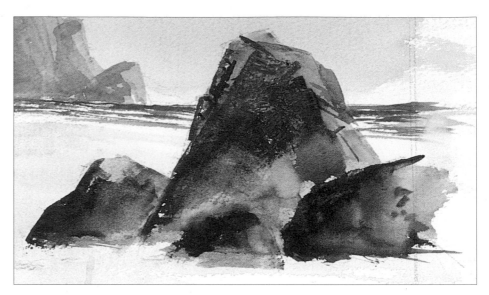

19. Prepare a stiff mix of burnt sienna with touches of raw sienna, then, using the side of the brush to create sparkle and texture, start to block in the foreground rocks.

20. Add highlights with a mix of raw sienna and ultramarine blue, then use the darker mix to continue building up shape and texture.

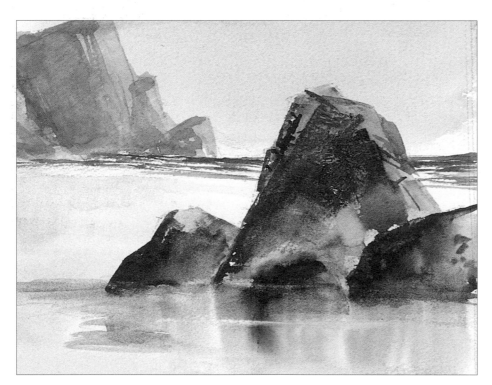

22. Mask the top of the painting, then spatter a few dark spots of colour across the foreground. Elongate some of these by wiping across them with short horizontal strokes of a clean paper towel.

21. Wet the area in front of the rocks, then use a thirsty brush to pull the rock colours down into the wet area to create reflections.

23. Finally, use a razor blade to rip the paper and create bright sparkles on some of the rocks.

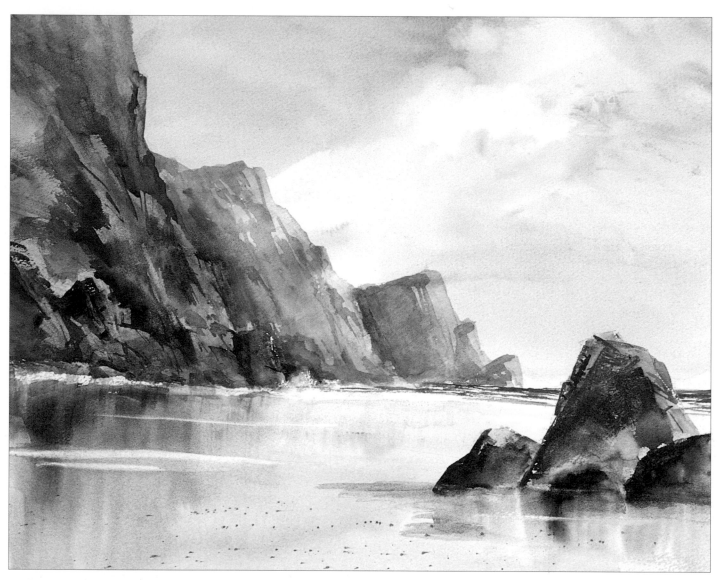

The finished painting
Size: 510 x 400mm (20 x 16in)

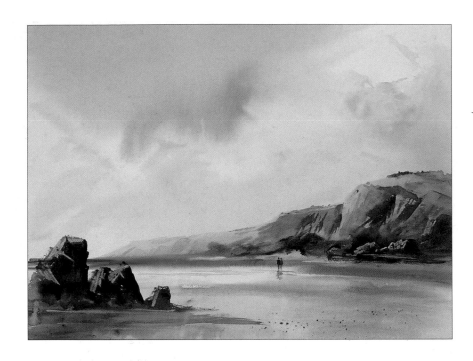

Low Water
Size: 685 x 510mm (27 x 20in)

This painting was executed in a similar way to the demonstration painting on pages 106–111, but the paper was kept wet longer to give a softer effect. The final addition of two people walking on the beach provides a scale for the eye to appreciate the physical size of the beach.

Caldy Island Lighthouse
Size: 720 x 500mm (27 x 20in)

This image was painted on 190gsm (90lb) Not cotton paper. The soft-edged effect was created by completely wetting the paper before adding any colour. The lighthouse provides the focal point, and the gap in the cliffs leads the eye from the sea up across the island.

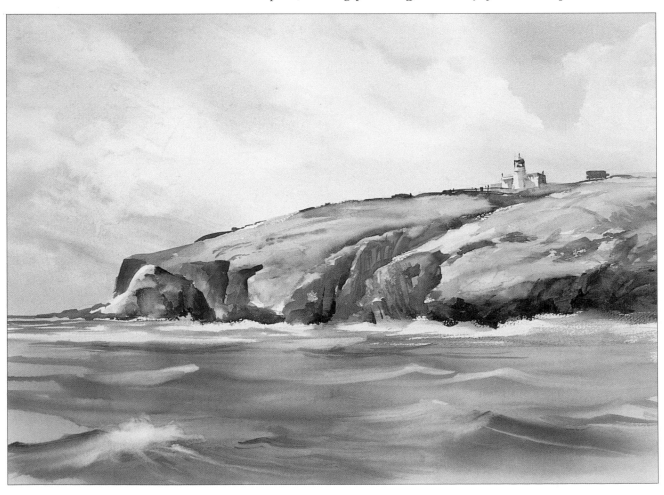

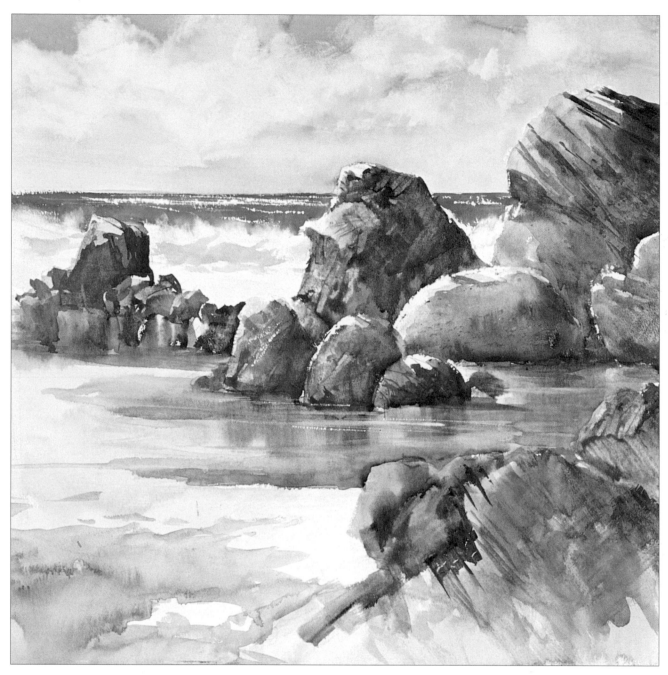

Sunny Day, Welsh Coast
Size: 510 x 510mm (20 x 20in)

In this painting of a rocky beach, I contrasted the rough sea against the tranquil rock pool. The rocks have a variety of colours and edge textures to make them more interesting. The light, coming from the left-hand side of this composition, produces shadows which contrast with the sunlit sand.

BUILDINGS IN THE LANDSCAPE

Here, Ray Campbell Smith shows how to paint buildings, which are an important element in many landscapes.

Buildings can make marvellous subjects in their own right: think only of a jumble of period buildings clustering round a medieval church, or groups of weathered fishermen's cottages fringing a stone harbour, to realise something of their potential. It is also true to say that buildings are such a vital feature of the countryside that even those whose prime interest is the unspoilt rural landscape must learn how to paint them convincingly.

In this chapter, I shall look at different types of buildings and examine how best to convey them in fresh, transparent watercolour. My aim is to capture their essence and atmosphere in full, liquid washes, rather than to paint in every detail with a tiny brush. Some knowledge of perspective is essential because of the geometric shapes of buildings, and aerial perspective is also important. Composition is important too: a badly-composed painting, however brilliant the brushwork, will always be a bad painting. I shall also consider the different styles and periods of architecture, as well as ways in which to convey the effects of age and weathering. Urban and industrial buildings will be included, showing what wonderful subjects they can make when handled with imagination and understanding. My main objective throughout will be to use the wonderful medium of watercolour correctly, so that the paper shines through fresh clear washes, without a hint of the muddiness and dullness that are the result of laborious overworking.

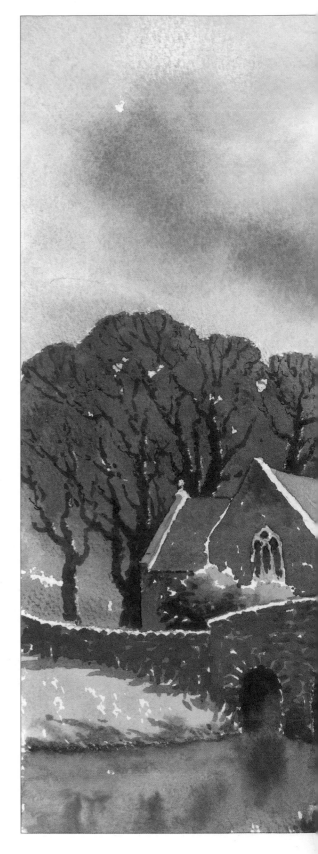

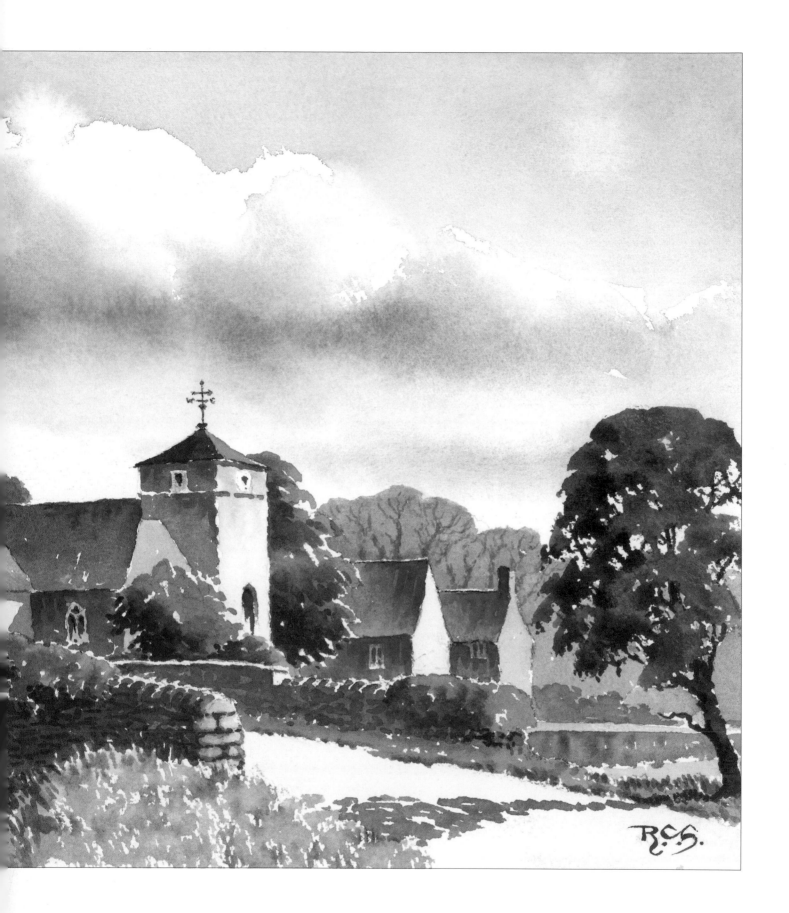

Architectural details

The shape and design of details such as windows, doors and chimneys will vary according to the style of building, and careful observation will help to ensure accurate drawing. It is a good idea to familiarise yourself with architectural styles including Tudor, Jacobean, Carolean, early, middle and late Georgian, Victorian, Edwardian and contemporary. This need not involve detailed study, but it helps to have a broad idea of what to look for: the stone mullions of the Jacobeans, the pleasing proportions of the Georgians, the confident and sometimes florid approach of the Victorians.

Manufacturing methods have improved progressively in the centuries since the first use of glass. It became possible to make glass in increasingly larger sizes, which naturally had an impact on window design. Early windows were made up of many tiny rectangular or diamond-shaped panes set in lead lattice. Later, larger panes facilitated delightfully proportioned Georgian windows, while with even larger sheets of glass at their disposal, the Victorians were able to do away with glazing bars. Today, 'picture windows' often make the most of pleasant views. It is not necessary to paint windows in precise detail and it is usually better to indicate them fairly broadly. The important thing is to avoid making them all look exactly the same. Sometimes you can see into a room; sometimes the glass reflects the light, or perhaps a bit of both. There may be draped or drawn curtains. Use these differences to achieve variety in your treatment.

Introduce variety into your windows.

A traditional chimney and a contemporary chimney

Chimneys and their stacks can also vary greatly with architectural styles, from ornate and decorative Tudor designs at one extreme to stark contemporary styles at the other. The pitch of roofs also varies greatly, from steep Jacobean slopes to the far gentler Georgian slopes. The amount of detail of guttering, downpipes and other features you include will depend on the proximity of the building, but make sure you put in all the shadows as these help to give shape and solidity.

Creepers and adjacent trees and shrubs also need careful handling. They can provide useful tonal contrast but should not be allowed to obscure too much of the building – and remember that they, too, cast shadows.

The Pantiles, Tunbridge Wells

*The assortment of periods and styles in this fascinating jumble of buildings provides
an interesting variety of architectural details which have been painted fairly loosely.*

Farm buildings

The countryside in Britain and many other countries is rich in farm buildings, many of them constructed before mass transport when building materials had to be obtained locally. This gave buildings of all kinds their strongly regional flavour and much of their period charm. The Wealden clay of south-east England was used extensively for colourful bricks and tiles with glowing red, brown and orange tints; limestone provided the attractive honey-coloured building material characteristic of the Cotswolds; in the north, harder rocks contributed greatly to the rugged, uncompromising appeal of rural architecture, while in wooded or lowland areas timbered or half-timbered buildings were the norm. These buildings seem to have settled naturally and harmoniously into the countryside, adding to its beauty and character. Sadly, some modern farm buildings are very different, and are constructed more cheaply in a manner that often suggests light industry rather than farming. Landscape painters will continue to seek out the older, traditional farms for their subjects. Below is a small Cumbrian farmhouse and opposite an example of the older type of Wealden farm beloved of so many painters and painted on the spot in early autumn.

Cumbrian Farmhouse
This small farmhouse nestles into the hillside. Misty sunlight from the left touches everything with its warm glow, catching the tops of the trees, the line of washing, the slated roof and the dry stone wall in the foreground to create plenty of tonal contrast.

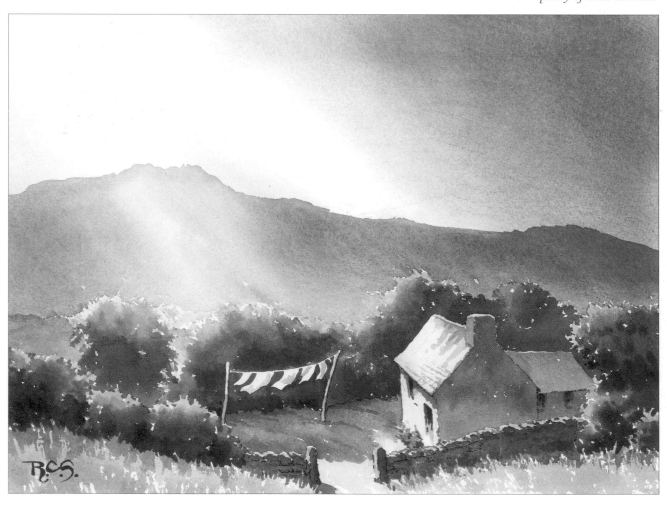

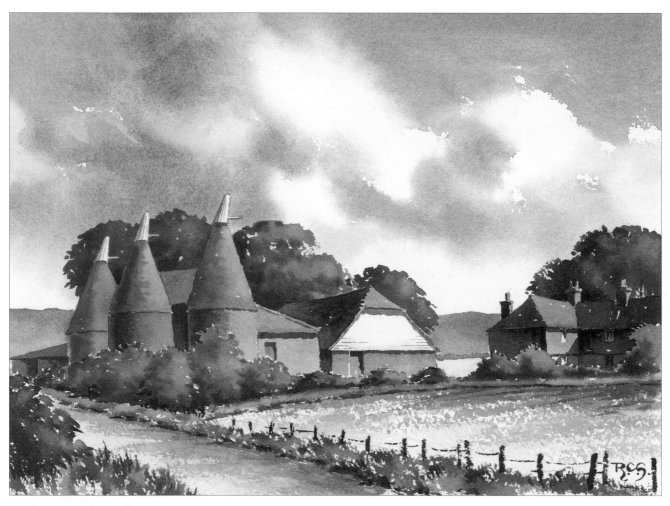

Stocks Farm, Wittersham

The afternoon sunlight from the right helped to give the jumbled buildings of this farm, with its warm bricks and roundel oasts, a three-dimensional appearance with plenty of useful tonal contrasts. The sunlit elevations of the buildings registered effectively against the dark trees so I placed one behind the white gable for additional tonal contrast. The lively cumulus sky went in first, with washes of pale raw sienna for the lower sky; French ultramarine and light red for the cloud shadows, and Winsor blue and French ultramarine for the blue sky. I let these washes blend softly, but retained some hard edges. The sunlit brickwork and tiles were various pale blends of light red and burnt sienna, with touches of green in the lower courses to suggest moss and algae. The shadowed walls and roofs were mainly light red and French ultramarine, with a little texture added, wet on dry, in deeper tones of the same wash. The distant hills were a wash of French ultramarine and light red, with a hint of raw sienna on the nearer slopes.

Some of the foliage had a hint of russet so I used burnt sienna, with a little raw sienna and Winsor blue, green shade, with strong shadows of Payne's gray and burnt sienna for the green foliage. A broken wash of raw sienna with a little added light red served for the pale tones of the foreground ploughed field, with added light red and French ultramarine texturing. The foreground features – the tussocky grass and line of fence posts – were put in fairly loosely so that they would not demand too much attention. Even the smaller passages were applied as liquid washes which helped to preserve the freshness and transparency of the paint.

Fishermen's cottages and harbours

Old fishing villages with cottages clustering round sturdy jetties make irresistible subjects. With their random, unplanned grouping, the buildings seem almost part of the natural scene; weathered, rugged and permanent. The port of Newlyn in the west of England became a magnet for artists inspired by the unspoilt beauty of the coast, and the Newlyn School attracted many fine painters. There are many other delightful fishing ports around the world, all with distinct national and regional characteristics, and well worth the attention of landscape artists.

Polperro is one of Cornwall's most popular and attractive fishing ports. My viewpoint from the inner harbour focused on the jumble of harbourside cottages, with just a strip of water and a few moored boats in the foreground. When painting groups of buildings, the direction of light is vital. Here, it was coming from the right: the resulting pattern of light and shade gave the cottages form and shape. In a subject like this, varying the treatment of windows is vital: fifty identical rectangles would be a disaster! I added a few roughly-painted figures for human interest, concentrating on posture rather than detail. The three moored boats contrasted effectively with their dark background.

Polperro

I made a quick, exploratory sketch, then drew the shapes of the buildings, paying careful attention to perspective. Working from light to dark, I began the sunlit elevations of the cottages. These were mainly the white of the paper, with pale broken washes in places to indicate texture and weathering. I used pale tones for the sunlit, slated roofs, and made the most of colour differences, adding the greenish tinge of moss and algae to the lower courses. For the rough stonework of the cottage on the left I used a broken wash in a mix of burnt sienna and French ultramarine, and added a few random blocks of stone to the adjoining harbour wall. The cottage walls in shadow contrasted effectively with the sunlit elevations and helped to give the buildings a solid, three-dimensional appearance, while the dark foliage of several trees made even stronger tonal contrasts with the adjoining whitewashed walls. I used masking fluid on a shadowed wall to preserve the shapes of two seagulls in flight. I emphasised the greenish local colour of the water to distinguish it from the scene above, and indicated the reflections very loosely, giving them indented outlines to suggest the gently rippling surface. I completed the painting with a few final touches, but these should be kept to a minimum and any urge to 'tidy up' strongly resisted!

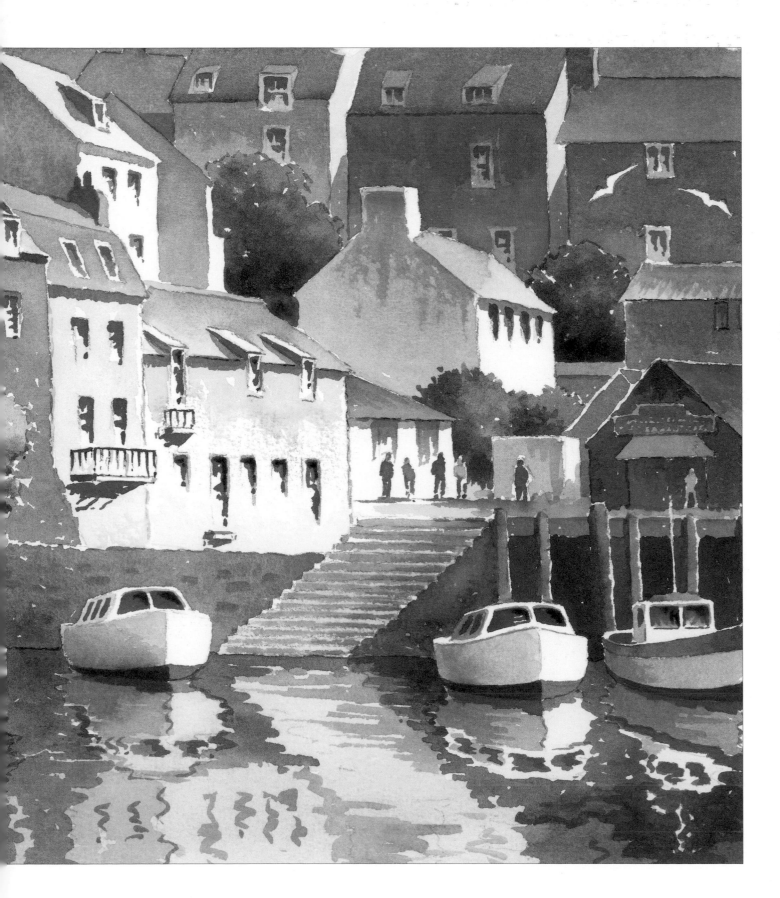

Industrial buildings

Most of us live or work in towns and cities, so it is understandable that we should seek relaxation, recreation and inspiration away from bricks and mortar. The countryside is under constant threat and artists should record its character and beauty while they can. Many landscape painters seek inspiration exclusively from the natural world and set off automatically for the countryside in search of subject matter. One disadvantage of this preoccupation with rural landscapes is that it may close our eyes to promising subjects nearer home.

Artists should be sensitive to all types of visual stimuli and should not limit their artistic efforts to the conventionally picturesque. They may perceive form and beauty where others see only squalor, and their paintings invite others to share their vision. On grey days city scenes may seem dull and drab, and lack visual appeal, but a dramatic industrial skyline against a fiery evening sky could pose an exciting challenge to the imaginative artist. The meanest back street, with light from shop fronts and windows reflected in its wet surface, may inspire an impression rich in atmosphere and feeling. The painting opposite shows the corner of an undistinguished East London street with a few run-down shops and not much else, but something about the contrast between the warm light from the shops and the grey, mizzling atmosphere beyond caught my attention.

Coal Mine

I painted this impression of a small Welsh coal mine in warm sunset tones, using just three colours: raw sienna, light red and French ultramarine. The buildings and machinery are strongly lit by the sunset glow from the right, and the pithead stands out starkly against the fiery sky to increase the dramatic impact.

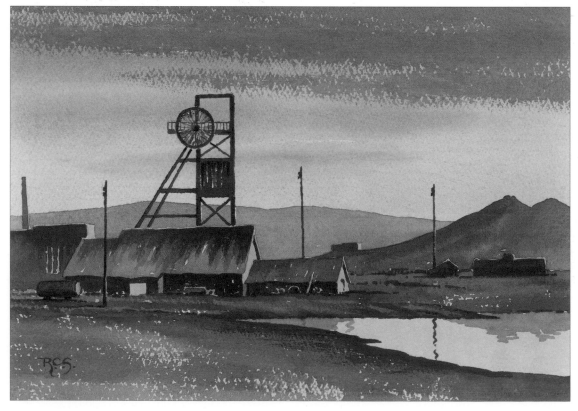

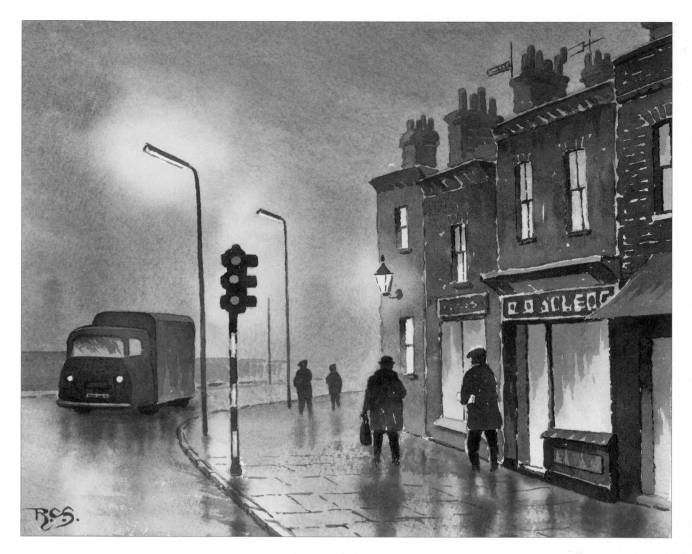

Fog

When I saw this scene, I made a mental note of the haloes cast by the lamps in the damp mist and made a scribbled sketchbook note of the road, the buildings and the figures hurrying home. Back in my studio the impression was still vividly in my mind so I sketched out the scene and set to work. I used masking fluid for the street lights, the truck headlights, the traffic lights and the lighted windows. While it was drying I prepared a wash of raw sienna and a little light red for the glowing haloes of the lights, and one of French ultramarine and light red for the misty background. I applied both with large brushes and allowed them to blend softly, allowing for the fact that watercolour fades appreciably on drying.

I removed the dry masking fluid with my fingertip, then painted the warm lights in the windows, again in raw sienna and light red. The buildings were various deeper combinations of light red, burnt sienna and French ultramarine and I left a few chips in the wash applied to the nearest shop to suggest brickwork. I applied a pale wash of light red and French ultramarine to the pavement and roadway, then dropped in several vertical strokes of a deeper version of the same mixture, wet in wet, for some reflections in the wet surface. When the paper was again dry, I added some detail – the kerb, the paving stones and a little broken wash texture. The truck, the lamp standards, the traffic lights and the figures, all in deeper tones, completed the painting.

123

Grand buildings

Many buildings fall into this category, from cathedrals, castles and stately homes to town halls. Architectural styles may range from elaborate ecclesiastical Gothic to the more severe lines of the classic and neo-classic tradition. Watercolour is not at its best when used to describe the minute detail of carved stone embellishments; aim instead to capture the impact and grandeur of the subject, suggesting the mass of detail as economically as possible.

I made the most of the impressive lines and unique situation of Notre Dame (opposite). I made a preliminary sketch, with the cathedral off-centre, leaving plenty of space for the sky. It was a fine evening in late summer and the warm glow from the cloudless sky touched every part of the scene, including the foreground trees which showed hints of autumnal russets. The cathedral made a strong statement against the sky and the sunlit bridge registered equally strongly against the darker background. I exaggerated the lights and darks a little for tonal contrast. I gave the water a simple wet in wet treatment in soft, pale tones to complement but not compete with the scene above, and capture something of the soft reflections in the river. Note how the light catches the tops of the trees and embankment parapet: it is touches like this that help to bring paintings to life.

Chartwell

Winston Churchill's beloved former home overlooks the Weald of Kent. This view from below the main garden terrace includes the colourful shrubbery that sets off the plain brickwork of the house.

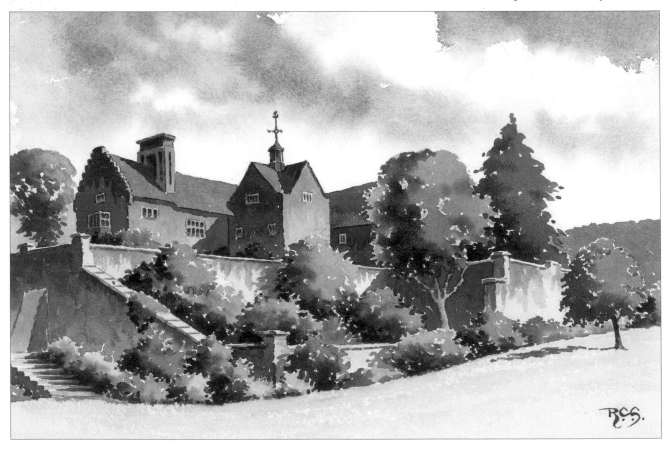

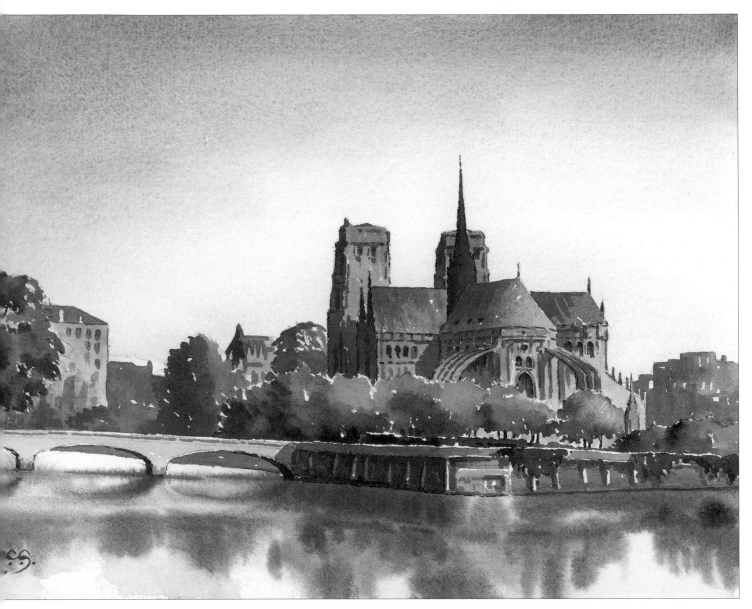

Notre Dame, Paris

I prepared a wash of raw sienna with a touch of light red for the warm lower sky area and one of French ultramarine and a little light red for the upper sky. With my board upside down and a large brush I began to apply the first wash, picking up and applying an increasing proportion of the second as I worked downwards to achieve a smooth transition and blending. I let the paper dry, then started to paint the buildings on either side of the cathedral in stronger versions of the sky washes. I used raw sienna and light red for the glow of sunlight on the cathedral masonry, adding a little French ultramarine for the towers, which looked darker against the pale sky. I added shadow and some texture, wet on dry, with a wash of French ultramarine and light red, using a stronger mix for deeper shadows, the spire, windows and other details.

The slate roofs were a warm grey mix of French ultramarine with a little light red. I left a space with a broken edge for the tops of the trees below, then added them, quickly and boldly, using various washes of raw sienna, burnt sienna and Winsor blue, green shade, with a deeper wash of Payne's gray wet in wet for the shadows. I used a very pale wash for the sunlit bridge and deeper tones of French ultramarine and light red for the embankment, particularly the shadowed part. A touch of raw sienna, wet in wet, suggested algae just above the water line. For the water, I prepared washes in slightly paler versions of the colours of the reflected objects. I applied a pale wash of raw sienna, slightly warmed with light red, to the whole area and began dropping in the prepared washes with vertical brush strokes.

Oast Houses

by Ray Campbell Smith

This view is of one of my favourite farms in the Kent countryside. The rich natural tones of the local clay used to make its bricks and tiles harmonise wonderfully with the landscape.

With a scene such as this, it is important to ensure that all the shadows fall in the same direction. Be aware that, if you take a long time to complete your painting, the direction of the shadows may change. To overcome this, sketch them in before you start to paint.

You will need
Rough watercolour paper
2B pencil
Putty eraser
Brushes: 25mm (1in) flat;
 no. 12, no. 10 and no. 8 round
Paints: my basic palette of raw
 sienna, burnt sienna, light red,
 French ultramarine and Winsor
 blue (green shade) plus Payne's
 gray and burnt umber

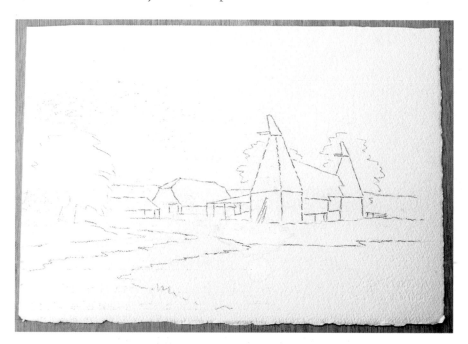

1. Using a 2B pencil, lightly draw in the outline of your composition.

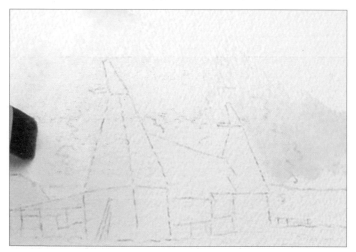

2. With the flat brush and a mix of raw sienna with a touch of light red, put a pale wash over the sunlit clouds, leaving white paper here and there for highlights.

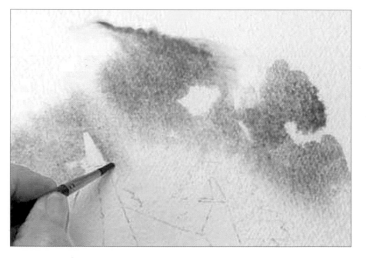

3. Using the no. 10 round brush and a mix of French ultramarine and light red, paint in the cloud shadows, allowing them to blend with the first wash.

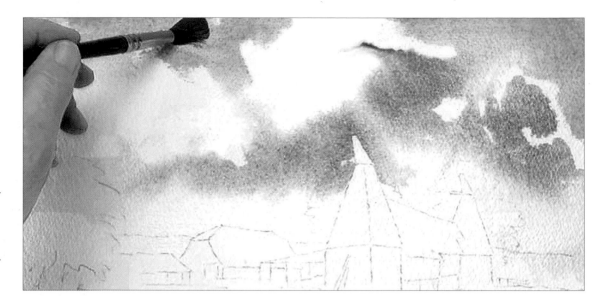

4. With the no. 12 brush and a mix of French ultramarine and Winsor blue (green shade), paint in the blue of the sky.

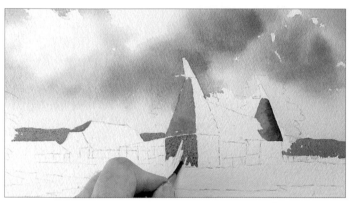

5. Change to the no. 8 brush and using a wash of burnt sienna for the tiles and light red for the brickwork, paint in the oasts. Working wet in wet, add a touch of green to the lower courses.

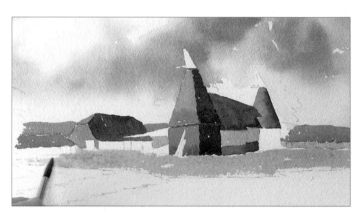

6. Using the no. 10 brush and a flat wash of French ultramarine and light red, paint in the distant hills. Using a mix of raw sienna and Winsor blue and a slightly broken wash, begin to put in the foreground grass.

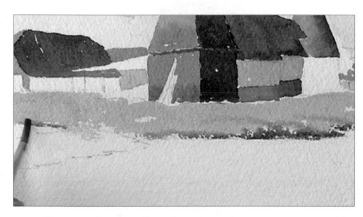

7. Still using the same brush and working wet in wet, add a little burnt sienna and Payne's gray to the lower edge of the grass.

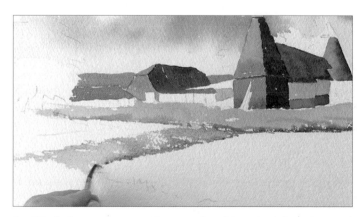

8. Work forward, using the same technique as for step 6, and put in some more grass. Add shadow using the same mix as for step 7.

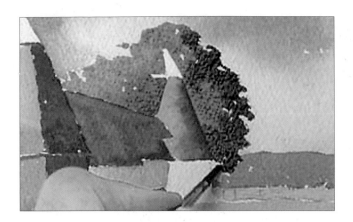

9. Using the no. 12 brush and a mix of raw sienna and Winsor blue, green shade, put in the trees. Add shadow, wet in wet, using a blend of Payne's gray and burnt sienna.

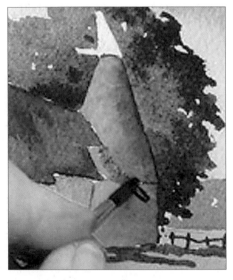

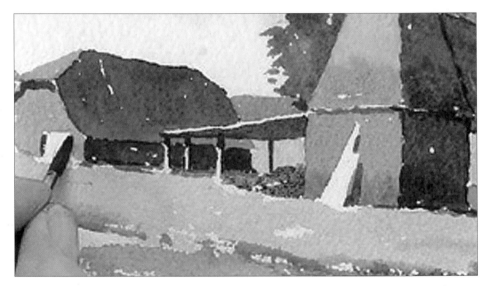

10. With a mix of light red and French ultramarine, add a cast shadow to the oast on the right.

11. Using a deep mixture of burnt sienna and French ultramarine, put in the underside of the lean-to roof, the posts and the shadows on the barn.

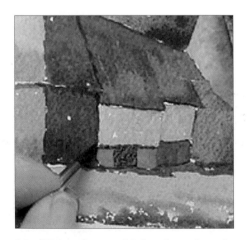

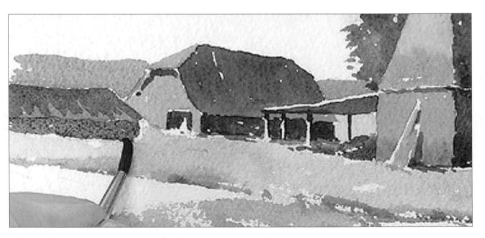

12. Using the no. 10 brush and a mix of burnt sienna and Payne's gray, add detail to the oast buildings.

13. Still with the no. 10 brush and a mix of French ultramarine and a touch of light red, apply a wash to the shadowed elevation of the long shed.

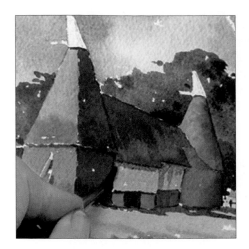 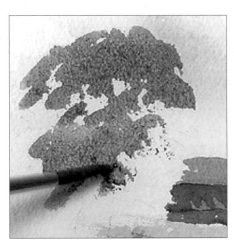 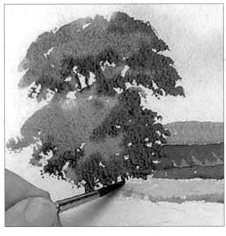

14. Using a mix of light red and French ultramarine, add shadow and texture to the white painted wall.

15. Put in the sunlit foliage of the autumnal tree using blends of raw and burnt sienna.

16. Working wet in wet using a mix of light red and French ultramarine, add shadow to the tree.

17. Using the no. 10 brush and a pale wash of raw sienna with a touch of burnt umber, put in the farm track. Allow to dry then, using a mix of burnt sienna and Payne's gray, and following the contours of the ground, begin to put in the tree shadows.

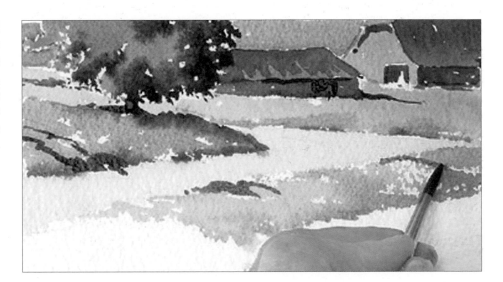

18. With the same mix, continue the tree shadows across the farm track.

19. Change to the flat brush and apply a very pale wash of raw sienna to the water surface.

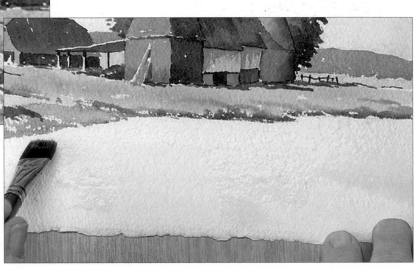

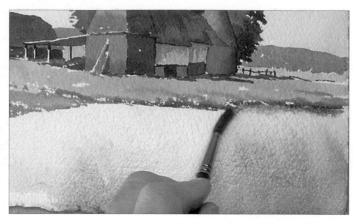

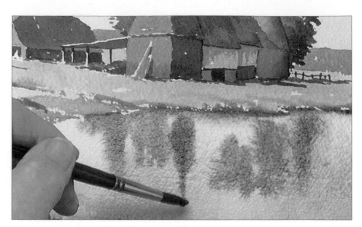

20. Using a mix of French ultramarine and light red, add blue tones to the water. Add shadow beneath the bank with a mix of burnt sienna and Payne's gray.

21. Working wet in wet with vertical strokes, begin to put in the reflections using the colour mixes that were used before.

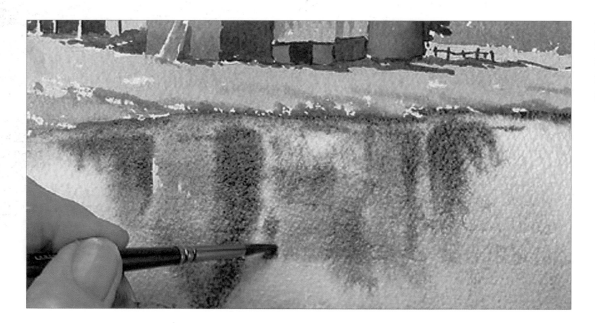

22. While the paper is still moist, add some more vertical strokes in deeper tones for the shadow reflections.

23. With the side of the no. 10 round brush, apply a broken wash of raw sienna to the foreground. Working wet in wet with a mix of burnt sienna and a touch of Payne's gray, add shadow.

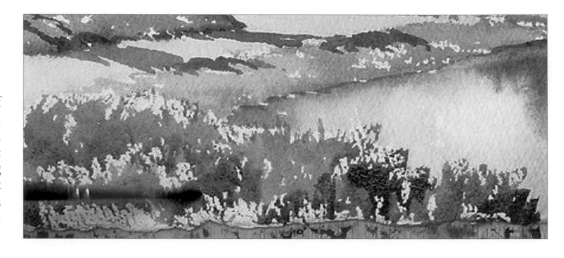

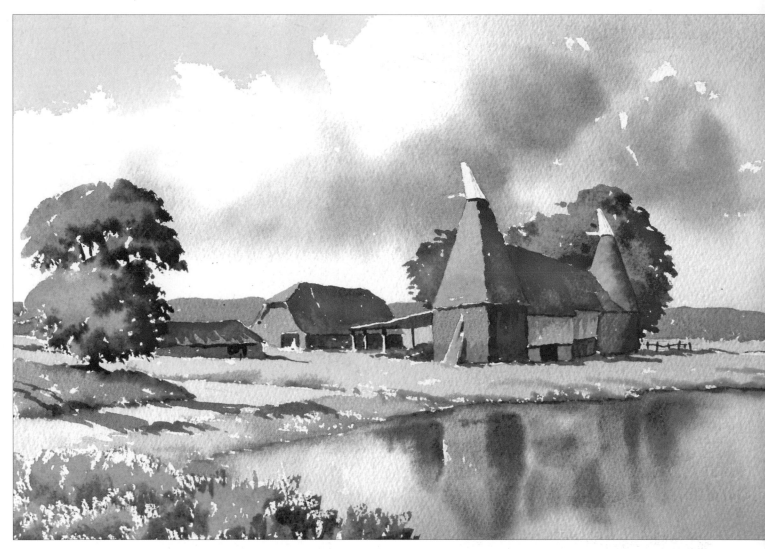

The finished painting

The Fish Market, Venice

by Ray Campbell Smith

This painting is based on a sketch that I made several years ago of the famous fish market in Venice. The buildings are mainly in tones of raw sienna and light red, but it is possible to achieve a remarkable variety of shades and colours by varying the concentration and the amounts of pigment in the washes. When you are adding shadows, pay particular attention to the effect of reflected light.

With a subject such as this, it would be easy to become bogged down in detail. For a more lively and spontaneous result, try to keep your approach free and fairly loose.

You will need
Rough watercolour paper
2B pencil
Putty eraser
Brushes: 25mm (1in) flat; nos. 12, 10 and 8 round
Paints: my basic palette of raw sienna, burnt sienna, light red, French ultramarine and Winsor blue (green shade)

1. Lightly pencil in the outline of your composition.

2. Using the flat brush, apply a pale wash of raw sienna, merging softly into light red towards the horizon.

3. With the no. 10 round brush and mixtures of raw sienna and light red, begin to paint the sunlit elevations of the buildings.

4. Use a pale mix of raw sienna for some of the elevations.

5. Add shadow using the no. 8 round brush and light red and French ultramarine mixes.

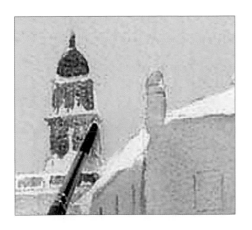

6. Paint in the distant tower using the no. 8 brush and a mix of French ultramarine with a little light red,

7. Using light red, paint in the pantiled roofs, leaving white paper 'lines' to suggest form economically.

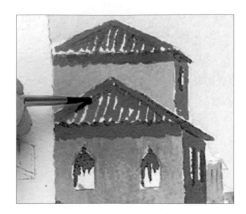

8. Add shadow using a mix of light red and French ultramarine. Use a darker version of the mix for the windows and soffits.

9. Add shadows and windows to the front elevations of the buildings using blends of light red and French ultramarine.

10. Complete the windows using a deep shadow mix of light red and French ultramarine.

11. Add broken, vertical strokes of a light shadow mix to suggest texture on the wall.

12. Using medium and deep shadow mixes, add windows to the side of the building.

13. Paint in the bridge using mixes of burnt sienna and light red.

14. Paint in the deep tones of the shadowed foreground building using various combinations of French ultramarine and light red.

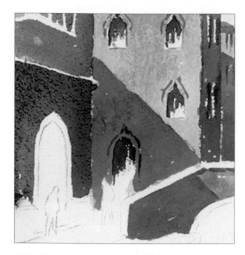

15. Put in some more tones, reserving white paper for detail.

16. Paint in the niches using a dark shadow mix.

17. Strengthen the mix still further and add deeper tones.

18. Using the point of the no. 8 brush, paint in some quick impressions of figures. Change to the no. 10 brush and begin to put in the reflections on the water...

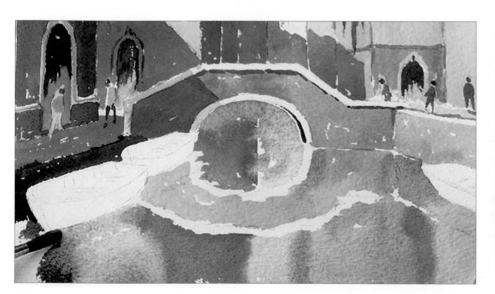

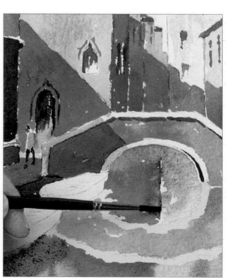

19. ...painting in washes that correspond roughly to the shapes and colours above, and giving them a slightly indented edge to suggest the rippling surface of the water.

20. Add a vertical line to the reflection to represent the side of the building.

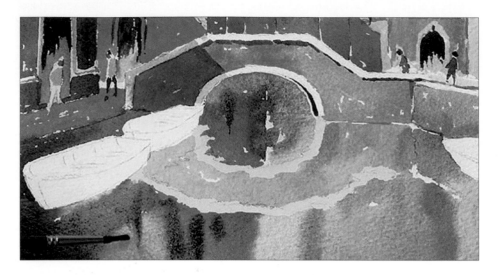

21. Using the no. 8 round brush, begin to add the deeper toned reflections, painting carefully round the shapes of the boats.

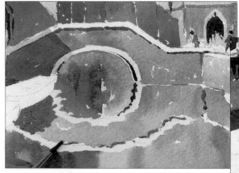

22. Add the reflections of the parapet...

23. ...then, using a dark shadow mix, begin to paint in the shadowed sides of the moored boats.

24. Using raw sienna, paint the inside of the boats.

25. Add detail to the boats using a medium shadow mix. Paint in the reflections on the water beneath the boats using a deep mix of French ultramarine and light red.

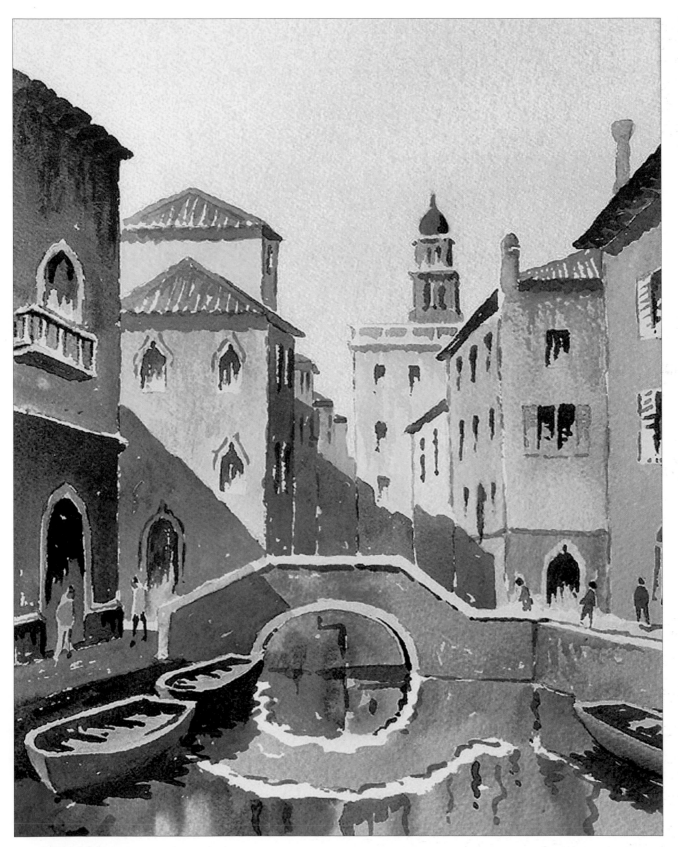

The finished painting

MOOD & ATMOSPHERE

In this chapter, watercolour painter and master of mood and atmosphere, Barry Herniman, shares his expertise.

When I first started painting, my intention was to produce a worthwhile facsimile of the scene in front of me. Basically, this was fine, and I learnt a lot of my painting craft that way. As time went on, however, I became less enamoured with creating just 'straight' paintings, and I started to explore other ways of putting paint on to paper.

What I really wanted to do was to capture the essence of a scene, 'the sense of place', and to inject the subject with that extra something... mood and atmosphere! Mood comes in many shapes and forms, and is open to individual interpretation. Each of us has our own perfect time of day, a favourite season or certain weather conditions that set our senses alight. When these elements prevail, that is the time to get painting.

Every landscape is dependent on light. Whether it is diffused through a soft hazy morning mist or coloured with the intense glow of a hard-edged sunset, light is the main governing factor. How often have you passed by a scene that is totally familiar to you, then, one day, the light changes or some unusual weather sets in and wham! the ordinary becomes the extraordinary? To me, that is what painting is all about, and I call it 'art from the heart'. Before I start to paint, I ask myself what it was that grabbed my attention and made me look twice. When I have answered that question it is then a matter of deciding how to capture it.

When it comes to painting, try not to be too literal with the colours, but rather use mixes that respond to your feelings. Too much time and energy can be used mixing *just* the right green only to be disappointed with the rather static result that the colour mix produces.

Let the watercolour have its head and allow it to move about of its own accord. This can be quite scary, but I am sure you will be surprised at some of the results.

This is what I am endeavouring to impart to you in this chapter – to move away from just realism, and inject your paintings with mood and atmosphere. So, good luck, and get moody!

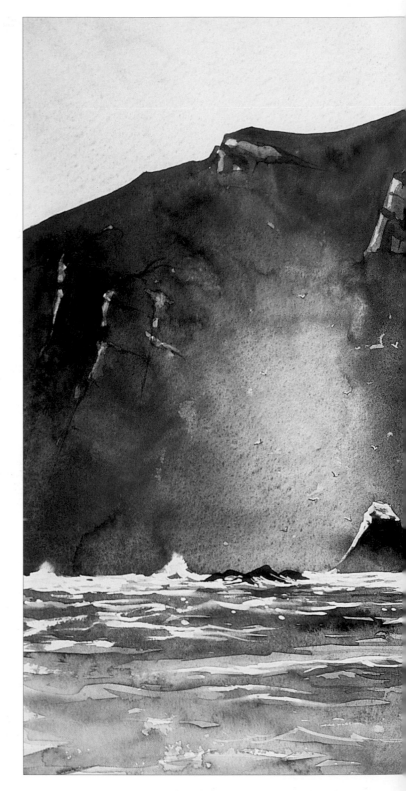

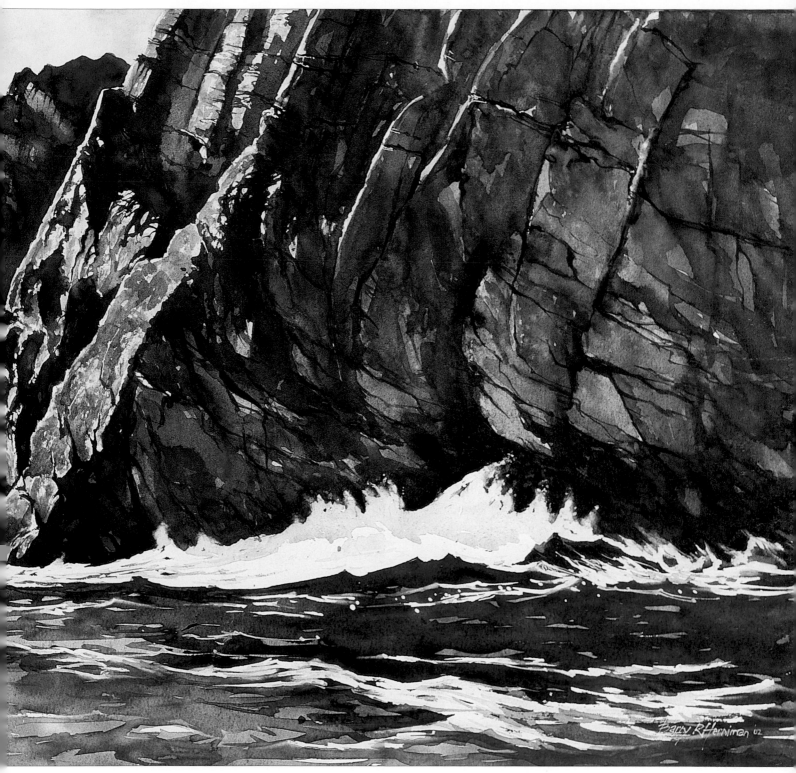

Wheeling in the Mist, Horn Head, Donegal

Size: 680 x 420mm (26¾ x 16½in)

You really cannot get moodier than Horn Head, a great slab of rock on the northern tip of Donegal. I have witnessed the peninsular in all weathers, but on this day I hired a boat to take me to the foot of the cliffs to get the view looking up at them. Because we were so close to the rock face, the sun was shielded behind cliff tops, but it caught the leading edge of the head, which counterchanged beautifully with the shadowed cliff face in the distance. Seagulls were wheeling about in the up currents of the early morning mist. A very exhilarating day which inspired me to do a series of paintings of this wild Irish coast.

Capturing the mood

There is mood and atmosphere all around you, even on a bright sunny day – depending where you look! This was the case with this rather tranquil scene at Faversham in Kent. I went to the boatyard and there were a multitude of wonderful subjects all in the glare of the afternoon sun. Boats, buildings and water all in sharp relief and all very colourful. When I looked over my shoulder, however, the scene changed dramatically; I was now looking into the sun, *contre jour*, and all those bright colours were severely muted, but there were some beautifully highlit shapes counterchanged against some velvety details. Painting a scene *contre jour* bleaches out a lot of the colour, but it does produce a moody scene where shapes and shadows merge together.

I took some reference photographs, but, mindful of the fact that I had to wait to see the results, I set about doing a quick tonal sketch to work out the main lights and darks and the mid-tones. I then painted the loose colour sketch (opposite) in situ as a demonstration of how to paint highlights without using masking fluid.

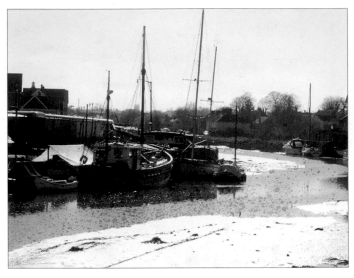

One of the photographs taken on my visit to the boatyard at Faversham. Beware when taking any photographs into the sun, as the lights go white and the shadow areas go black.

This tonal sketch was worked up using a 4B water-soluble graphite pencil.

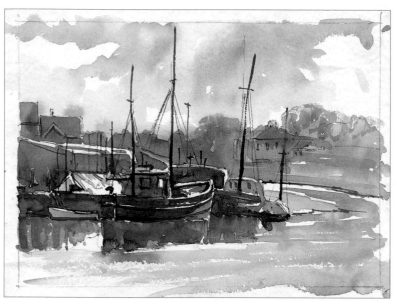

Quick colour sketch

This quick sketch demonstrates how you can paint a scene directly, without using masking fluid. I just painted around all the highlights as I worked down from the sky. It is very rough and ready, but I think it gets across the prevailing mood of the scene, and it also loosened me up to do the finished painting.

Moored up for the Day – Faversham, Kent
Size: 460 x 340mm (18 x 13½in)

This small watercolour, built up with a series of wet overall washes, was painted when I got back to my studio. The highlights were masked out so I did not have to worry about reserving them and I could concentrate on getting the washes down.

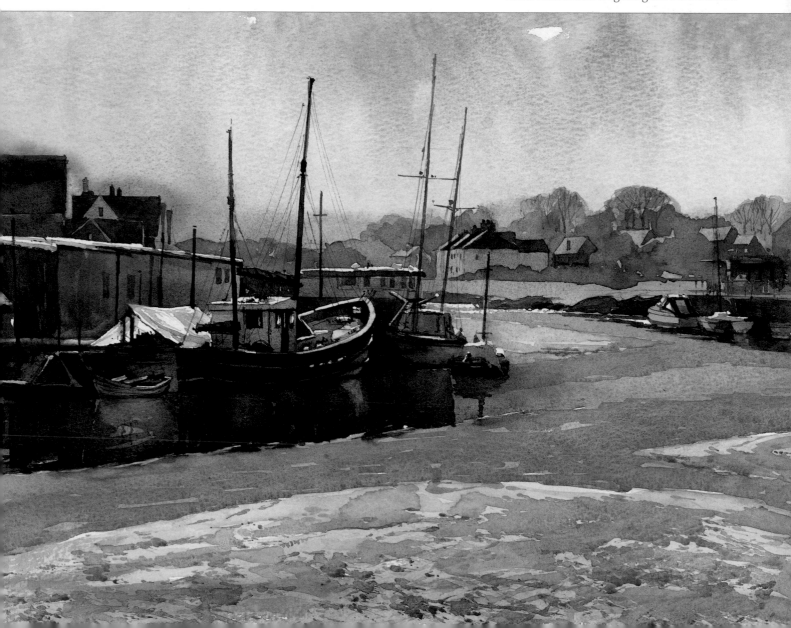

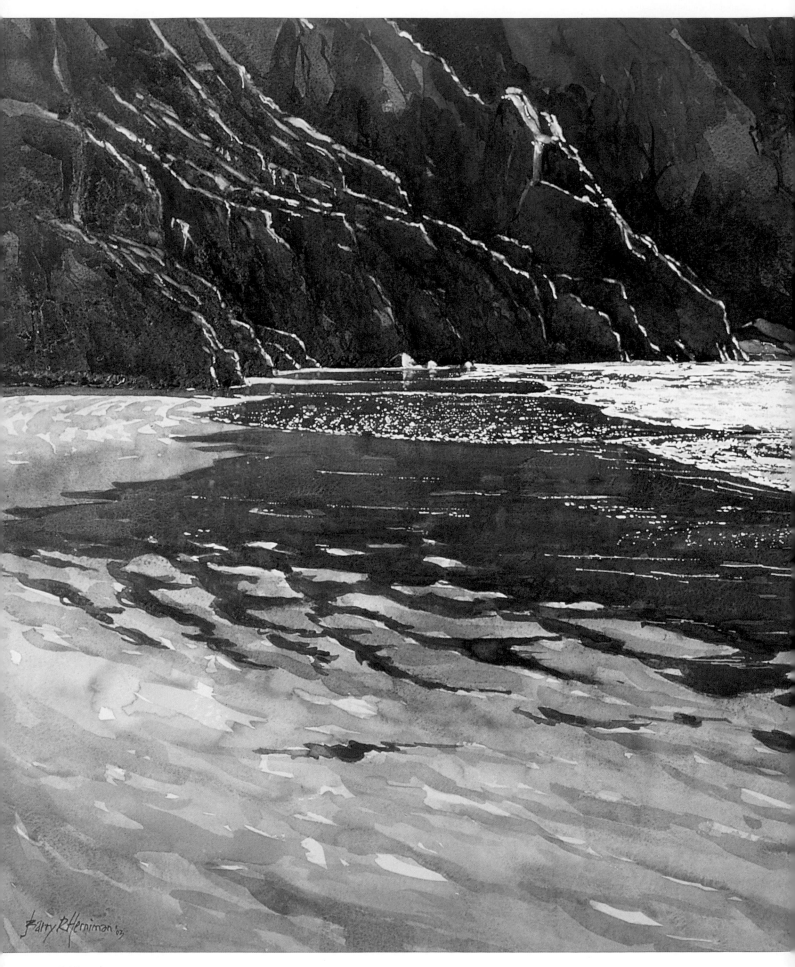

When you have found a scene that excites and inspires, all you have to do is paint it! While the adrenaline is running, I sometimes dash off a quick watercolour painting just to see how it works and comes together. Here are two versions of the same scene, one painted on site, the other worked up in my studio.

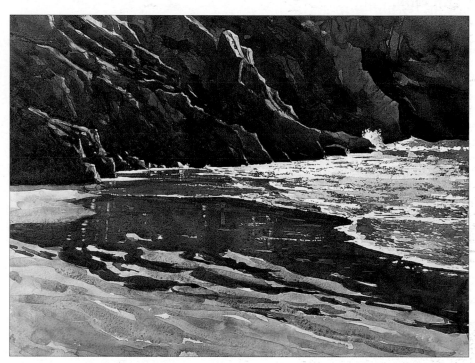

Receding Tide, St Catherine's Rocks
Size: 400 x 300mm (15¾ x 11¾in)

This painting was quite small, but I had a great time getting all the rock colours moving and mingling together, and highlighting their edges to give them a little lift.

I experimented with masking fluid for the highlights in the water to get the sparkling effect and built up the colour densities of the sea with a succession of transparent glazes.

Receding Tide, St Catherine's Rocks
Size: 775 x 660mm (30½ x 26in)

Having completed the small painting above, I was all fired up to paint this much larger version – with a few modifications. I was happy with the colour combinations in the rocks and the sea, but the overall format was not what I wanted. I felt that a larger expanse of foreground beach would give the scene a greater air of solitude. Having worked up various pencil compositions, I decided on this almost-square format. It has a good amount of wet and dry sand in the foreground that helps lead the eye into the painting, and this also acts as a foil to the darkness of the sea and rocks.

Magic of the moment

It is not always possible to sit and paint a scene that really grabs you, but, when you can, it is a bonus. I was very lucky with this scene of the Roman Bridge at Penmachno, North Wales. While giving a painting demonstration one morning, I was able to get the magic of the moment down on paper. In this very quick, direct painting, I was intent on capturing certain light qualities rather than concentrating on detail. The morning sun was just clipping the fringe of yellowish grasses on top of the bridge, and the strong silvery light on the water brought the underside of the bridge into sharp relief.

It was quite a magical moment!

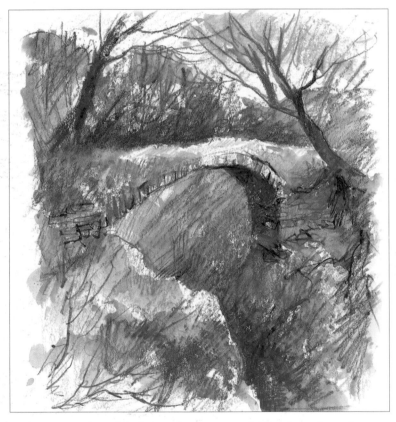

Back in my studio I played around with water-soluble coloured pencils, simplifying some of the elements and emphasising others to give a more dramatic slant to the scene.

Catching the Light
Size: 430 x 330mm (17 x 13in)

144

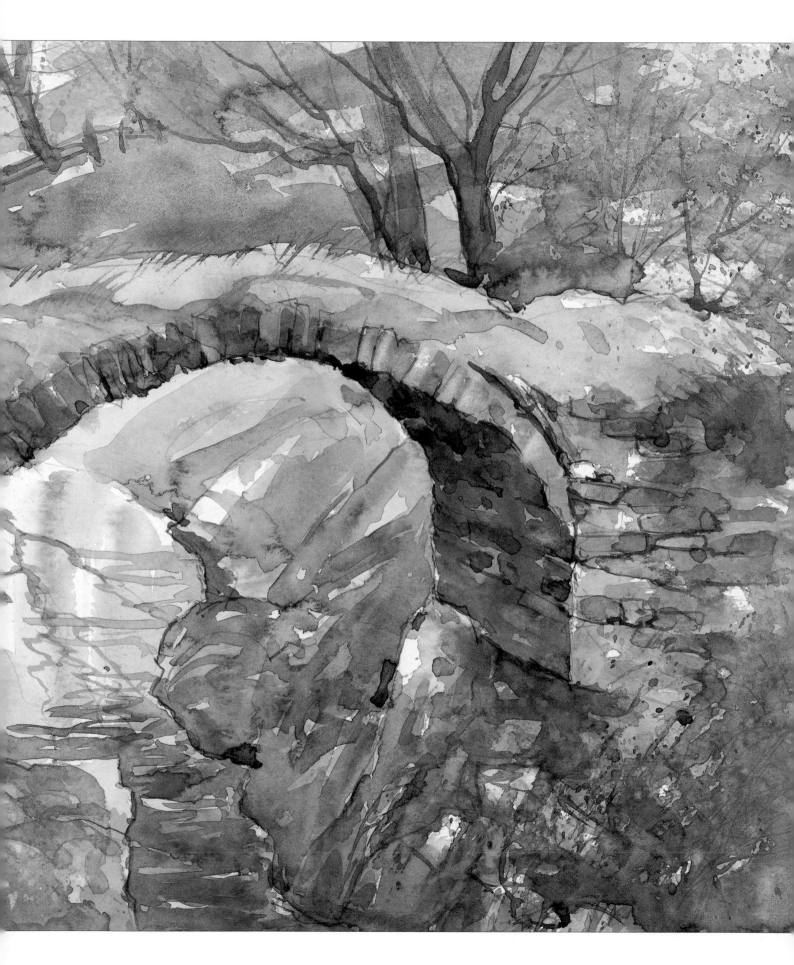

Frosty Morning

by Barry Herniman

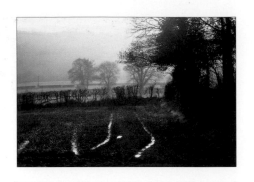

This is a scene from my small corner of Herefordshire. I know every inch of these fields, but it never ceases to amaze me just how different the scene becomes when the light changes and the seasons move on. It just goes to show that the combination of weather, lighting and season can produce some wonderful painting subjects right on our doorsteps.

On this particular late autumn morning, the first frosts had arrived. The air was crisp and clear, and the sun had just risen above the background hills. There was a lovely warm glow over the whole of the countryside, and the sun was shining through the trees in the foreground. Because of this, I was able to look directly at the scene without being blinded and capture the bright light that silhouetted the trees.

You will need:

Brushes: nos. 8, 10 and 12 round, no. 3 rigger and bristle brush

Colours: aureolin, Indian yellow, quinacridone gold, Winsor yellow, rose madder genuine, Winsor red, cobalt blue, French ultramarine, manganese blue, brown madder

Masking fluid and an old brush

2B pencil

Water sprayer

Paper towel

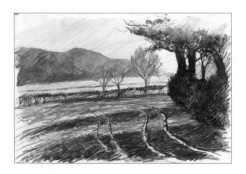

I got out my water-soluble coloured pencils for this quick preliminary sketch. I hatched in yellow over most of the picture, leaving white areas around the trees, built up the colours with a series of overlays, then softened some of the areas with clean water. I changed the angle of the tractor tracks so that they entered the composition from the bottom-right.

1. Transfer the main outlines of the composition on to the watercolour paper. Note that the detail on the left-hand side is barely suggested. Apply masking fluid (tinted here with a touch of blue) to the icy water in the wheel ruts in the field. Spatter some into the top of the tree at the right-hand side, then across the foreground as frosty highlights on the ploughed field. Prepare the initial washes: aureolin, Indian yellow, quinacridone gold, Winsor yellow, Winsor red and manganese blue.

2. Spray a liberal amount of clean water over all the paper...

3 ...then, working quickly and leaving the highlight area among the trees as white paper, start to lay in Winsor yellow, aureolin and Indian yellow.

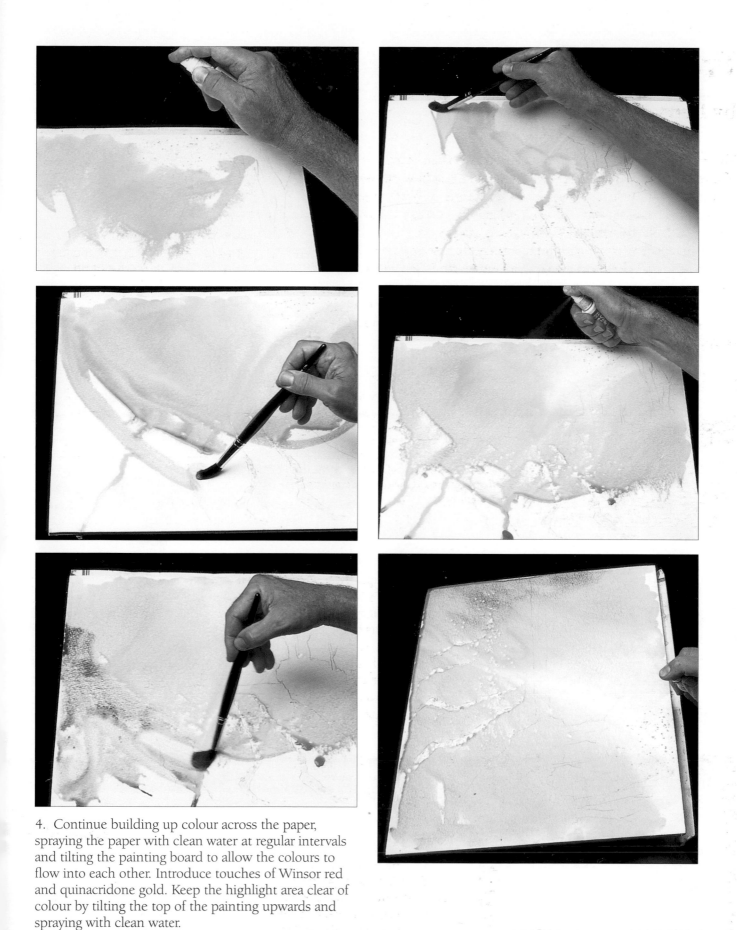

4. Continue building up colour across the paper, spraying the paper with clean water at regular intervals and tilting the painting board to allow the colours to flow into each other. Introduce touches of Winsor red and quinacridone gold. Keep the highlight area clear of colour by tilting the top of the painting upwards and spraying with clean water.

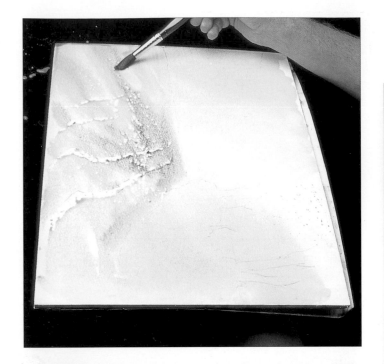

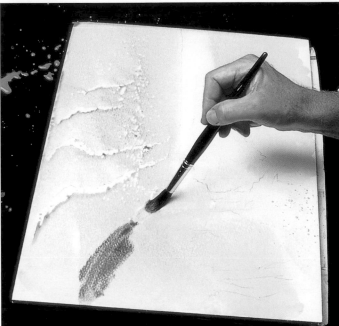

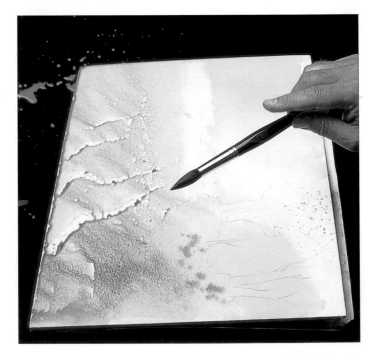

5. Still working quickly, wet in wet, add more Indian yellow at both the left- and right-hand sides. Lay in a weak wash of manganese blue to define the background area where the hedges are. Add Winsor red and quinacridone gold across the right foreground area, then spatter more quinacridone gold wet in wet. When laying in my initial washes, I am continuously tilting and turning the paper to allow the colours to blend on their own. In the series of photographs above, the top of the painting is at the right-hand side.

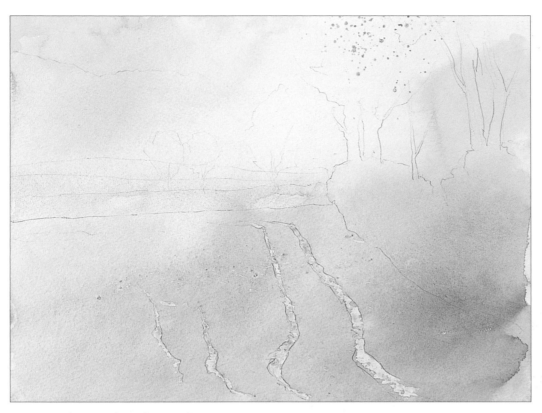

6. Leave the initial washes to dry.

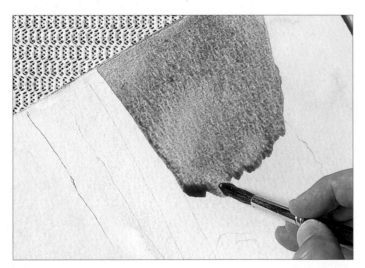

7. Turn the painting on its side, then, working wet on dry, use the no. 12 brush to apply cobalt blue, with touches of French ultramarine and rose madder genuine, into the distant hillside...

8. ...work down (across) the paper, adding more of the same colours, and introducing Winsor yellow to give a warmer glow towards the right-hand trees.

149

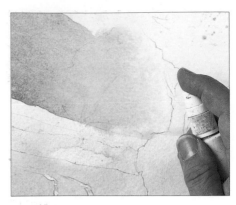

9. When you get close to the right-hand trees, spray the Winsor yellow with water, then use paper towel to absorb any excess paint.

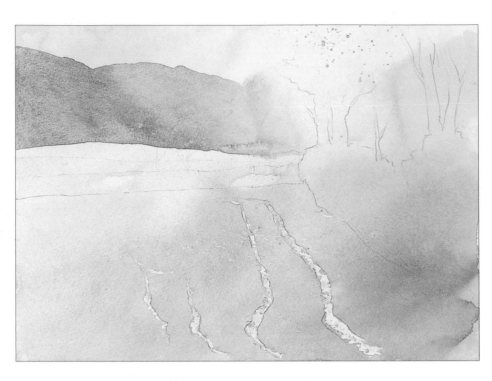

10. Leave the painting to dry.

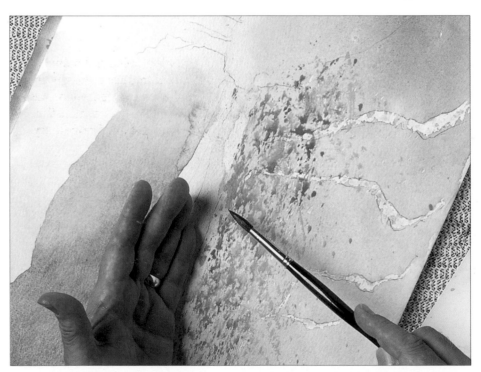

11. Turn and tilt the painting board, then use the no. 10 brush to spatter the foreground with water followed by Winsor yellow and quinacridone gold. Use your other hand to mask the edge of the field.

12. As you work down the field, spatter more water followed by Winsor red, more Indian yellow and brown madder. Spatter some cobalt blue to create darker tones. Gently move the paint around with the brush to pull the colours together.

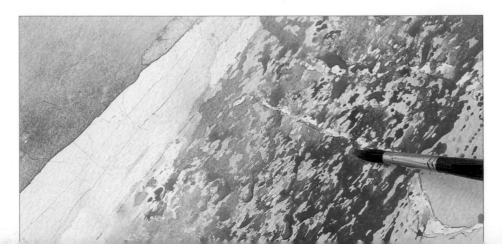

13. Mask the middle distance with a sheet of paper, then, tapping the side of a loaded brush with your finger, spatter smaller marks of the previous colours over the foreground.

14. Darken the right-hand corner of the foreground with cobalt blue to create shadow areas. Then, keeping the painting angled down so the paint runs and colours mingle, bring this colour across over the centre of the foreground. Use the brush to soften the edges.

15. Use cobalt blue and brown madder to introduce a shadow area under where the hedge will be. Use the same colours to work smaller shadows in the field. Leave to dry.

16. Now start to work on the right-hand trees. Spray the paper with clean water, then, masking the paper with your other hand, use the no. 8 brush to spatter Indian yellow into the tree. Mop up excess water and colour with clean paper towel.

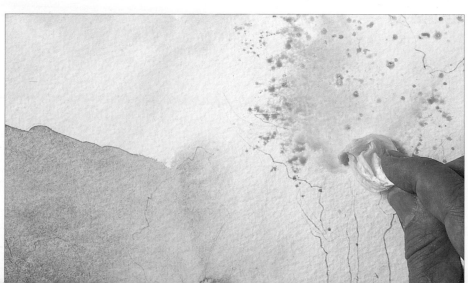

17. Spatter quinacridone gold into the damp yellow and allow colours to merge. Raise the top of the painting, then add brown madder and cobalt blue to the lower area.

18. Allow the colours to merge, then pull the bead of colour down to form the trunk. Use the handle of the paint brush to pull the colour down to form two smaller trees. Spatter dark tones of colour to suggest foliage on these trees.

19. Spray the foliage area with water, then paint the two right-hand trees. While the paint is still wet, add touches of French ultramarine on the shadowed sides of the trunks.

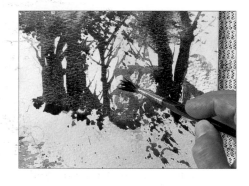

20. Spatter more foliage wet in wet, then pull out more branches. Drag the side of the brush over the surface to create background foliage between the trees.

21. Use French ultramarine with touches of rose madder genuine to accentuate the branches and shadows. Bring these colours down over the area beneath the trees, then introduce touches of brown madder and cobalt blue.

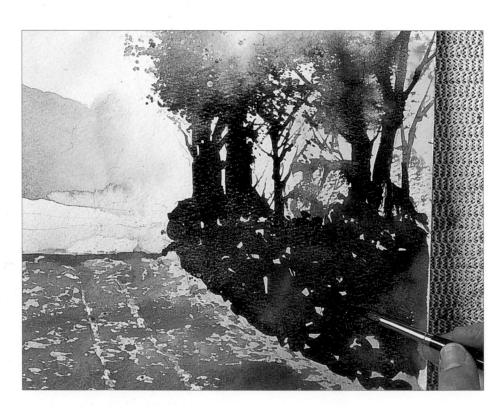

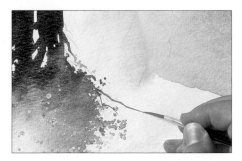

22. Turn the painting upside down, then use the rigger brush with brown madder and cobalt blue to paint some thin branches.

23. Turn the painting on its side so that the colours will run down the paper, then use a no. 12 brush to apply a flat wash of Winsor yellow over the middle-distant fields.

24. Working into the drying edge of the woodland, add a band of Indian yellow down the edge of the field where it meets the wooded area.

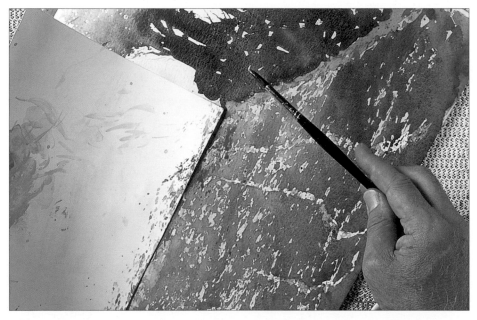

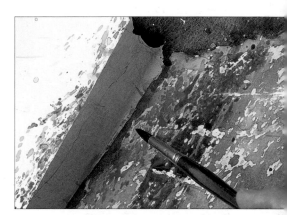

26. Spatter more quinacridone gold, cobalt blue and the reds on the palette into the field, then push and pull the colours together. Develop the distant edge of the field.

25. Still working at an angle, mask the middle distance with paper, then, painting wet on dry, use the no. 8 brush to flick darker tones of quinacridone gold into the foreground field.

27. Suggest undulations in the field by creating areas of shadow with the dark colours on the palette.

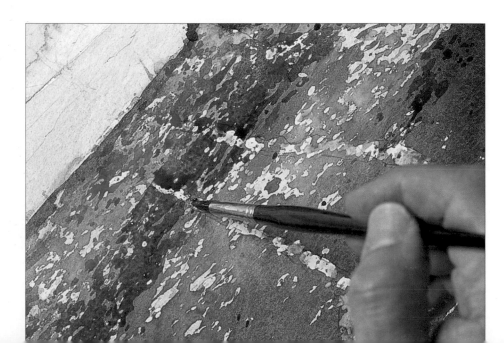

28. Use a no. 10 brush to spatter more reds and cobalt blue on the near foreground. Add touches of French ultramarine, then blend the colours with the brush.

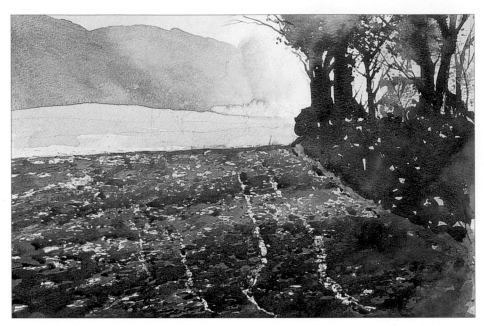

29. Use the same colours to develop the whole width of the foreground. Add some dark shadows at the right-hand side of the field.

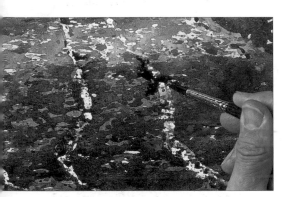

30. Accentuate the ruts in the field by creating shadows with touches of French ultramarine and brown madder. Spatter these colours over the foreground as you work.

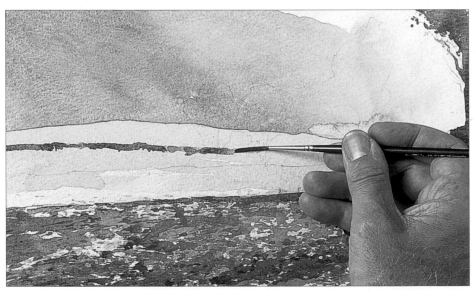

31. Working wet on dry with a no. 3 rigger brush, lay down flat brush strokes of cobalt blue, quinacridone gold, Indian yellow and rose madder genuine to form the more distant of the two hedges.

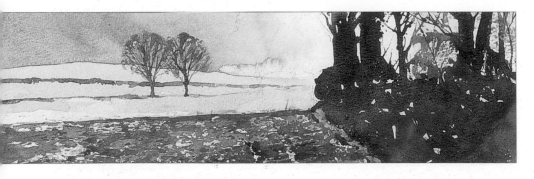

32. Weaken the colours as you work towards the right-hand side. Lay in another band of the same colours to form the nearer hedge. Create the trunks and branches of two trees then, using a damp brush, drag it across the surface of the paper to suggest some foliage.

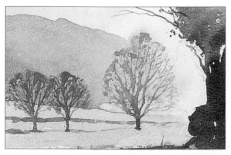

33. Now use a weak brown wash to work up a larger tree to the right of the others. While this is still wet, drop in a blue wash on the shadowed side of the trunk and branches. Work up some foliage with quinacridone gold and a touch of brown madder. Notice that there is more detail on the left-hand side; the right-hand side is blurred by sun.

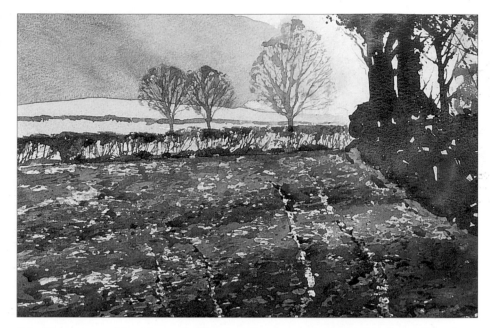

34. Using a no. 8 brush, apply downward, near-vertical, dry brush strokes of brown madder, cobalt blue and quinacridone gold to form the top of the hedge. Use similar colours and upward strokes to form the bottom of the hedge, then use the rigger brush to link the top and bottom parts of the hedge. Add touches of quinacridone gold to the brighter right-hand end of the hedge.

35. Remove all the masking fluid in the field and in the large sunlit tree. To remove large areas of masking fluid, lift one edge and carefully pull the rest off the paper.

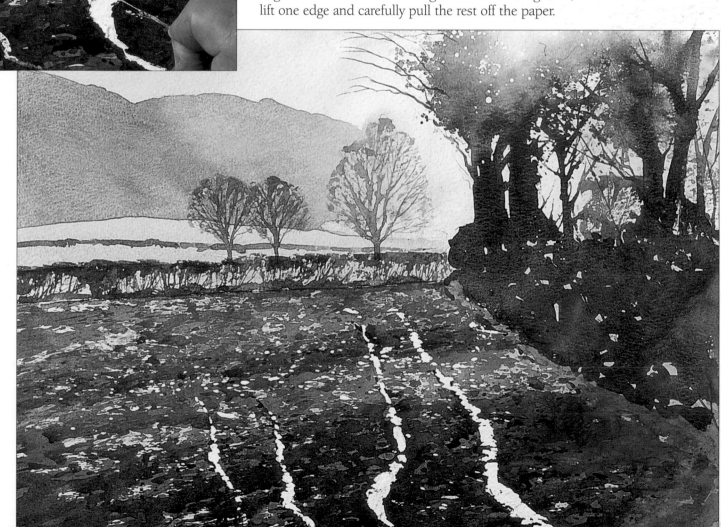

36. Brush Winsor yellow, with touches of quinacridone gold, into the icy ruts in the field and over some of the white highlights created by the masking fluid.

37. Spatter darks from the palette into the deep shadowed area at the right-hand side. Trickle more colour into this area, then use the brush handle to create 'squiggles'. Spatter a few specks of quinacridone gold.

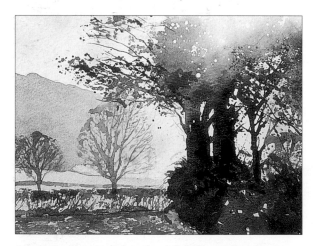

38. Use the no. 8 brush and delicate spattering to suggest foliage on the bare branches of the trees at the top of the painting. Pull the brush handle through the paint to redefine the structure of branches.

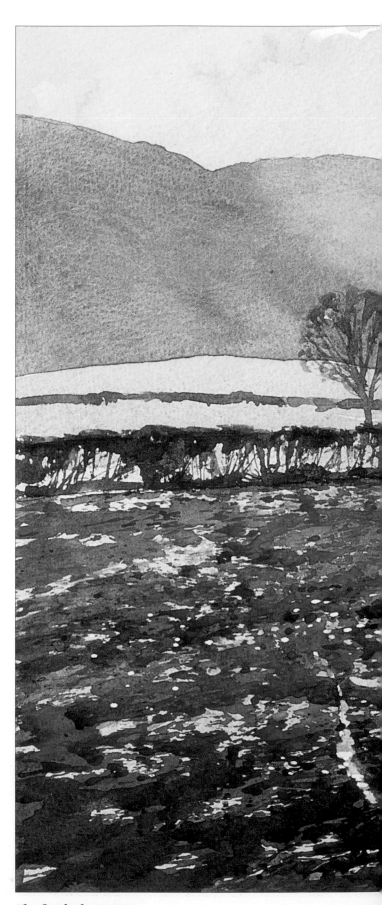

The finished painting.

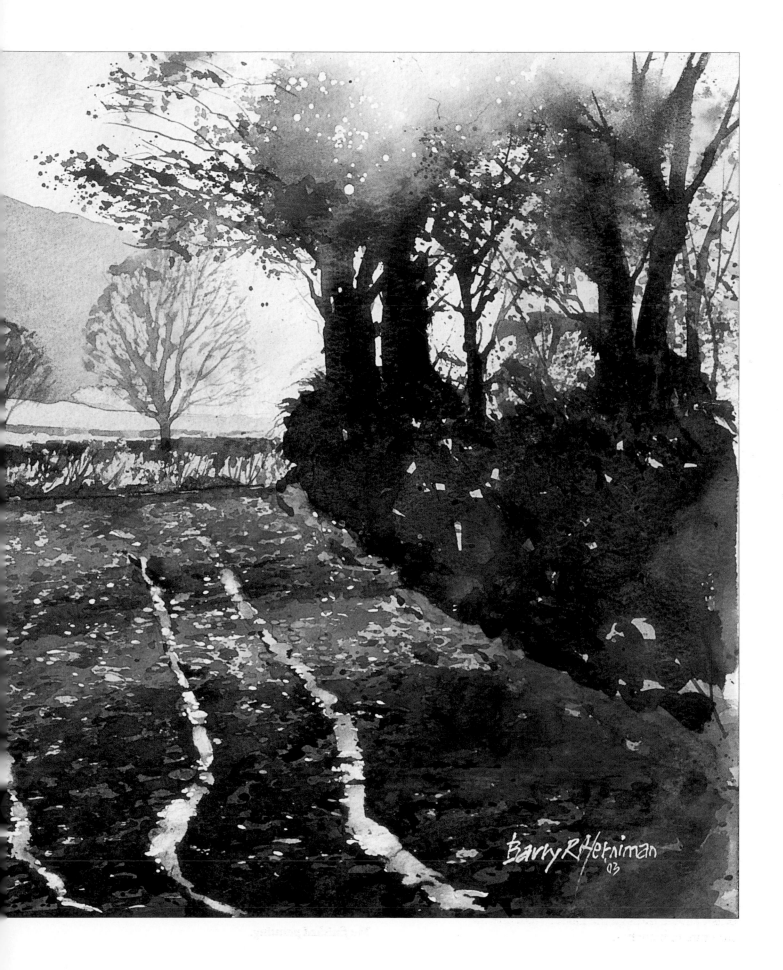

Barry R Herniman
03

Sunlight in the Cemetery, Belmont, USA
Size: 520 x 340mm (20½ x 13½in)

The sunlight shining through these autumn leaves was almost blinding. The leaves were made all the more dramatic by contrasting them with the purple shadows and gravestones. I used pure colours for the leaves: yellows, reds and golds straight from the tube.

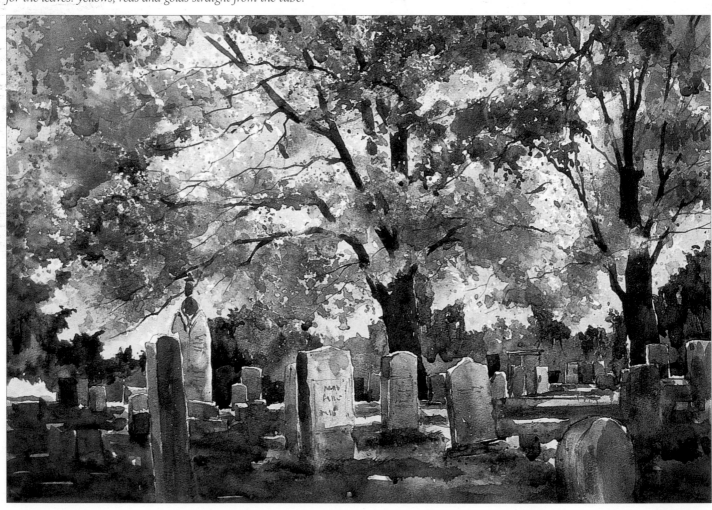

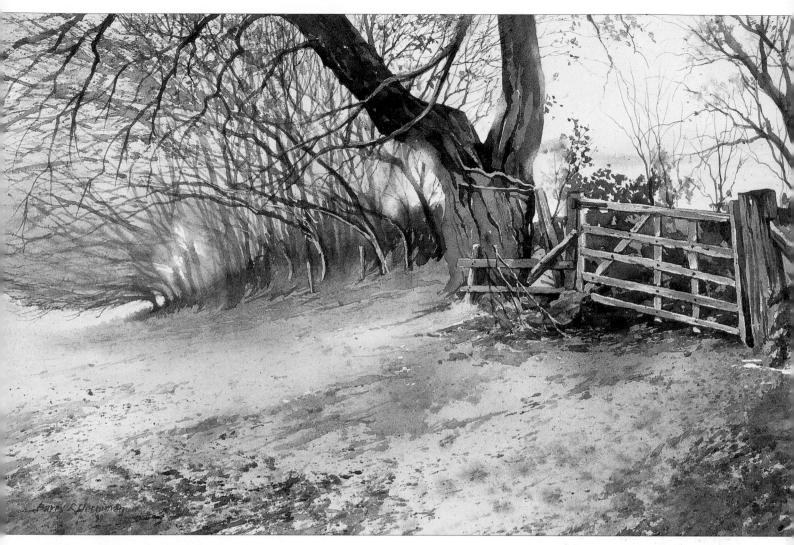

First Frost at Way-go-Through, Llangarron
Size: 535 x 335mm (21 x 13¼in)

This is one of the walks around our village which we have done many times. This particular morning there had been a heavy frost. The early morning sun was just filtering through the trees infusing intermittent areas with warmth in an otherwise cold scene.

I flicked and spattered paint over the foreground making the colours progressively cooler the further they were from the light source.

This painting is reproduced by kind permission of the owners, Jacqs and Ken Anstiss.

Index